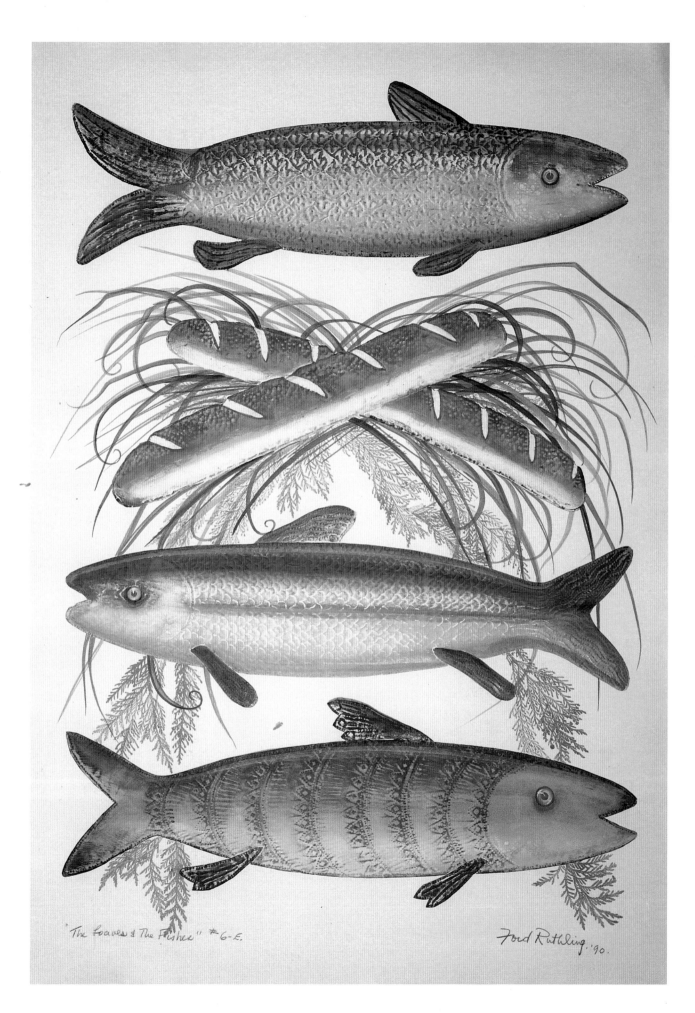

"The Loaves & The Fishes" #6-E. Ford Ruthling '90.

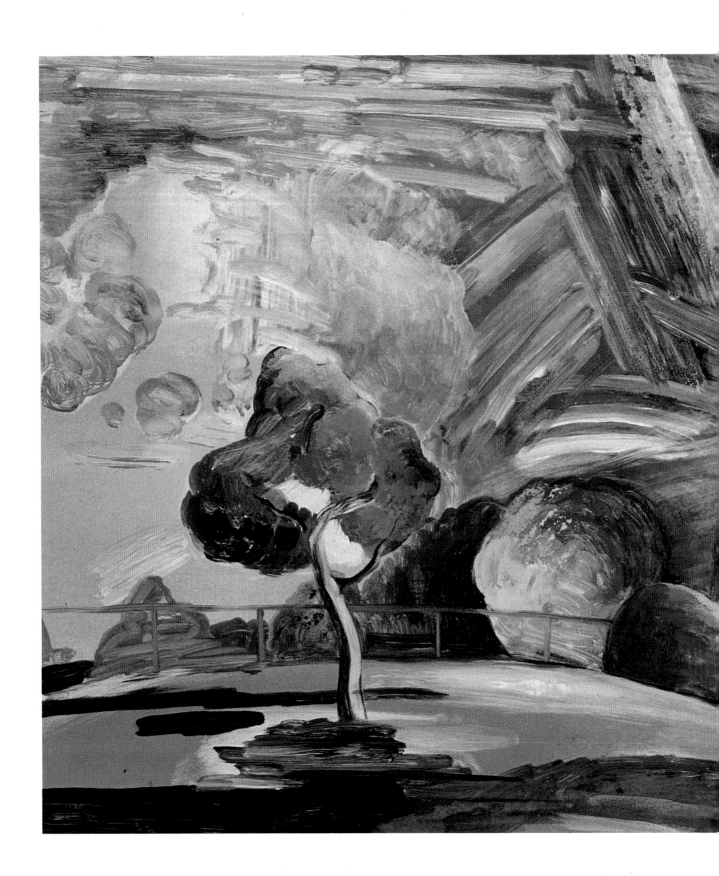

Monotype

Mediums and Methods
for Painterly Printmaking
Julia Ayres

Watson-Guptill Publications / New York

Art on first page:
Ford Ruthling, *The Loaves and the Fishes,*
embossed monotype, 29½ × 42″ (75 × 106.7 cm).

Art on title page:
Nancy Friese, *Johnson's Fence,*
18 × 24″ (45.7 × 61.0 cm). Courtesy of
Giannetta Gallery, Philadelphia.

Art on dedication page:
Joseph Raffael, *San Diego Parrots,*
62 × 38″ (157.5 × 96.5 cm).
Courtesy of Experimental
Workshop, San Francisco, and
Nancy Hoffman Gallery, New York
City.

For their efforts in helping me
prepare this book, I am grateful
to all of the contributing artists
and to these special consultants:
Patricia Alice
William Ayres
Vern Clark
Richard Fleming
Martin Green
Chris Hicks
Dorothy Hoyal
Mildred Karl
Vince Kennedy
Ann McLaughlin
Anne Morand
Ron Pokrasso
Kathryn Reddy
Daniel Smith
Joseph Solman
Judith Solodkin
Mary Turnbull
Anthony Zepeda

I would also like to thank my
editor, Lanie Lee, and the
Watson-Guptill staff, especially:
Candace Raney, Senior Editor
Marian Appellof, Senior Editor
Ellen Greene, Production Manager

Text set in 10 pt. ITC Berkeley Oldstyle Book
Edited by Lanie Lee
Graphic production by Ellen Greene

First published in 1991 in the United States by
Watson-Guptill Publications, a division of
BPI Communications, Inc., 1515 Broadway, New York, NY 10036.

Library of Congress Cataloging-in-Publication Data
Ayres, Julia S.
 Monotype / Julia S. Ayres.
 p. cm.
 Includes index.
 ISBN 0-8230-3129-2
 1. Monotype (Engraving)—Technique. I. Title.
 NE2242.A95 1991 90-23570
 760—dc20 CIP

Distributed in Europe, the Far East, Southeast and Central Asia, and
South America by RotoVision S.A., 9 Route Suisse, CH-1295 Mies, Switzerland.

Manufactured in Malaysia

First printing, 1991
 4 5 6 7 8/01 00 99 98 97

*This book is dedicated
to my mother, Ruth Meyer Spencer,
to my father, Robert V. Spencer, Jr., and
to my husband, David B. Ayres.*

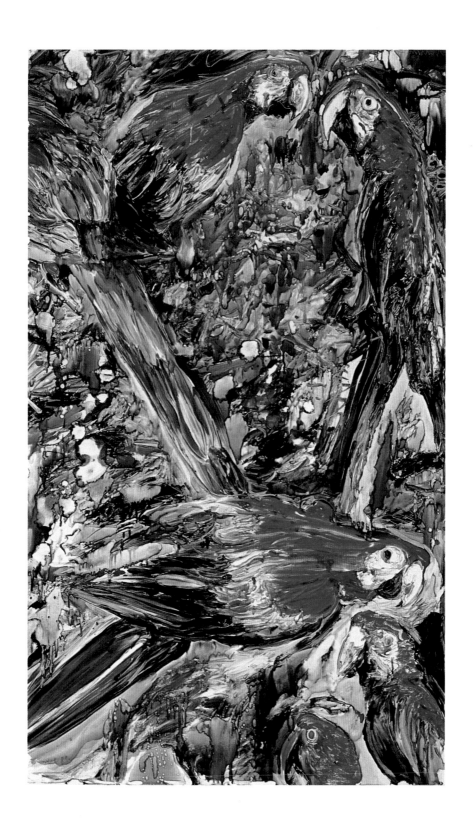

Contents

Introduction

My first question about making monotypes was, "Why paint on a plate and then print the work on paper?" I soon learned that some of the effects achieved with monotypes were not possible in other forms of art. The further I experimented and researched monotypes, the more doors opened to new ways of exploring its possibilities. The following are some of the basic characteristics of monotype work that captured my attention and imagination.

Monotype is a unique process in which you can use a combination of painting and printmaking techniques. It results in a one-of-a-kind image that is developed on a flat plate with oil- or water-based mediums, and then transferred to another surface, usually paper. The transfer can be made either by hand or with a press. For a hand transfer, essentially you place a sheet of dampened or dry paper over your plate and rub the back of it with a tool such as the bowl of a spoon, a baren, or a pot scrubber. In a press transfer, the plate and paper are placed on the press bed and mechanically moved under rollers (in an etching press) or scrapers (in a lithography press) to produce a print. After the transfer is completed, there is often some medium left on the plate, which is called the *ghost*. It is possible to use the ghost of a former work to develop a new monotype.

Monoprint is a term art dealers often use interchangeably with monotype. While the dictionary does not differentiate between the two, in the academic art world, the term mono*type* is used for work developed on top of an unaltered plate, utilizing its flat surface, while mono*print* refers to monotype work that also includes elements of another printmaking process such as etching, woodcut, lithography, silk screen, and so on.

This book has been written to show you how to develop a monotype with a wide variety of materials and techniques. You will be shown the two basic methods of working on the plate—

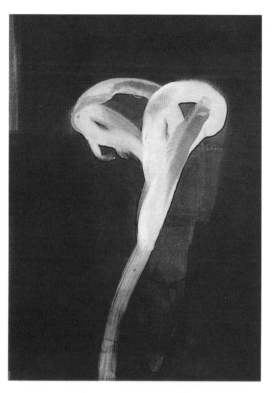

Michael Mazur, *Calla,* monotype, 30 × 22" (76.2 × 55.9 cm), 1987–88.

Mazur developed this monotype using the subtractive method, removing the image from a dark inked field with a piece of cloth.

Michael Mazur, *Calla Lily Pair B,* monotype, each sheet: 41½ × 29⅝" (105.4 × 75.3 cm), 1981.

After Mazur completed one transfer from the plate (left), he used the "ghost" that remained to develop a similar but softer image (right).

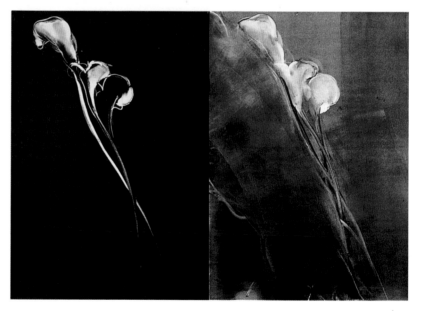

the additive and subtractive techniques. In the additive approach, the image is painted in positive, directly on the plate; this is known as working into a light field. In the subtractive approach, medium is applied over the entire plate and the image is developed in negative by removing the medium with various tools; this method is also known as working from a dark field.

Before learning about the diversity of monotype, you should know about how the process developed. The brief history that follows will introduce you to a few of the artists who discovered and utilized the technique.

History

The earliest known monotypes were made by the Italian printmaker Giovanni Benedetto Castiglione. These monotypes date back as early as 1640. To develop his image, Castiglione used the subtractive technique. He rolled printing ink onto a metal plate, and wiped out the medium with rags and other tools, such as brushes, to produce an image. It is believed that he used a pointed wooden tool to inscribe lines into the ink that transferred as white lines to paper. In later monotypes, he also painted images on a clean, uninked plate.

At approximately the same time, Rembrandt van Rijn, the Dutch painter and printmaker, was experimenting with his intaglio plates. After inking a plate, he would wipe the ink in such a way as to produce tones that resulted, in essence, in monotype effects in his images. Adding monotype elements to a printmaking matrix, in this case etching or drypoint, makes each impression unique and constitutes a monoprint.

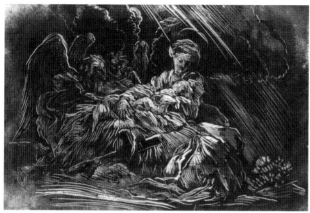

Giovanni Benedetto Castiglione, *The Nativity,* monotype, 9¾ × 14¾" (24.9 × 37.5 cm), 1650–55, collection of Windsor Castle, Royal Library. © 1990 Her Majesty Queen Elizabeth II.

This white line drawing was created by drawing into a dark inked field.

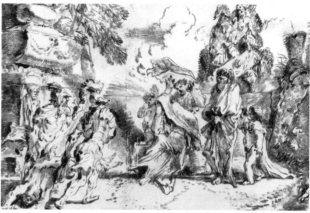

Giovanni Benedetto Castiglione, *Two Soldiers Dragging a Corpse Before a Tomb,* monotype, 1660, collection of Windsor Castle, Royal Library. © 1990 Her Majesty Queen Elizabeth II.

For this print, Castiglione painted directly on the plate.

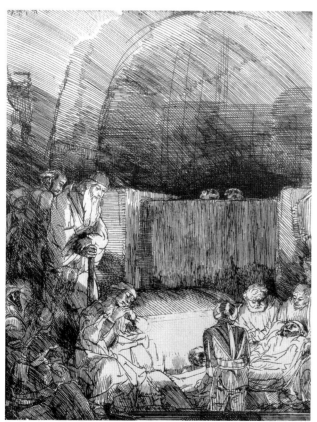

Rembrandt van Rijn, *The Entombment,* etching, first state, 8⁵⁄₁₆ × 6⁵⁄₁₆" (21.1 × 16.0 cm), c. 1654. Courtesy of The Metropolitan Museum of Art, The Sylmaris Collection, Gift of George C. Graves, 1920. [20.46.17]. All rights reserved, The Metropolitan Museum of Art.

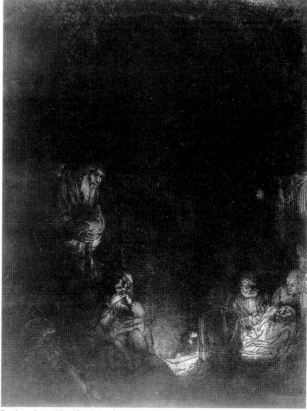

Rembrandt van Rijn, *The Entombment,* etching, second state, 8¼ × 6⁵⁄₁₆" (21.0 × 16.0 cm), c. 1654. Courtesy of The Metropolitan Museum of Art, Gift of Henry Walter, by exchange, 1917. [23.51.7]. All rights reserved, The Metropolitan Museum of Art.

In the first-state etching (left), the surface of the intaglio plate was wiped clean, leaving ink only in the incised lines. The version at right qualifies as a monoprint because Rembrandt left some of the ink on the plate's surface to create tones, which he could vary with each impression.

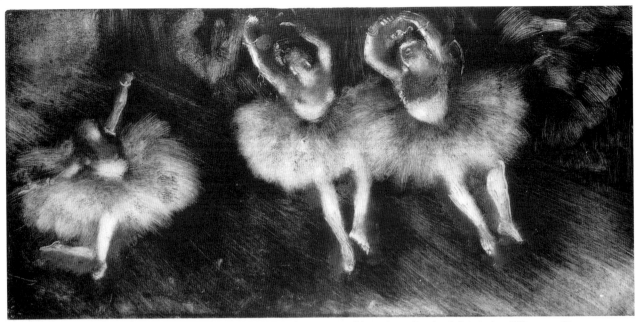

Edgar Degas, *Three Ballet Dancers,* monotype, 7⅞ × 16⁷⁄₁₆" (20 × 41.8 cm), c. 1878–88. Courtesy of the Sterling and Francine Clark Art Institute, Williamstown, Mass.

From a dark inked plate, Degas used the subtractive method to create the forms of the dancers. He often printed the ghost left on the plate. Degas also used monotype as a support for many of his pastel drawings.

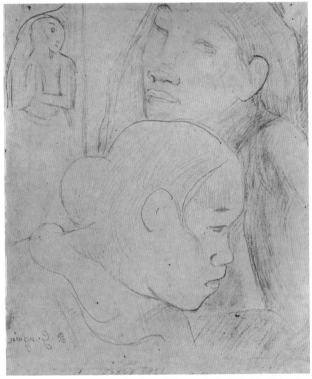

Paul Gauguin, *Two Marquesans* (verso), pencil drawing, 14⅝ × 12½" (37 × 31.8 cm), c. 1902. Courtesy of the Philadelphia Museum of Art: Purchased with funds from the Frank and Alice Osborn Fund.

Gauguin probably produced this work by drawing on the back of a sheet of paper that had been placed over a black-inked plate.

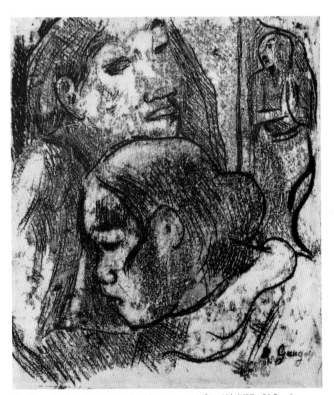

Paul Gauguin, *Two Marquesans* (recto), monotype, 14⅝ × 12½" (37 × 31.8 cm), c. 1902. Courtesy of the Philadelphia Museum of Art: Purchased with funds from the Frank and Alice Osborn Fund.

Here is the traced monotype. It appears that the plate had texture—perhaps wood? Also, some of the marks suggest that Gauguin used his fingers to press shadows into certain areas.

Edgar Degas also experimented with working on plates. His first monotypes were developed in the subtractive method; later he used the additive method. Degas delighted in printing the ghost remaining on the plate after the first monotype was transferred. Many of his pastels were done on these ghost transfers. Degas also developed some of his etching plates in a monoprint fashion.

Paul Gauguin used watercolors instead of the traditional printing inks to create monotypes. Unfortunately, a great deal of these works were lost or destroyed, obscuring some of the details of how he worked. There is also evidence that Gauguin used paper for plates instead of metal—there are works that show textured paper surfaces transferred to the support papers. He also made traced monotypes, which he referred to as printed drawings. For this technique, Gauguin first inked a piece of paper, then he laid a second sheet of paper on top. On the back of the second sheet, he made a drawing. The pressure of the drawing tool transferred the ink from the bottom sheet to the top; thus an ink drawing was printed on the reverse side of the original drawing.

In the late 1800s a number of artists in the United States were also working with monotype techniques. Thomas Moran referred to his dark-field works as ink-blot paintings. I was privileged to study some of these small works closely with a magnifying glass. There were effects on the paper that suggested that he developed the images with ink on a hard surface, working with hard rubber brayers and brushes. Unfortunately, Moran left no record of how he made these paintings, but it is not surprising that he would work on a plate, as he did make etchings.

Maurice Prendergast produced a notable collection of oil color monotypes using the additive method. He often developed the ghost for a subsequent transfer. The Terra Museum of American Art in Chicago owns an extensive collection of these works.

Interest in monotypes continued to develop in this century with artists such as Picasso and Matisse. Picasso painted color directly onto the plate, while Matisse removed a minimum amount of lines from a dark field. In the United States, artists such as Michael Mazur, Joseph Solman, Nathan Oliveira, Jasper Johns, and Sam Francis also work in monotype technique.

Recently, a virtual explosion of new ways to develop monotypes has occurred. In the following chapters, the methods of a number of monotype artists working in various mediums will be demonstrated. Through their personal experiences, you will be able to learn firsthand the techniques in current use and the almost limitless creative possibilities monotypes offer.

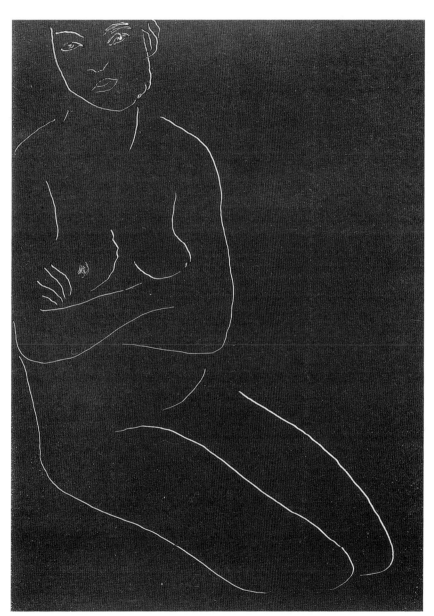

Henri Matisse, **Nude Study,** monotype, 6¾ × 4¾" (17 × 12 cm), c. 1914–17. Courtesy of The Metropolitan Museum of Art, Gift of Stephen Bourgeois, 1917 [17.75].

Drawing into a dark inked field, Matisse achieved maximum expression with a minimum of lines.

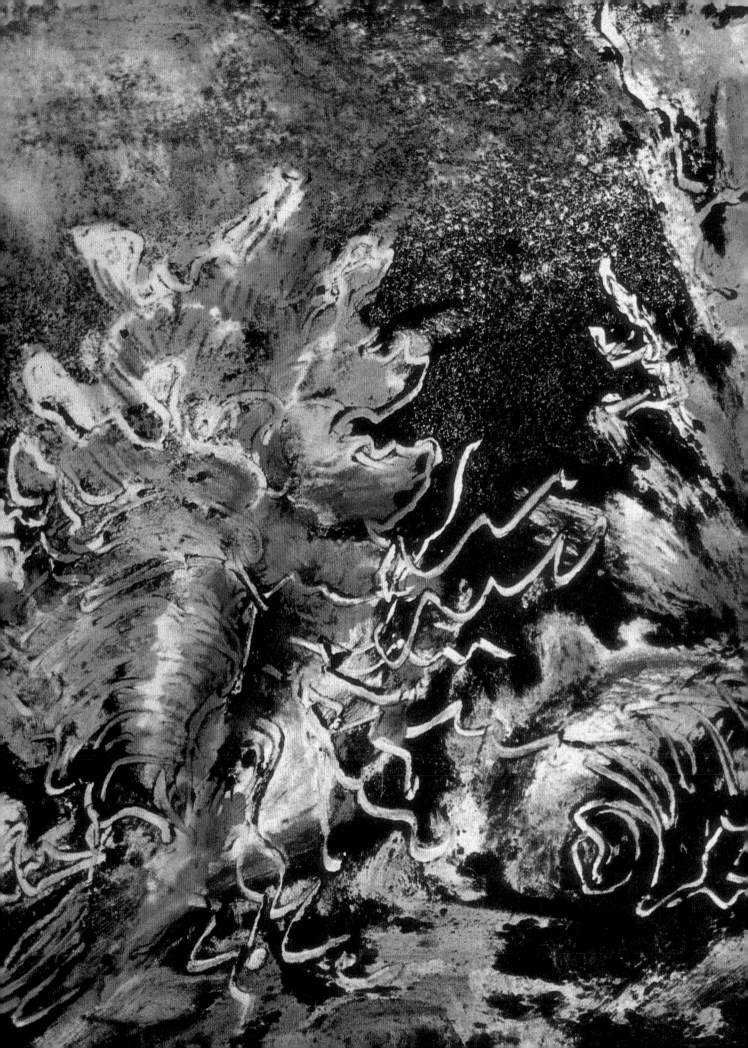

Chapter 1

Materials

Monotype is a spontaneous technique that gives you the freedom to work with a wide selection of materials. From water- and oil-based inks and paints to water-soluble crayons, pencils, and pastels, your choice may be based on personal preference, material availability, or the spirit of experimentation.

The variety of mediums, plates, papers, tools, and transfer methods that you have to choose from will encourage you to collage and combine different materials and techniques. Through experience, you will discover your personal preferences and style for developing a monotype.

Because there is such a large range of materials, this chapter deals with the most available ones on the market. It will help familiarize you with the basic terms and characteristics of various plates, mediums, solvents, painting tools, palettes, papers, transfer tools, and presses, so that you will be able to follow the specific methods described in later chapters.

Julia Ayres, detail, *Night in Coral Sea* (page 28).

Plates

The surface on which you paint a monotype is called a plate. Traditionally, metal, glass, sealed paper, and varnished wood have been used for this purpose. With the advent of plastics, there is a larger list of materials for you to work from, giving you a wider selection in the size and shape of the plate.

Metal plates are the most expensive, but they are also the most durable and can be used a number of times. If you are on a tight budget, Mylar, sealed paper, or Plexiglas may be more suitable. When working small, let's say under 22 × 30″, you will find a copper or zinc plate is desirable and affordable. However, for larger work, plastic, aluminum, or a number of paper materials will probably be more manageable.

Your plate can be the same size, smaller, or larger than the paper onto which the monotype will be transferred. You can either transfer the plate image onto paper with a press or by hand, using a baren or other hand printmaking tools. It is also possible to develop your monotype plate so that the image will cover the entire paper surface when transferred. On the other hand, white borders without a plate mark, an embossment, can be produced when your paper is the same size or larger than your plate. These white borders are produced by placing

a paper mask between the painted plate and the paper during transfer, or you can make margins on the plate and simply paint within the designated outline.

Plate marks are the embossments left by the beveled edges of the plate on dampened paper when pressure is applied during transfer, which can be done either by press or by hand. With a hand transfer, you burnish the beveled plate edges into the paper by running a hard, smooth tool such as the bowl of a spoon over them. The plates used in both hand and press transfers should be less than one eighth of an inch thick, and carefully beveled; otherwise the plate may damage the paper.

Almost all plate materials can be adapted to either the press- or hand-transfer method. One exception is glass. For safety reasons, you shouldn't use glass when a lot of handling or press work is needed. Materials should be chosen according to your needs and budget.

Metal Plates
Copper and zinc plates are most often used by etchers, while aluminum plates are primarily used by lithographers. For monotypes, the flatness of the plate is more important than the metal's hardness or highly polished surface. It is not

necessary for you to purchase plates prepared specially for etching or lithographic processes. Whatever you use, check that the surface is free of scratches, which will print like etched lines in the final work.

Metal plates sold by printmaking supply houses are usually between 16 and 18 gauge. The smaller number indicates a thicker plate. For example, a 16 gauge material will be .0508 of an inch. The 18 gauge will indicate thinner material of .0403 of an inch.

When storing plates, you need to preserve their smooth, flat surfaces. You can make coverings from plastic bags, heavy paper, or cardboard to protect the surfaces from inadvertent scratches. To prevent warping or bending, you can place them in an upright system, similar to the way LP records are stored.

Plastic Materials
Transparent Plexiglas offers a safer and lighter weight alternative to glass. Because it is transparent, you can set guidelines for the work in progress by placing it under the plate. However, since Plexiglas is softer than metal or glass, it is more predisposed to scratching.

Mylar sheets, available in drafting supply houses, are an inexpensive

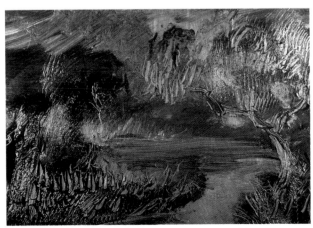
Before working on a copper plate, you can heat it so oil-based inks will flow more smoothly on the surface.

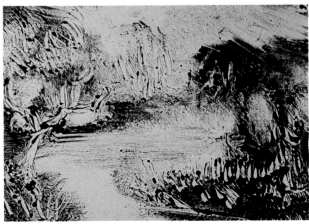
The copper color does not influence the final effect you will achieve. The uninked copper surfaces will become the color of the support paper after the transfer is completed.

When using a transparent Plexiglas plate, I usually place an outline drawing underneath. This becomes a guideline that helps me develop the image on the plate.

For this example, a thin, frosted Mylar sheet was used. A guideline drawing was placed underneath to aid in developing the plate work. The advantages of Mylar is that it is both lightweight and transparent. When making a hand transfer, you can place the Mylar, ink side facing down, on top of the paper and observe the progress of the transfer process.

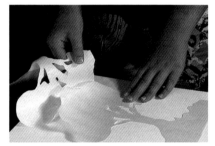

I cut a tree shape from Poly Print using scissors, then peel back the contact paper and attach the form to AHC multimedia board.

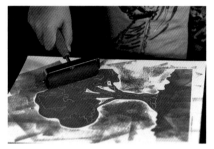

I textured the surface of the Poly Print by pressing into it with a pencil. With a brayer, I coat it with water-based block-printing ink.

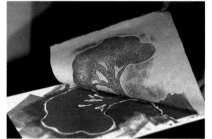

After hand rubbing the support paper on top of the plate, I pull the print.

alternative to Plexiglas. If you want plate marks, you can mount Mylar to mat board with spray adhesive, then bevel the edges with a mat cutter.

Speedball manufactures Poly Print, a thin sheet of plate material that has a finish similar to a Styrofoam cup. It has an adhesive backing protected by a liner that peels away so you can adhere it to another surface. Poly Print adheres to most surfaces but is usually mounted on a cardboardlike material such as an AHC all-purpose board. You can cut Poly Print with scissors or an X-Acto knife, and you can draw lines into it with simple tools such as a pencil or a ballpoint pen. The incised lines will print similar to lines in a linocut relief print.

Plastic materials are sold in the thousandths of an inch standard rather than gauge measure. To compare numbers, 1/4 inch is .250, 1/8 inch is .125, and 1/16 inch is .0625. For further comparison, I measured a matchbook cover and found it to be .015 of an inch. A Mylar sheet may be only .004 of an inch and can still be worked on.

Wood

Woodblocks designed for printmaking can be used as monotype plates. You can buy woodblocks in either the end- or plank-grain cut. The end grain is the width, or cross cut, of a tree, showing its growth circles, whereas the plank cut is the length of a tree, revealing knots and other interior grain lines. Some of the woods used are cherry, maple, or mahogany. Most woodblocks are too thick for techniques requiring plate marks.

You can also purchase plywood, pine, and other woods directly from the lumberyard. Before purchase, you should closely examine the texture of the wood because it will transfer onto your monotype.

All types of wood should be sealed with either acrylic varnish or polyurethane before you begin working on them. Martin Green, a California monotype master, has used mahogany sealed with polyurethane. The texture of the wood is beautifully and subtly incorporated into his images.

Recently, Green has used white plastic-coated wall panels for his mural-size works. Available in building supply houses, the panels are sold in one size, 4 × 8', but can be cut. For a modest fee, most lumberyards will do the cutting for you.

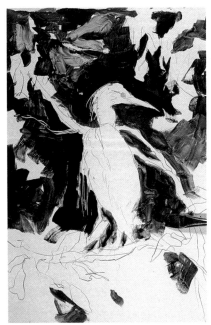

White plastic-coated wall paneling is a new, convenient material that can be used as a plate. In this example, the sketch guidelines were done with a black lithography crayon, and the image was developed with water-based relief printing inks in the direct painting method.

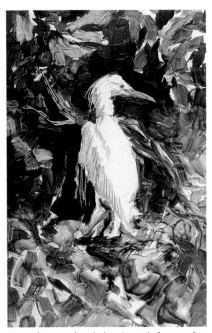

Here, the completed plate is ready for transfer. Plastic-coated paneling is suitable for either a press or hand transfer. In this case, a hand transfer was done on a sheet of moistened Arches 88 paper.

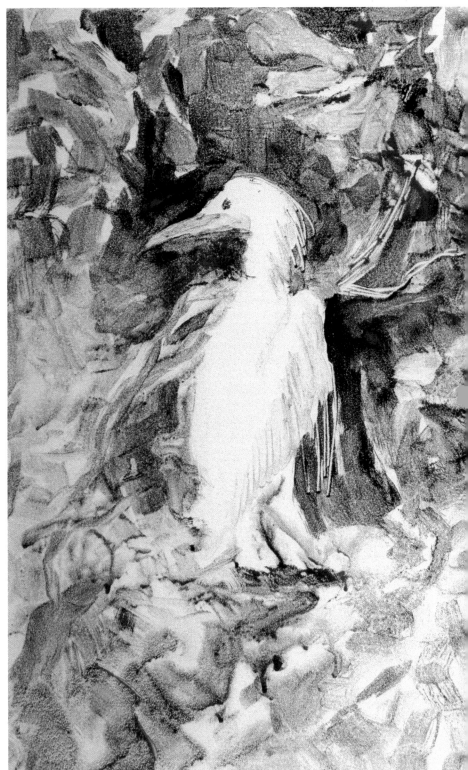

Julia Ayres, *Snowy Egret,* 22 × 15" (55.9 × 38.1 cm).

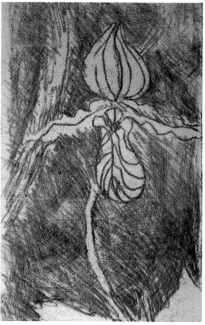

A wood-block plate can be either an end- or plank-grain cut. For unique texture contrasts, you can combine both grains to make a plate, which is the case in this example.

Lady Slipper is a hand-rubbed monotype made on an end-grain wood block. Because the plate is an inch thick, it is best suited for a hand transfer.

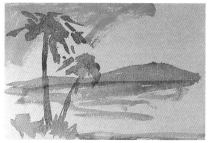

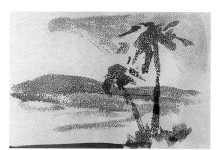

Rough watercolor paper sealed with acrylic medium was used as a plate for the quick watercolor sketch at left. It was transferred while still wet to very smooth, warm-toned Japanese paper. Notice how the rough texture of the plate predominates in the transfer.

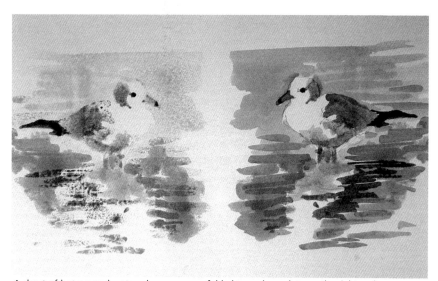

A sheet of hot-pressed watercolor paper was folded to make a plate on the right and a monotype on the left. The watercolor painting was transferred by folding the sheet in half and hand rubbing the two sides together. The smoothness of the paper complements the resulting image.

Masonite, a board composed of pressed wood fibers, can be finished in a number of ways and used as a plate. You can coat it with white or clear acrylic, using either a brush or spray can. You can also texture Masonite with modeling paste or gesso to produce embossed textures.

Paper, Cardboard, Canvas

The variety of textures found in heavy papers, cardboard, and canvas make for unique plate surfaces (corrugated board, sandpaper, loose-weave canvas, and so on). With paper and cardboard, you can draw on the surface, seal it, and use it as your plate. In the past, varnishes were used to seal paper surfaces, but today, fast-drying acrylic sprays and liquid mediums are available. AHC, an all-purpose board, makes a good painting surface for all mediums. It is thin, durable, and will not buckle.

A number of artists have used a wet canvas to transfer an image to paper or onto another canvas. For this technique, you have to take the weave of the canvas into consideration.

Beveling Edges of Plates

After you have purchased and cut a plate to size, the edges should be beveled (filed smoothly at an angle), unless the plate is larger than the paper. If you leave the edges raw and sharp, not only will you risk personal injury, but you might cut the paper or press blankets during transfer. To bevel metal, plastic, and wood plates, you need to use a flat metal file. Holding the plate securely on top of a work table, you should overlap the edge of the plate so that it is parallel to the edge of the table. Then hold the flat file at a 30- to 45-degree angle and push it down from the top edge of the plate. This is repeated on all four sides until the edges are smooth. Finally, you should push the file around the corners to remove their sharpness. The quality of the plate mark, or embossment, in the paper is influenced by how precisely and evenly you bevel. Wood and some plastics, such as Plexiglas, will require sanding to finish the bevel.

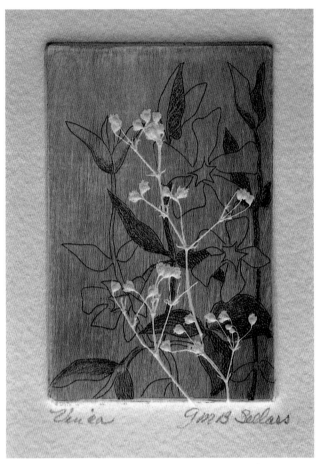

Evenly beveled edges on the plate not only help make a clean emboss-ment, but they also prevent the paper from ripping during transfer.

Betty Sellars made this monoprint on a 3 × 2" (7.6 × 5.1 cm) zinc plate with etching inks. Sellars used the subtractive method, and placed a "found" piece of dried weed on the plate before transferring it to Arches Cover paper by press.

If you are using thin paper or plastic, such as Mylar and Poly Print, and want plate marks, you usually need to mount the material on mat board, and use a mat knife to bevel the edges.

Texturing Plates

It is possible for you to texture, or sur-face, a metal or plastic plate so that it will accept all mediums, including wa-tercolor. To accomplish this, you need a sponge and a dry, abrasive household cleanser. After applying water, you scrub the entire surface in a circular, even manner with the cleanser. Not only will this remove all traces of oil, but a fine tooth is evenly etched into the metal. When you rinse the surface off, the water should glide over the

plate. If the water beads up, additional work is needed. If the plate still will not accept the medium in an even fash-ion, you should try a very fine pumice.

Very fine sandpaper of around 400 grain also works to put tooth in a plas-tic or metal surface. By sanding the en-tire plate in even, circular movements, you will obtain an evenly etched sur-face. The best sandpapers for this pur-pose are the ones labeled self-lubricating or the wet/dry waterproof variety.

Miscellaneous

With the outline of materials already mentioned, you should have an idea of what will suit your needs and budget.

There are many creative possibilities

not yet mentioned. The following sug-gestions include other materials that you might find useful.

- The absorbency rate of your plate ma-terial can usually be controlled with spray plastics.
- Unmounted linoleum used for block-printing techniques can also be used for a monotype. With linoleum, you can create an overall soft texture.
- For low-budget school projects, you can use aluminum foil for making plates. My sister, Jean Klein, teaches preschool and her class transfers their fingerpaintings from plastic "messy trays" to paper.
- Newspaper publishers use aluminum offset plates that they are often willing to donate or sell for student use.

Mediums

For monotypes, you can use practically all the mediums used in painting and printmaking. Since there are few specific requirements for this technique, you should not feel restricted when selecting mediums. Water- and oil-based printing inks, as well as oil, watercolor, and acrylic paints are all possible choices and exist in a wide range of brands and hues.

When using oil-based inks and paints, you will have to use solvents for thinning and cleaning, whereas with watercolors and water-based mediums you just use water. You should take into consideration what medium your working conditions are best suited for, since working with solvents and oils may require a ventilation system.

The following is only a basic rundown of the mediums that are available to you. More detailed information about each medium can be found in the chapter "Working in Specific Mediums."

Oil-Based Printing Inks

Printing inks are primarily mixtures of colorants or pigments in a number of formulas of fast-drying oils and varnishes. Since printing inks vary in the way they are applied, it is important that you test them before use.

Oil-based inks can appear very stiff when first removed from the can—temperature and humidity will have an effect on this. You can use a palette knife to knead, or "work", the ink, making it looser and smoother. When left standing it will stiffen up again.

The "viscosity" of the ink refers to its flow characteristics. For example, a high-viscosity ink will be too stiff for transfer, whereas an extremely low-viscosity ink will flow too easily, making it hard to control. There are reducing oils or ink modifiers, such as Graphic Chemical's Easy Wipe, which you can use judiciously to soften inks that are too stiff to transfer well. On the other hand, you can add magnesium carbonate or cornstarch to stiffen oil-based inks.

It is through practice that you will learn how to manipulate inks according to their viscous characteristics. For instance, the thin, low-viscosity inks will repel the thicker inks. A thick, high-viscosity ink rolled over a thin ink will leave color only in the areas where the plate is clean.

An ink that is too tacky will either "pick" up or rip part of the printing paper when it is removed from the plate. You can use a reducing oil to decrease the tack of an ink. If only the tack characteristic is to be modified, you can add Vaseline to soften the ink.

Once a can of ink has been opened, it will tend to dry on the surface, leaving a skin. You can avoid this by using antiskinning sprays or papers that are on the market.

Intaglio Inks. Intaglio inks are used in printmaking techniques such as etching, drypoint, and engraving. In these techniques, lines are cut into the plate. Therefore, a heavy, dense ink that will remain in the grooves yet allow the surface of the plate to be wiped clean is needed.

If you want inks that are similar to oil paints in consistency, you should try Lefranc & Bourgeois etching inks. They are highly lightfast and are manufactured in tubes in a full range of colors.

Most often, you will need to thin intaglio inks in order to make monotypes. To loosen them, you can use a conditioner, such as Graphic Chemical's Easy Wipe Compound; a solvent, such as turpentine; or a thin burnt plate oil (used for printmaking techniques) with a low identifying number such as 00.

Lithography Inks. Lithography inks are high-pigmented "thin inks," which means that if you roll them out thinly

Here is a display of some of the oil-based printing inks that are available on the market.

This demonstration was done by Ron Pokrasso for the Graphic Workshop in Santa Fe. It demonstrates how a thin, low-viscosity ink will resist a thicker ink. First the artist rolled a thin yellow ink on the plate. Then he scratched lines into the surface, removing lines of ink from the plate. Next a thicker, medium-viscosity red ink was rolled on top. Notice how the red ink clearly took only where the plate was clean—the scratched areas.

For this illustration, Pokrasso first inked the plate with a medium-viscosity red ink. Then he scratched lines into the surface. Afterward a thin yellow ink was rolled on top. The yellow ink not only altered the red color but also took where the plate was clean.

on the plate they will maintain their color saturation. Usually they do not need to be thinned or extended for monotype work.

Many lithography inks are made for the offset printing trade. Since commercial printers are not as concerned with the lightfastness of colors as fine art printers, you should seek out fine art ink manufacturers such as Daniel Smith Inc., Graphic Chemical, the Hunt Mfg. Co., and Sinclair and Valentine.

Serigraphy Inks. Serigraphy inks are specifically designed for silk-screening. There are both water- and oil-based serigraphy inks on the market. They are especially fast drying, but you can alter the drying time with retardants. There are extenders and retarders available for various types of serigraphy inks. Many artists use serigraphy inks because of their matte finish. They are strongly pigmented, usually opaque, and can be rolled or painted on the plate.

The Hunt Speedball Company manufactures water-based printing inks, which are made especially for serigraphy and block-printing techniques. Thinning is done with either water or an extender made especially for the medium.

Relief Inks. Relief inks are made for printmaking techniques such as linoleum and wood-block printing. There are both water-based and oil-based inks on the market. They are designed to be rolled on a flat surface. Most often, they do not require thinning for monotype techniques. If you need to thin these inks, you can purchase transparent extenders made available by the manufacturers.

Oil Paints

Oil paints are a popular medium to use on the plate. You can thin them to a watercolorlike consistency or apply them in an opaque manner. You can also add oils to oil-based printing inks to create a wider range of colors. Oil paints are produced by mixing pigment into a binder, usually a mixture of linseed, safflower, and poppy seed oils.

When you transfer oil to paper, it is desirable to speed up the drying time of the oils to protect the paper as well as to continue with other transfer work needed on the same paper. You can use solvents such as mineral spirits or refined turpentine to thin and shorten their drying time. If you want to add oil extenders to paints from the tube, you should use printmaking mediums such as stand oil and burnt plate oil. These oils are actually raw linseed oils that have been heated to change their molecular structure. These polymerized oils will protect the paper fibers once they have dried. On the other hand, linseed oil used for oil painting on gessoed canvas has a slight acid condition, which can create a detrimental effect on untreated paper fibers.

Alkyds

Alkyds are oil-based colors that are fairly new on the market. They are pigments mixed in a rapid-drying base. The chemical makeup of the medium allows all colors to have the same

Nancy Friese, *Spring's Grace*, 18 × 24″ (45.7 × 61.0 cm).
Using a copper plate, Friese worked with printing inks in both the additive and subtractive techniques. The transfer was made by press. (Courtesy of Giannetta Gallery, Philadelphia.)

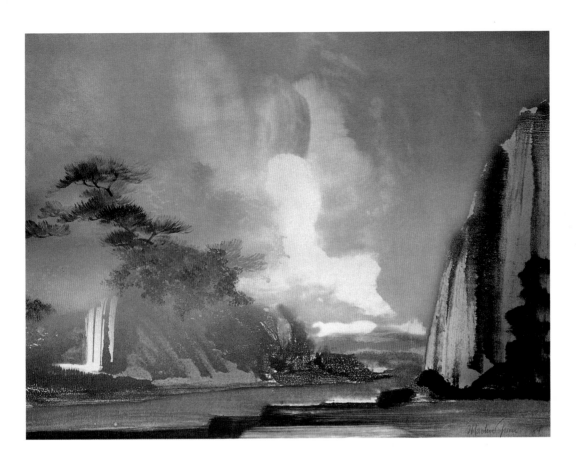

Martin Green, *Water Passage,* 30 × 40"
(76.2 × 101.6 cm), 1984.

Green preferred using highly pigmented lithography inks for this monumental monotype, which was transferred by press. Notice how the colors maintain their brilliance even though they were applied thinly to the plate.

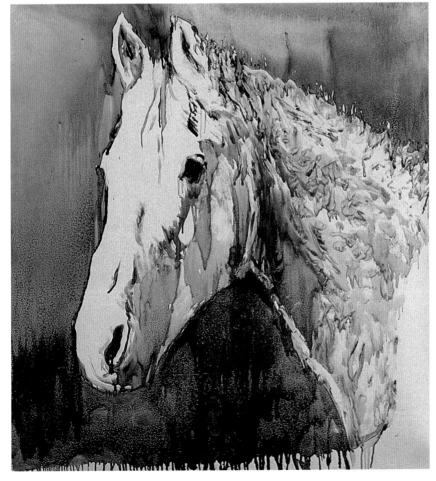

Joseph Raffael, *Inzio,* 42¼ × 39¼" (107.3 × 99.6 cm).

This monotype is a fine example of how oil paints can be thinned to a watercolor consistency with turpentine. (Courtesy of Experimental Workshop, San Francisco, and Nancy Hoffman Gallery, New York City.)

drying time—unlike oils, which have different drying speeds for each pigment on the palette. You can use solvents to thin alkyds or Winsor & Newton Liquin medium to extend it.

Water-Miscible Oil Paints

A new medium, Pelikan Mastercolor oil paints, has recently been added to the market. Although they are oil-based, these paints can be mixed with water, so you do not need to use harsh solvents. The notable advantage to these paints is that they are simply thinned and cleaned up with water and do not contain some of the health hazards related to other oil paints. They are a reasonable substitute if you like the effects of oil paint but have health problems working with solvents.

Pelikan Mastercolor oil paints come in eighteen hues—advertised to be nontoxic, permanent, and lightfast. They come with long, thin dispensing tops, which you can use to squeeze controlled lines of paint across the plate.

Acrylics

Because acrylics are fast drying, they must be worked and transferred to your paper in a rapid, spontaneous fashion. You can slow the drying time by adding an acrylic retardant, available at art-supply stores. Drying time will be directly related to the humidity in the work area. I do test sheets to discover varying situations. If the acrylics dry, you can spritz isopropyl alcohol on the paper to make the transfer.

Watercolors

Watercolors are pigments mixed in a gum arabic base. You need to paint watercolors in a bolder technique than what you actually want in the final monotype because they will dry lighter than they appear on the plate. Watercolors will also be less saturated because of the "ghost," which is the residue ink left on the plate after the transfer.

Gouache

Gouache paints are made by grinding pigments in the same base as watercolors, gum arabic. An inert material, such as chalk, is added to the mixture to give it an opaque quality. As designers often use this medium, there are more fugitive colors available since permanence is not always a concern for their needs. Therefore, you should stick to the familiar pigments when using these paints unless you check them on a color permanency chart.

Caran D'Ache and Other Water-Soluble Crayons

Water-soluble crayons, pastels, and pencils can also be incorporated into your monotypes. You can transform water-soluble Caran D'Ache crayons into vibrant, workable paints by dissolving them in water. Some artists use them in their crayon form to draw on both the plate and later on top of the transferred monotype. Water-soluble pastels and other water-soluble pencils can be used in a similar fashion.

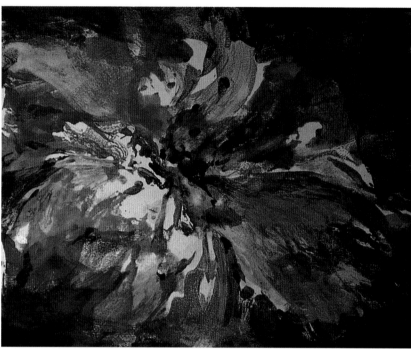

Nancy Swindler, *Flower,* 14 × 17" (35.6 × 43.2 cm).
The artist developed this acrylic monotype with multiple layers of wet paint hand transferred onto ANW paper.

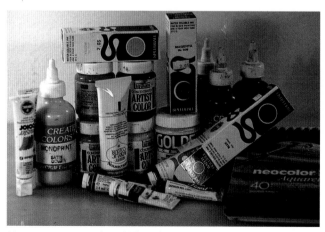

Here are some water-based inks and paints that are available for making monotypes.

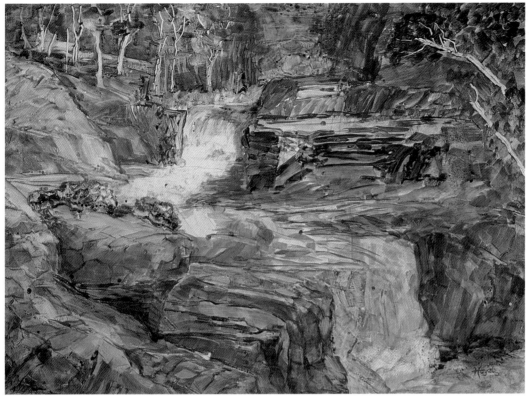

Dorothy Hoyal, *The Waterfall,* 22 × 30" (55.9 × 76.2 cm).
The watercolor image was transferred to moist Arches 88 paper after the paint had dried on the plate.

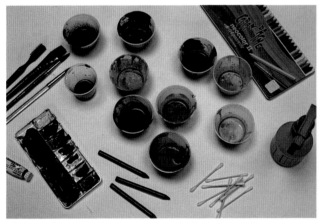

Gloria Jacobson sometimes uses Caran D'Ache water-soluble crayons because they offer her a wider range of bright colors. She usually shaves them into plastic containers and dilutes the colors with water.

Richard Berenson made a test plate of watercolor and Caran D'Ache crayon colors that he planned to use for his palette. After this test transfer was made, he was able to judge how the colors would print. The cerulean blue watercolor formed bubbles on his test sheet, which was a color characteristic that Berenson found held true in his monotypes.

Solvents

You can use solvents to thin oil-based inks and paints. Turpentine and mineral spirits are the most commonly used thinners. Clean up can also be done with other solvents; my favorite is Leinos-Thinner #7222, a plant chemistry product manufactured in Germany. When using any solvent, you should make sure that the work area is well ventilated. It is best to avoid using benzene, ether, or gasoline because of the high health and fire risks involved in handling them. Before working with any solvent, it is important that you check the potential health and fire safety risks involved with their use.

Acrylic and water-soluble colors can be thinned with water. When using acrylics, there are acrylic mediums on the market that you can use for thinning. After acrylic has dried, you cannot thin or clean it up with water. But you can use isopropyl alcohol, which will dissolve dried acrylic. If acrylic-based inks or paints have dried on the plate, you can still make a transfer by misting the paper with pure isopropyl alcohol. When working with isopropyl alcohol, you need proper ventilation and must follow the proper fire hazard precautions. (An alcohol fire can be put out with water.) Read warning labels carefully.

Safety in the Studio

There are precautions every artist must take when working with various art materials, especially dry pigments or solvent-based materials. It is important to discover the toxicity of the pigments on the palette as well as the base they are in. Cobalt blue, for example, may cause an allergic reaction if you have repeated skin contact. Chronic inhalation can cause asthma and possible fibrosis. Safety and health information is often available in most handbooks of art materials.

It is important not to breathe airborne dry pigments or evaporating solvents, as these agents can affect your respiratory system. There are respirator masks on the market that are graded to the materials they are designed to block out. Pay attention to warning labels that accompany the products you use in making monotypes. Most mediums that require solvents should not be used without a ventilation system. Fortunately, more information on toxic problems with art materials is becoming available, and it is important that you learn all about the products you are using.

To protect yourself against fires and explosions, covered metal containers should be available for the disposal of rags and papers used to work with oil-based materials and solvents. A proper exit path and a fire extinguisher should also be provided.

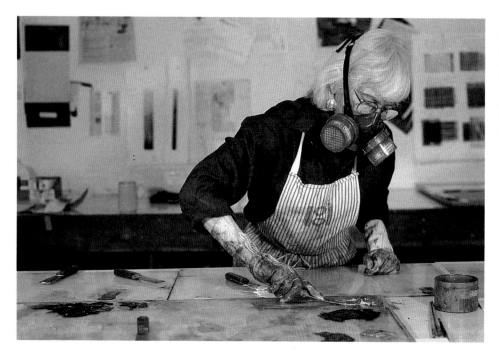

Joyce Macrorie wears a face mask when working with solvents or dry pigments. In this case, she is mixing a dry pigment into dark ink. Since there is adequate ventilation in her work space, Macrorie only wears the mask when adding the pigments or solvents to her palette.

Painting Tools and Palettes

Depending on the type of effects you want to achieve, there are a variety of printmaking and painting tools to choose from. For instance, with rollers and brayers, you can create smooth, even surfaces with gradating tones. For a painterly quality, brushes can be used to develop textured strokes.

For the most part, you will probably find yourself using a combination of tools, and sometimes you may even want to use your fingers.

You will usually need a palette—the surface where you work and mix inks or paints—but it is also possible to work directly on the plate without one. As you gain experience, you will discover the methods that give you the best results.

Brushes

Brushes are manufactured in a number of shapes and hair types. Your choice of brush will depend on the texture, shape, and length of the stroke that you want to produce.

Various hairs with different characteristics are used for making brushes. For instance, a watercolor brush made from the natural hairs of the expensive kolinsky sable will spread more uniform color for the longest stroke when compared with a brush made with synthetic hairs, whereas brushes made with synthetic filaments will take more use and abuse.

You should use the stiffer hog-bristle and badger-hair brushes for stiffer mediums such as oil paints and oil-based inks. If you use soft-hair brushes, such as sable or synthetic blends, on stiff mediums, they will leave less brush texture on the plate. A good hog-hair brush will maintain its shape under painting pressure; a poorly made brush will splay out from the edges.

With few exceptions, brushes are made with wood or plastic handles attached to metal ferrules that hold the hairs. You can use the pointed end of the handle as a painting stick. For instance, the bevel end of an Aquarelle-style brush handle makes a convenient scraping instrument.

Round watercolor brushes are also set in round metal ferrules. A good brush will widen from the ferrule to a belly, which will hold a reservoir of paint, and then taper to a perfect point. Before purchasing a round watercolor brush, you should test its spring and flexibility by dipping the brush in water and painting with it on paper. The brush should return to its original

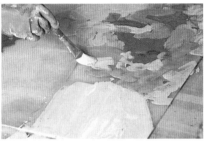

Here Nancy Bowen uses a wide, stiff bristle brush designed for oil painting to apply serigraphy inks freely on her Plexiglas plate.

In this photograph, Shirley Ward uses a wide natural-hair brush to apply watercolors to her plate. With this brush, she is able to make wide strokes with the flat side or thin lines with the narrow edge, as in the stroke she has just completed.

Dorothy Hoyal scrapes out white accents on the plate with the beveled end of an Aquarelle brush.

shape after you swirl it in water and then shake out the excess moisture.

Flat brushes are probably the most versatile. You can make thick to thin strokes by slowly rotating the brush from its wide side to its narrow side. For scratchy textures with long, thin strokes, you can splay your brush in varying degrees.

To maintain brushes, it is important that you keep them clean all the way to the ferrules. You shouldn't let your wet brushes sit with the hairs upright, even after cleaning, as residues will congregate at the metal edge and force the hairs out of shape.

Aside from turpentine and mineral spirits, you can purchase special brush-cleaning products sold in art-supply stores to remove oil mediums. You can maintain your watercolor brushes by rinsing them with warm water, using mild soap occasionally. If natural-hair brushes are to be stored for a length of time, you should use moth crystals to prevent insect damage.

Brayers and Rollers

Brayers and rollers used in a number of printmaking and painting techniques can be used to apply paints and inks to your plate. They are made in different materials and sizes that give varying effects. The primary characteristic of the brayer and roller is related to the hardness of the material and its surface smoothness.

A brayer is made with a single, centered wooden or metal handle attached to the sides of a roller. You will probably find that small one-inch-diameter brayers, made with hard or soft rubber rollers, are the most affordable tools to start with. When using some hard-surface brayers, you often need more than one application to produce an even ink cover, but the random-patterned texture you get with the uneven first roll-up of ink may prove desirable. A soft rubber brayer affords a more even distribution of ink.

You can also purchase professional-class brayers that are made of either polyurethane or rubber. Polyurethane is

considered to be the more sensitive material for distributing ink; it replaces the roller of the brayer made of composition (gelatin), which is appealing to mice and insects as food, and easily broken down in heat or moisture.

Rollers are shaped like oversized rolling pins, usually made of rubber or polyurethane, with handles made of either metal or wood. Large hand rollers are manufactured for professional print shops. Print-shop rollers are around 4 1/2 inches in diameter and are available in various lengths, usually from 12 to 20 inches. When you use a professional-class roller, it will take only a single rolling of ink to cover a plate narrower than the roller width, resulting in an even distribution.

Miscellaneous Tools and Materials

There are a number of other tools that you can use to create imagery on your plate. For instance, engraving tools, or any sharp, hard-pointed implement, can be borrowed from printmaking techniques to produce permanent textures on a metal or plastic plate. You can also use linoleum and wood-cutting tools to cut into Plexiglas.

Texturing tools that you would use in painting, such as palette knives, can also create unique textural effects on the surface of your plate. Interesting stamping textures are easy to produce when you use synthetic or natural elephant-type sponges. For scraping out details, you can use a pen knife. With a toothbrush, you will be able to splatter paint or wipe out lines.

You should also consider any material that gives interesting embossed textures, since a major part of the monotype process is "transferring under pressure." Plastic doilies, flattened leaves, grasses, or flower petals are a few possibilities. You should select thin materials so that you do not damage the paper or leave a "white halo" around the object, where the paper is unable to reach the plate next to the object during transfer.

To create repeated patterns on your plate, you can use stencils in both their positive and negative forms. Stencils can be made of paper, Mylar, or thicker materials if you want an embossment.

Cloth, paper towels and tissues, and cotton swabs are usually used to manipulate and remove ink. Printmaking suppliers sell both cheesecloth and tarlatan material for this purpose.

From bits of mat board and old credit cards, you can make tools. You can use the flat wide edge of a piece of mat board to apply ink. If you carve notches in the edge, you can add an irregular line to the stroke. You can cut credit cards into scraping tool shapes to remove ink from the plate.

Artist Martin Green often uses an airbrush to apply inks to his plate. By keeping a combination of lithography ink and thinner well mixed, he is able to maintain a consistent, fluid flow of medium. At times, Green also does airbrush work on top of his monotype.

Palettes

A nonporous material such as glass, plastic, or metal makes a good palette. Many artists often choose pieces of the same material from which their plate is made. A large, flat surface is needed if you plan to roll up ink. However, if your technique will be limited to painting directly on the plate with brushes, a palette used for oil or watercolor painting will suffice.

Oklahoma artist Dianne Haralson uses a practical system to keep the inks on her palette from drying from one session to the next. She cuts a sheet of glass (her palette) to fit into a shallow plastic box. The edges of the glass are covered with tape for protection. She inks her palette with small cloth daubers, each with a different color. When she is through working, Haralson sprays the remaining ink still on the glass palette with anti-skinning spray. It is then placed with the daubers inside the box. The box top is then pressed closed to further protect the inks.

A polyurethane brayer with a metal handle is shown on the right, and a soft rubber brayer with a simple plastic handle is shown on the left.

While resting, or during storage, a brayer should be placed with the roller up and away from the surface, to maintain its shape.

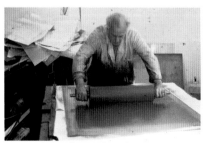

Large gelatin rollers such as the one Michael Mazur uses here to ink a plate are available in printmaking facilities.

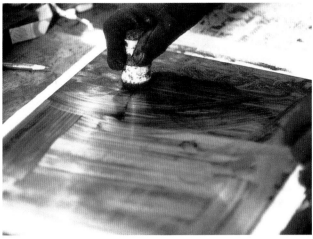

Here Maxine Richard spreads ink with a cloth dauber made of felt, available for printmakers through Graphic Chemical.

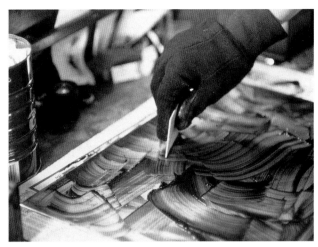

Then Richard continues to manipulate ink with a small piece of mat board.

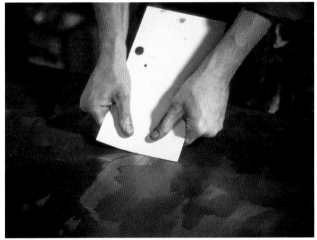

Martin Green removes ink with a large piece of mat board, which he is able to press and manipulate to vary the width of the areas he is removing.

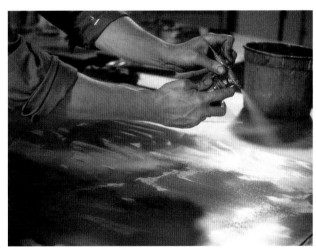

Next Green uses an airbrush on his plate.

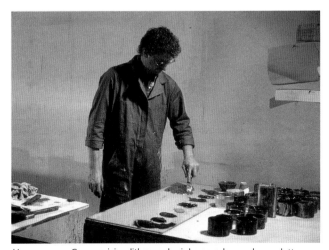

Here you see Green mixing lithography inks on a large glass palette.

Dianne Haralson's glass palette fits into a plastic box, which she uses to save her paints. The daubers she used for inking the plates are stored with their corresponding colors. Antiskinning spray is used on the lithography inks before placing them in the box and sealing the lid.

Paper

The paper you select will influence the overall feeling of your monotype. It is the critical support on which the work is transferred and finished, and is an integral component of your monotype composition. For instance, you may want the color of the paper to be a part of your monotype composition, leaving it exposed and free from inks or paints. If you're looking for unique textures, there is an enormous selection of hand-made papers from around the world to choose from. Swirling fibers and woven textures can be incorporated into your monotype. If you need a smooth surface for a clear, crisp transfer of your image, try smooth Arches 88.

How Paper Is Made

By understanding how paper is made, you will appreciate the variable characteristics between papers. The basic papermaking steps are the same today as they were centuries ago when first invented in China. First, in a large vat, fiber is beaten and macerated in water until individual filaments are separated. A tray-shaped mold with a screen bottom is dipped into this pulp slurry and lifted out of the vat. A thin stratum of wet fiber forms on the screen as the water filters through it. This sheet of intertwined filaments becomes the paper. When the frame (or deckle) of the mold is removed, there will be a natural feathery deckled edge to the sheet, where some of the pulp seeped through under the frame.

In Europe and the United States, paper is commonly transferred and pressed (or couched) against felt. The newly formed sheet will have the impression of the mold on one side and the felt on the other. It can be left in this "rough" condition or pressed to have a smoother surface.

In Asia, paper is traditionally thinner, but strong due to the longer fibers used. Paper is pressed in a stack without an interleaving of felts. It is then dried on a flat surface that will give it a smooth texture.

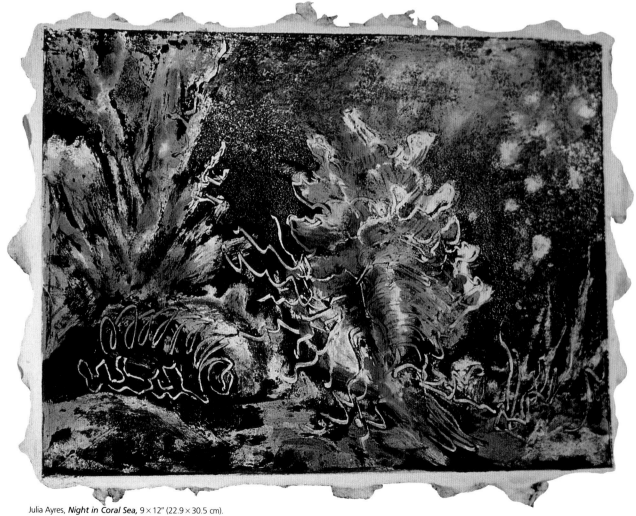

Julia Ayres, *Night in Coral Sea,* 9 × 12″ (22.9 × 30.5 cm).
This monotype was made with Pelikan oil paints and transferred to Twinrocker handmade paper, which has an exaggerated deckled edge.

The pattern of the screen will also effect the character of the paper. A "laid" texture is created when thinly stripped bamboo or wires are laid closely side by side and fastened together with wires or thread sewn in evenly spaced straight lines running the opposite direction of the strips. A "wove" texture is created with screens woven in a method similar to window screening.

Sometimes there are embossed marks in the paper, known as watermarks. They are usually simple designs or letters signifying the manufacturer or the name of the paper.

Paper Fibers

The fibers used for papermaking will also vary. Most art papers are made from short-fiber cotton linters, a by-product of the cotton industry. Linen is a stronger but more costly fiber. Wood pulp that has been made acid-free is termed "sulphite." It is the most common addition to cotton pulp not indicated as 100 percent rag.

Rice paper is a misnomer that probably dates back to early Europeans who traded in Asia who were ignorant of how the fine paper was actually made. These fibers are actually "bast" fibers gathered from the inner bark of trees and plants. In Japan, the strong, long fibers are primarily kozo, from the Japanese mulberry. Mitsumata fibers provide a soft, absorbent, lustrous characteristic to paper, and gampi fibers impart a strong translucent quality. In recent years, acid-free sulphite has also been added to some of these papers.

Fiber content alone will not indicate if a paper is archival. Due to present-day environmental conditions, it is important that the pulp is buffered with alkaline salts to continue to neutralize the acidity. If you want long-term survival of your work, make sure the paper is labeled pH neutral.

Sizing

Paper that has not been sized acts like a blotter and is called a waterleaf. Sizing, usually a warmed gelatin glue, is either added to the pulp mixture or as a coat to the paper; it helps to decrease the absorbent nature of the fibers. For example, ink will sit on top of a highly

sized paper, but will sink further into the fibers of a waterleaf. When you soak paper in water, the sizing will dissolve into the water and out of the fibers.

Paper Weight

There are two methods of indicating a paper's weight. In the United States, it is measured by the weight of a 500-sheet ream. Unfortunately, this gives you little indication of the actual density and thickness of the paper, as the

poundage will vary according to the size of the paper. In other parts of the world, it is most often measured in the metric system at g/m^2 (grams per square meter), which refers to the tissue thickness weight. Measured in this system, a 140-lb. $22 \times 30''$ sheet of watercolor paper would remain 290 g/m^2 regardless of the sheet size, and a 90 lb. $22 \times 30''$ sheet would be 180 g/m^2. The popular Masa paper from Japan is 70 g/m^2; Unryu, on the other hand, is only 36 g/m^2.

These are examples of Twinrocker deckled-edge handmade papers. Deckled edges are produced from the pulp that seeps between the deckle (frame) and the bottom of the mold screen during the papermaking process.

I lightly pressed these papers on wet ink to demonstrate their inherent textures. The paper on the left has the more common "wove" texture, while the one on the right contains the "laid" texture of the screen on which it was formed.

Types of Paper

Monotype artists have used papers designed for printmaking as well as other fine art papers. Rives BFK is a popular unsized printmaking paper. If you want some sizing, Arches Cover is a good choice. Arches 88 is a waterleaf and has a very smooth surface. Many artists prefer the hot-press surface of fine watercolor paper for their transfers, while others prefer the translucent sheets of Oriental papers.

A number of supply houses sell samples of their papers. For example, Daniel Smith Inc. of Seattle sells sample packs of watercolor, printmaking, and Oriental papers. You can make miniature monotypes on these sample sheets to become familiar with their transfer characteristics.

Preparing Paper for Transfer

When the medium on your plate is still wet, you can transfer it to either a moist or dry sheet of paper. However, when a water-soluble medium dries on your plate, you must moisten the paper with water before printing. Methods to transfer other dry mediums are discussed in the chapter "Working in Specific Mediums."

For waterleaf and most Oriental papers, you can premoisten with water by misting with a spray bottle. Then you need to place the papers between plastic sheeting to help distribute the moisture evenly as they wait for transfer.

You can moisten other papers on both sides using a sponge with water. Then place each moistened paper on plastic sheeting with a dry sheet of paper on top, interleaving wet and dry sheets for all the paper needed for your project. Top and enclose the pack with plastic. To avoid buckling, you should place a board and weights on top of the pack. The paper will be ready for printing in a few hours.

In order to produce a successful transfer, you must be aware of certain conditions that require special

You can purchase samples of printing paper from suppliers such as Daniel Smith Inc. in Seattle. Here are a few possibilities, starting with the gray sheet on top and moving clockwise: Murillo Gray, Arches Cover White, Arches Cover Buff, Indian Tea, Rives BFK Tan, and Murillo Off-White.

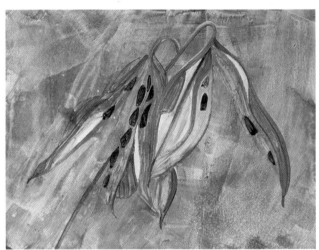

GMB Sellars, *Seeds*, 9 × 12" (22.9 × 30.5 cm).

Sellars chose Arches Cover Buff for her monotype. The color of the paper was left as part of her image, which is a consideration that should be made during paper selection.

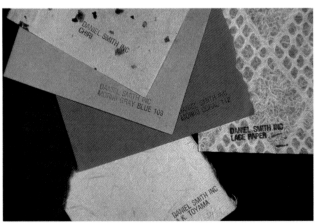

Also available are numerous Oriental papers, including, top to bottom: Chiri, Moriki Gray Blue 109, Moriki Coral 112, lace paper, and A. K. Toyama.

A detail of a monotype made with water-based inks that was transferred to moist Unryu paper. Notice how the swirling paper fibers are incorporated into the design.

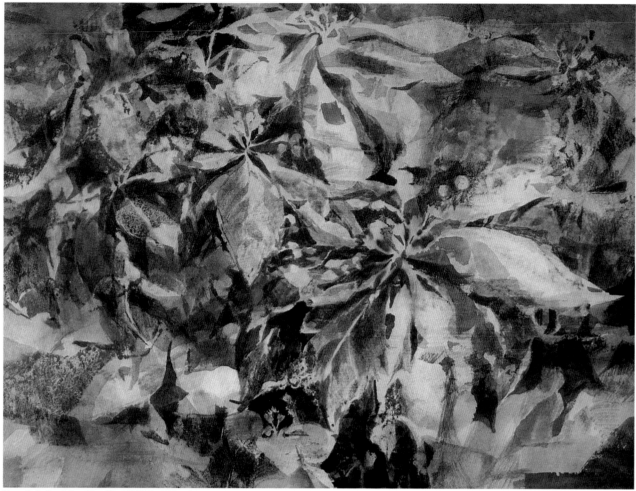

Nancy Swindler, *Poinsettias,* 22 × 30″ (55.9 × 76.2 cm).
This watercolor monotype on Japanese mulberry paper has a unique translucent quality that suits the subject matter well.

attention. For instance, if the ink is showing so much tack that it is plucking fibers from the paper surface during transfer, you can correct the problem by moistening the paper.

If your paper has too much sizing, the medium will sit on the surface and make a poor transfer. A prolonged soaking in a tub of water, for at least an hour, will correct this condition. To remove the excess water, you can press the paper between sheets of blotter until the wet sheen disappears.

Blotting Monotypes After Transfer

Blotters, made of unsized paper fibers, are used extensively when working with wet transfer work. When a transfer is completed, you need to place the moist monotype between blotters, with newsprint paper covering the image side (the newsprint protects the blotter

while picking up an insignificant amount of ink). After each transfer, you continue stacking. On top of the stack, you should place a board with weights to complete the needed pressure to flatten the papers as they dry. This stacking process is usually taken apart and repeated with fresh blotters at least two more times.

The Graphic Workshop in Santa Fe has devised a simple system of color coding blotters that permits the longest use from each sheet. To get the most use out of blotters, you should place them in the order of their usage. For instance, you should use new blotters during the final drying stage, as it is the easiest on blotters. After your transfer work is completed, you can hang wet blotters to dry with clothespins strung on a wire across your studio as done at the Graphic Workshop.

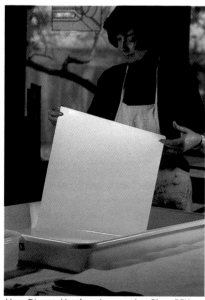

Here Dianne Haralson is removing Rives BFK paper from a water bath, where she had let it soak for twenty minutes. Next she will place the moist paper between the blotters on her left to remove excess water.

Hand-Transfer Tools

Traditionally, the back of a spoon bowl has been used to carefully rub-press the paper and plate together. You can also use household items such as a pad of folded cloth or paper toweling as transfer tools. For instance, a plastic mesh pad, such as a pot scrubber, has a natural drag that will be beneficial in some transfers.

With rollers and brayers used for inking plates, you can also roll-press the plate and paper together for transfer. The baren, a thin disc-shaped block designed for block-printing transfers, is another possibility. The Hunt Company manufactures a teflon-coated metal baren at a reasonable price.

Florida artist Janet Siamis gets good results when she uses a marble rolling pin for transfer. However, when I purchased such a treasure from a used item store, it was a different story. My rolling pin had an uneven shape, allowing only the ends of the roller to touch the paper.

To check the contour of a roller, you should place it at eye level on a perfectly flat surface. Slowly roll the pin over the surface and you will be able to see where contact is made.

Hard rubber rollers and brayers can also create the same problem. Therefore, you should also check them in a similar manner. However, trial transfers are the best method to acquaint you with each tool's characteristics.

The table that the paper and plate are laid on should be smooth in order to produce an even transfer; otherwise cracks, scratches, or bumps will appear in the final transfer. If you are using water-based materials, the surface should be waterproof. When you are using solvents, a plastic acrylic protection from all mediums, such as smooth plastic-coated Masonite, is desirable.

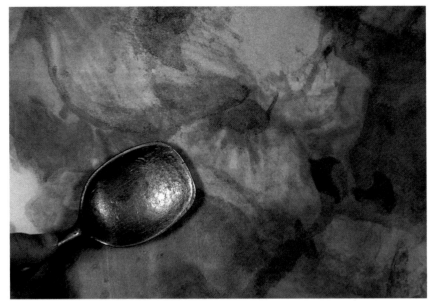

The bowl of a spoon is an ideal tool for hand transfers.

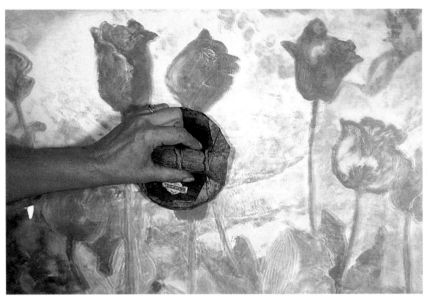

A Japanese "teacher baren" is used here to hand rub and press a thin Mylar plate (on top) to transfer the image onto paper (on bottom).

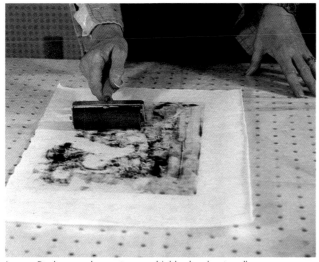

Joanna Duck uses a brayer to press highly absorbent mulberry paper onto a zinc plate with black ink.

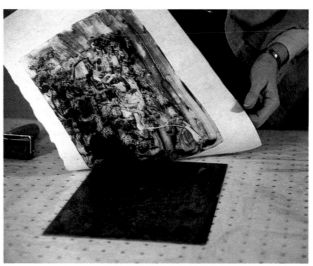

Here you see Duck pulling the monotype from the plate.

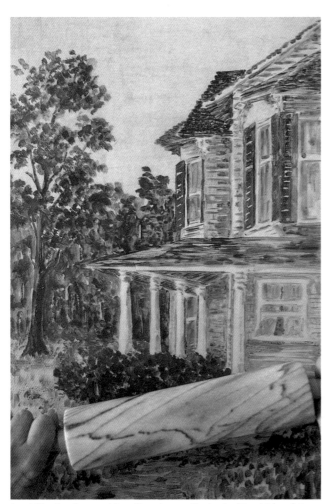

Janet Siamis rolls a marble rolling pin over the back of her Mylar plate.

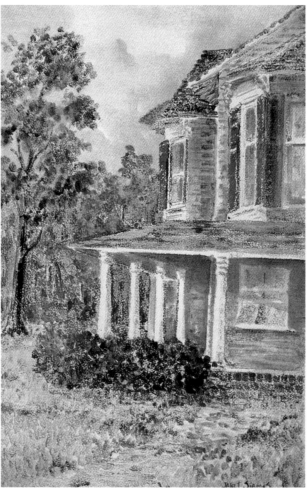

Janet Neal Siamis, *Victorian House,* watercolor monotype, 30 × 22″ (76.2 × 55.9 cm).

Equipment for Press Transfer

Presses come in a wide variety of sizes and mechanical designs, and are probably the most expensive equipment in a studio. Since a press is such a major investment, if you plan to purchase one, you should become familiar with the characteristics of different presses. An ideal way to do this is to join workshops and use a number of different presses to learn your personal preferences.

When properly used, a printing press provides uniform, consistent pressure to transfer plate work to paper. Many artists use presses in conjunction with hand-transfer methods to produce diversity in their monotypes.

Etching Press

An etching press is probably the most readily available equipment. Plate, paper, and blankets are laid on a flat bed and then pressed between upper and lower rollers. You control the roller pressure with adjustable knoblike gauges. You move the bed and rollers with either a crank handle or a "star wheel." Motor-driven presses are also available.

Today's presses are gear driven. The gear ratio determines how many times you need to turn the handle to operate the rollers one complete revolution. For instance, a press with an operating gear ratio of 2-to-1 would require two complete turns of the handle to turn the rollers one revolution. A low-gear ratio press, such as the one just mentioned, is harder to turn than a press with a 10-to-1 high-gear ratio, with the same diameter roller.

The press size refers to the size of the press "bed" or surface on which the plate and paper are placed during transfer. It should be spacious enough to accommodate the largest plate you plan to use. When you use small plates, you can get greater longevity and balance in the rollers if you place strips of material to cover the entire width of the rollers. The material should be the same thickness as the plate and set at equal distance on each side of the plate, which is placed in the center of the bed.

The bed should be made of warp-free, rustproof material. There are new plastic materials on the market that fit these requirements. You should have the bed comfortably positioned, so that the working height is somewhere between your hips and your waistline. You can control the height with the leg size of the metal support under the press.

The frame of the press should be strong enough so that it will not twist or flex on the floor. It is also important to have the press level with the floor.

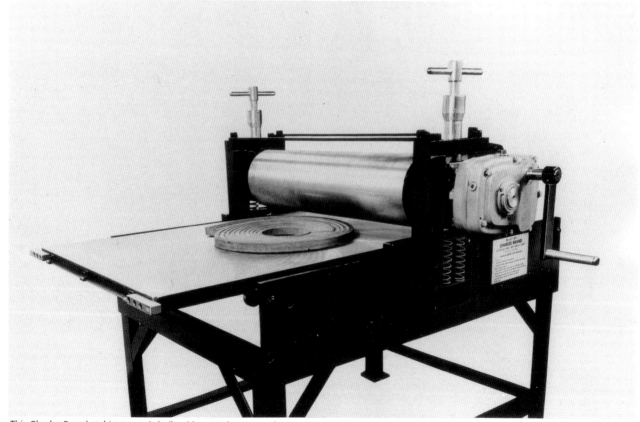

This Charles Brand etching press is built with a sturdy nonwarping stand.

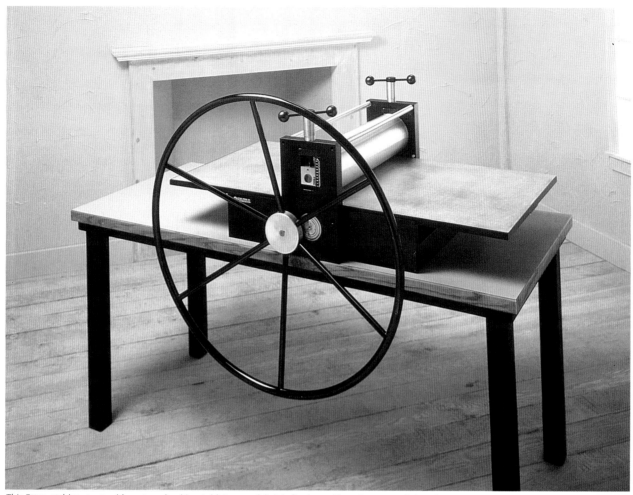

This Ettan etching press with a star wheel is a tabletop model; it is firmly positioned on a sturdy bench.

Most often you can accomplish this with shims placed under the legs. Presses usually carry special leveling instructions with them.

Proper Pressure for Printing

Most presses also have a system to adjust pressure. You need to preset the correct pressure before you begin work on the monotype. As you turn the handle or wheel, pressure is slowly applied until the plate, paper, and blankets cannot manually be pulled out from under the rollers. It is important that you have the pressure dials set evenly on both sides to protect the rollers and to ensure an even transfer.

Keep in mind that a poor transfer doesn't necessarily mean that you did not apply enough pressure; there are too many other factors involved in a successful transfer, such as how paints or inks are applied.

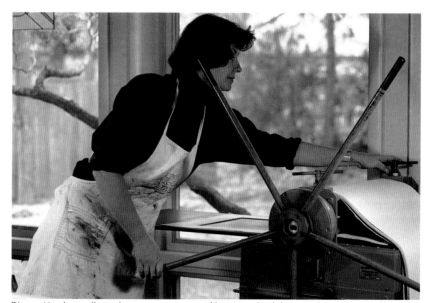

Dianne Haralson adjusts the pressure gauges of her star wheel-driven etching press, making sure they are set equally.

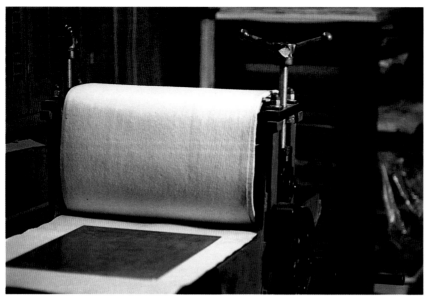

Three felt blankets have been pulled back over the rollers of Maxine Richard's etching press as she prepares the bed for a transfer. The blankets must lie smooth and in alignment over the bed before you begin the transfer process.

In this photograph, you see Arnold Brooks at Solo Press adjusting Plexiglas on the bed of a Takach-Garfield press. A huge tympan sheet is suspended from the ceiling.

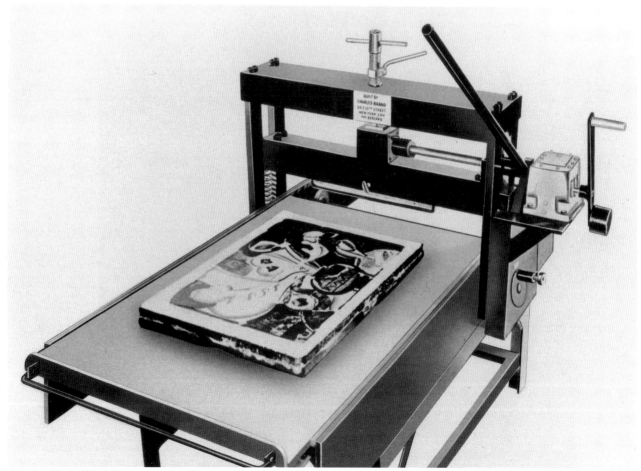

Here is a Charles Brand lithography press. The scraper bar (above the bed) and the operating mechanism on the right are clearly visible.

Blankets

Three felt blankets are usually used, one on top of the other, to cover the plate during transfer. The first blanket that you place on top of the plate and paper is the sizing catcher. It is made of absorbent material that will catch the extra moisture and sizing from the paper. On top of it you place the forming blanket, which is thicker than the catcher; it cushions the paper over the plate. The top blanket is the pusher blanket; it takes the abuse of the rollers and protects the two blankets underneath.

Lithographic Presses

Some artists and workshops prefer making monotypes on a lithography press. This type of press was used for commercial printing until the 1930s, when it was replaced for that purpose with the offset press. (Offset presses print first to a rubber blanket and from the blanket to the paper.) Lithography presses remain in wide use in fine-art printmaking and are excellent for monotype transfers.

Instead of rollers on top of the press bed, as in the etching press, the lithography press has a blade-shaped scraper bar. Traditionally, hard fine wood, such as maple, was used to make the bar, and a strip of leather was stretched on the thin sharp edge to act as the pressing edge. Today, this bar is often made of a high-density plastic, usually polyethylene, with a replaceable polyethylene strap. This scraper will impress the ink on your paper as the bed moves mechanically under it. A thin, flexible plastic sheet, known as the "tympan" sheet, is laid between the paper and the scraper bar for protection. Similar to etching presses, the lithography presses are moved either by electrical motor power or manual hand turning. The pressure enforced by the scraper bar is also adjustable.

Miscellaneous Presses

There is also some inexpensive equipment you can use as a press. A wringer washer with rollers can be used to transfer small monotypes. Make sure that you place the plate and paper between blotters for protection.

I often borrow my husband's sheet metal roller to use as my press. This machine has steel rollers on top and bottom, with just over a 1/4-inch thick entry. I can use a 1/4-inch sheet of plastic-coated Masonite, which becomes the bed of the press as well as the plate. I place the paper in registration with the plate, and lay a blotter over the entire Masonite bed. With a simple gear-driven handle crank, I move the work through the rollers for transfer.

Printmaking Workshop Facilities

When it is not possible to have a press in the studio, you can gain access to such equipment as well as instruction through printmaking classes and workshops. Initially, you should have an experienced instructor guide you through the correct operation of the press mechanism. Local college facilities are probably the most available resource for such classes.

At some workshops, press time can be rented by the day. The Graphic Workshop in Santa Fe provides work space and press use with or without a pressman. Sometimes established artists are invited to work with a shop, such as the Experimental Workshop in San Francisco, where proceeds from the sale of finished works enter into the arrangement.

Listed below is an abbreviated selection of some of the better-known workshop facilities in the United States. Write them for further information.

Graphic Workshop
Ron Pokrasso
632 Aqua Fria
Santa Fe, NM 87501

Rugg Road
Brick Bottom Artist Bldg.
1 Fitchberg St.
Somerville, MA 02143
Tel.: (617) 666-0007

Solo Press and Gallery
Judith Solodkin
578 Broadway, 6th Floor
New York, NY 10012
Tel.: (212) 925-3599

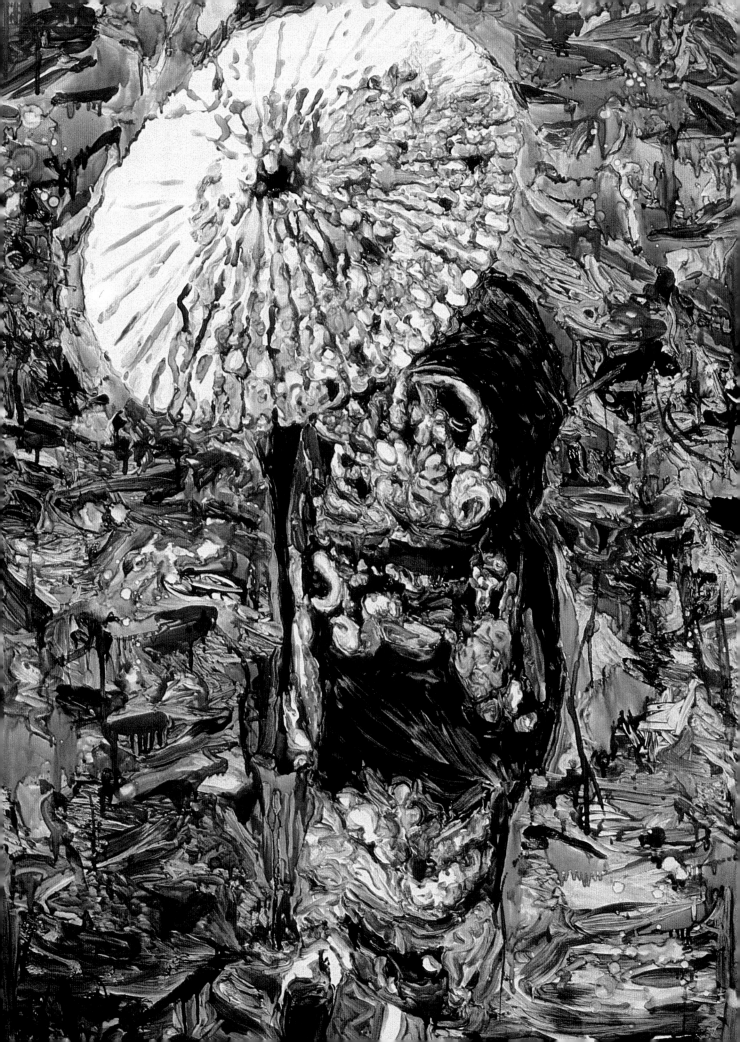

Chapter 2

Basic Imaging Techniques

There are numerous techniques you can use for making monotypes, but the two basic ones are the additive and subtractive methods. In the additive approach, the image is painted in positive directly on the plate with an oil- or water-based medium, working the way you might on canvas or paper. In the subtractive approach, paints or inks are applied over the entire plate and the image is developed in negative by removing the medium with various tools. For both methods, you develop the image on one surface, the plate, and then transfer it to another surface, most often paper.

Because there are many variations of the additive and subtractive techniques, most often you will use them in combination with one another. The final effect is influenced not only by the painting technique you choose but also by the plate surface, the tools, the mediums, and the type of transfer made.

Joseph Raffael, detail, *Kimono Woman* (page 42).

Working into a Light Field

The additive approach is often called "working into a light field" because the painting is developed on a clean or lightly pigmented plate. A transparent plate made of Plexiglas or Mylar, for example, is helpful when you work in this method because a sketch can be placed underneath to guide you in the work on the plate. (In monotype, as in most forms of printmaking, the completed print is a reverse image of your original drawing. Therefore, if you want to avoid confusion, you can use tracing paper to redraw the image and place the reverse side of the tracing under a Plexiglas plate.)

If you have painted on paper or canvas, you will have no trouble painting on plates. Even a beginning artist can feel confident, because it is easy to correct work on a plate—all you need to do is clean the area to be reworked with cloth, tissues, or cotton swabs and solvent. This will help you to avoid overworking a piece, and is one reason for the fresh look of monotypes.

You will also quickly discover that the medium you use, whether it is water- or oil-based, will glide freely on a nonabsorbent plate surface, enabling you to manipulate inks or paints in ways that aren't possible in other techniques.

When using a brush, you will notice that brushstroke textures will appear more exaggerated in the final transfer; therefore, many artists use brushes to enhance the design of their composition. For example, you can use brushstrokes to create contours that suggest dimension. At other times, with quick, energetic strokes, you will be able to express action or mood. The most noticeable brushstroke textures are made when you use stiff bristle brushes with thick mediums such as oil-based inks and paints, and acrylics.

When you use a more fluid medium such as water-based inks, the textures made by brushes are less evident. However, here too, the way you manipulate the medium on the plate contributes to the final effect. For instance, if you drop a fluid color into a wet area, the colors will spread into random patterns, or you can control them with a brush.

During the transfer process, you are pressing the medium between the plate and paper. Wet colors spread in relationship to how thickly you have applied them. For this reason, it is more effective if you paint in a thin, even manner.

The relative viscosities of the mediums will also influence how they print. For instance, colors of the same viscosity tend to mix when you press them together. In most cases, when you add a new color on top of another color already on the plate, it will be lost or diluted during transfer. To make sure you have the desired color on the final print, you need to apply the color directly on the plate surface.

If your monotype will involve repeated transfer steps, you can layer wet colors for special effects. Transparent pigments applied in the second transfer will act as a "glaze" over the first transfer, whereas opaque pigments will usually cover up any colors underneath them.

Once the transfer is completed, you will notice that the plate retains an impression of the image. This is known as "the ghost." To achieve the desired color saturation in the final work, you should allow for the amount of color left for the ghost on the plate. Sometimes using a richer color hue than what you originally planned will create more satisfying results. The pigment remaining on the plate will vary according to the medium and transfer method used. Oil-based painting inks, for example, usually leave the most ghost, while watercolors tend to leave the least amount of ghost ink.

It is possible for you to work in either an opaque or transparent technique in most mediums. You can thin oils and acrylics to watercolor consistency, creating lights with the white of the exposed paper, or you can mix watercolors with white to make them opaque. Experimentation will tell you what feels best.

In this example, acrylic paint was applied to the plate with a synthetic bristle brush.

Note how prominent the brushstrokes appear after transfer from plate to paper.

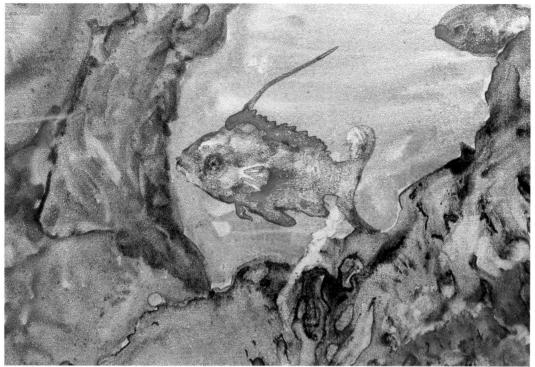

In my watercolor monotype *Coral Sea,* you can see how a fluid medium is used to blend and stain colors. There is very little brushwork evident.

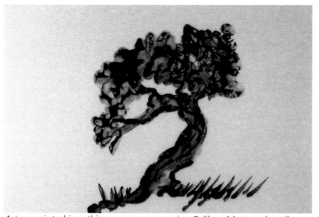

A tree painted in a thin, even manner using Pelikan Mastercolor oils.

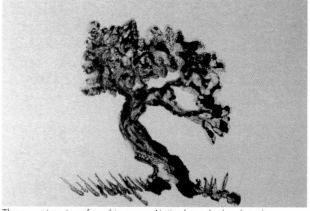

The same tree transferred to paper. Notice how the brushstrokes were translated.

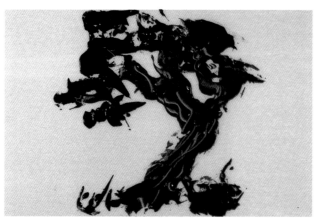

A tree painted with heavy strokes using Pelikan Mastercolor oils.

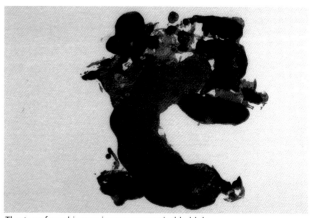

The transferred image is an unrecognizable blob.

Joseph Raffael, *Kimono Woman*, 62 × 48″ (157.5 × 121.9 cm).

Raffael executed this monotype in the direct painting method. The image was developed on an aluminum plate with oil paint thinned to a transparent consistency. Then he transferred the image to Rives BFK paper, using a Takach-Garfield etching press. (Courtesy of Experimental Workshop, San Francisco, and Nancy Hoffman Gallery, New York City.)

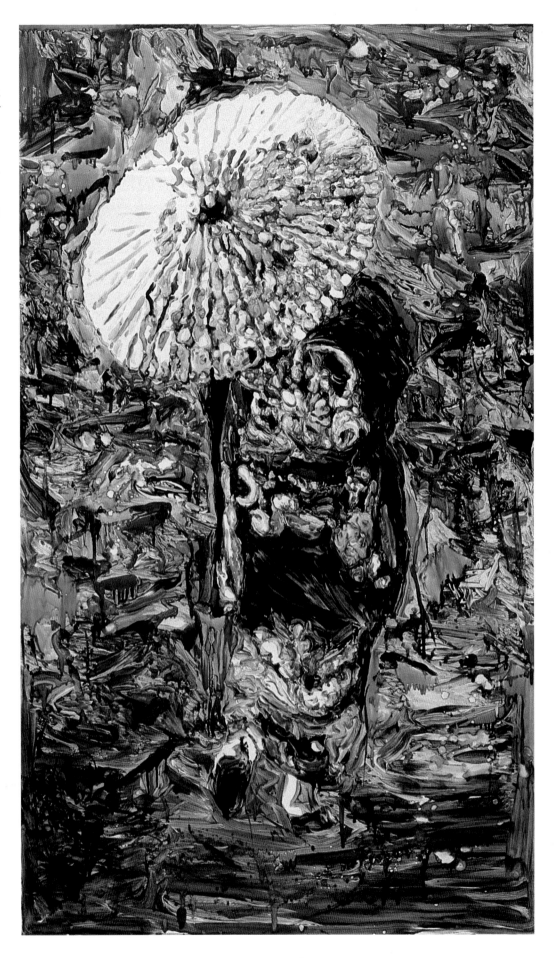

The Additive Approach, Step by Step

This demonstration typifies the process of making a monotype in the direct painting, or additive, method—rendering a positive image on a light field. Here I have used acrylic paints as my medium, working on a plate made of frosted Mylar. Transfer from plate to paper was accomplished by hand, using a baren. In this case, I built up the final image section by section with multiple transfers. When you work this way, you must ensure that plate and paper remain in registration—that is, aligned so that each layer prints exactly on top of the one below. To accomplish this here, I've hinged my plate to the paper with low-tack drafting tape. (Various registration systems are explained later.)

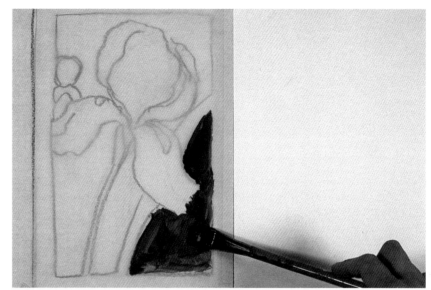

With a guideline drawing under a frosted Mylar sheet, which I am using as my painting plate, I apply acrylic paints with a brush. The plate is hinged to the support paper with low-tack drafting tape to keep it in registration for additional transfer steps.

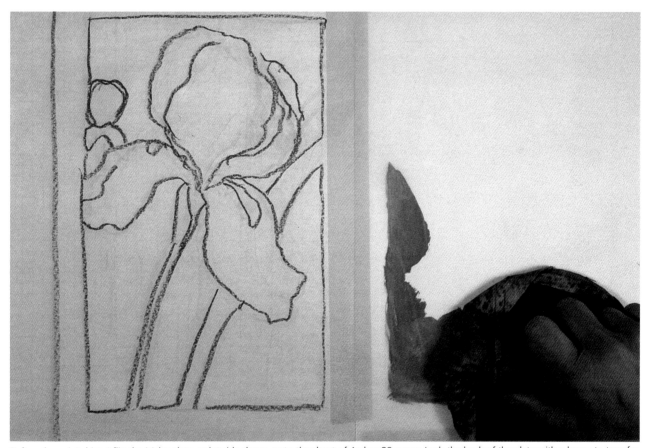

Before the paint dries, I flip the Mylar plate, paint side down, onto the sheet of Arches 88 paper. I rub the back of the plate with a baren to transfer the paint to the paper.

I return the plate to
its original position
for additional work.

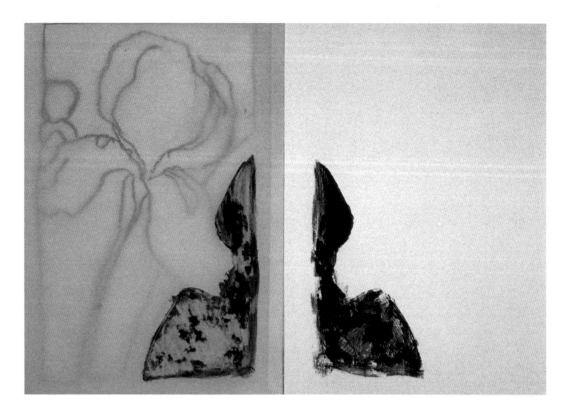

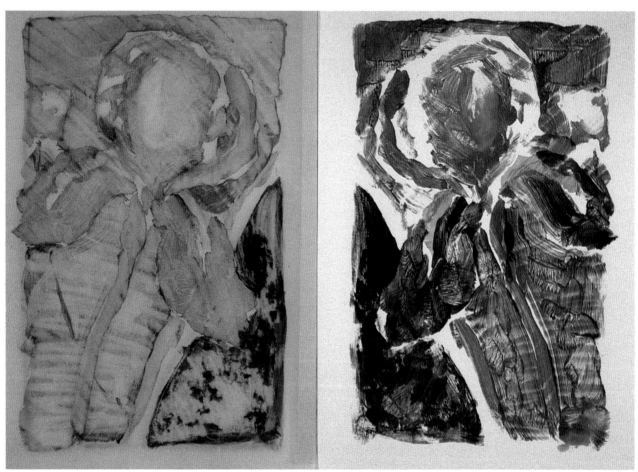

In this stage, I painted the irises and transferred them to the paper.

In this photograph, you see the "ghost" plate.

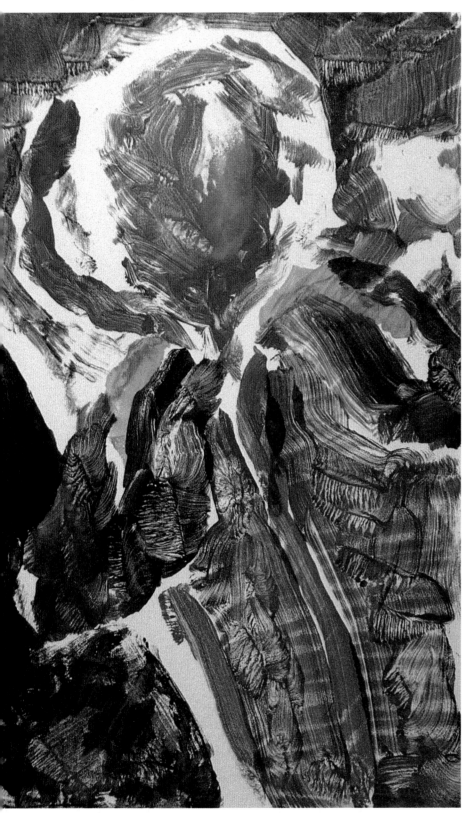

Here is the completed monotype, measuring 9 × 5½" (22.9 × 14 cm).

Working from a Dark Field

The subtractive method is known as "working from a dark field." For this technique, a plate covered with medium is worked in the negative, meaning that the paints or inks are removed or manipulated to create images. This method is probably a natural first step for those with a printmaking background. Giovanni Benedetto Castiglione used the subtractive technique in the seventeenth century when he made the first known monotype.

When preparing a dark field, you usually coat the plate evenly with pigment. Traditionally, this is done by rolling printing ink evenly over the plate. Then you develop the image by removing the ink in a number of ways. For instance, scratching or drawing into the ink is possible with a pointed tool or stick. Sometimes I cut up credit cards, mat board scraps, or use the pointed handle of a paintbrush to create calligraphic effects. The drying time of the ink you use will determine how detailed a drawing you can produce. An oil-based etching ink, for example, will have a longer working time than a quicker drying acrylic medium. On the other hand, you can continue to work and transfer water-soluble inks after they have dried on the plate by dampening the paper before printing.

It is also possible for you to develop an image by removing or "lifting" inked areas with brushes, cloth, tissues, paper towels, tarlatan, or cotton swabs. Solvents will also help you remove or extend oil-based mediums. I use mineral spirits to thin oil-based mediums in order to make them simpler to manipulate. Sometimes I remove the medium from the plate surface so that the paper will show through after the transfer.

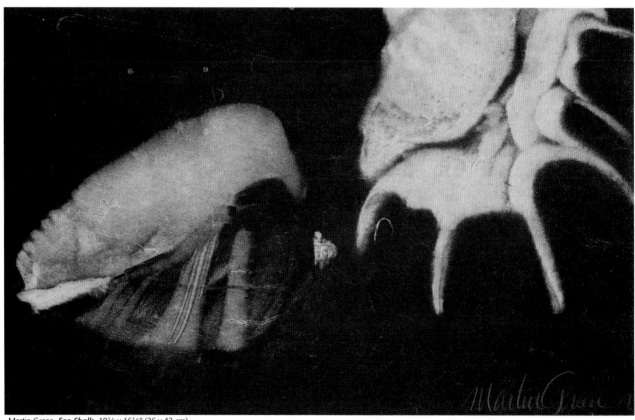

Martin Green, *Sea Shells,* 10¼ × 16½" (26 × 42 cm).
The artist rolled lithography inks evenly onto his plate, then removed it in areas to create shell forms.

The Traditional Subtractive Approach, Step by Step

For this demonstration, I utilize various tools to show how to work in the subtractive, or negative, method—rendering an image on a dark field.

Here, using a soft rubber brayer, I rolled water-based block-printing ink evenly onto a frosted Mylar plate. Then I began manipulating the medium—moving and removing the ink on the plate. With a piece of cloth, I rubbed areas to produce blurred edges. Using a brush, I lifted color as well as created varying textures. To draw in details, I used the end of an Aquarelle brush.

For transfer, I hand rubbed the back of the Mylar plate onto paper using a baren.

For this demonstration, I used a soft rubber brayer to evenly roll water-based brown block-printing ink onto the plate.

Then I wipe some areas with a piece of cloth to remove the ink.

Using a moist brush, I manipulate and lift the ink further.

47

With the pointed end of an Aquarelle brush, I scrape in more texture and emphasize the details.

At this stage, I am ready to transfer the image by hand rubbing the back of the frosted Mylar to a sheet of moistened Arches 88 paper.

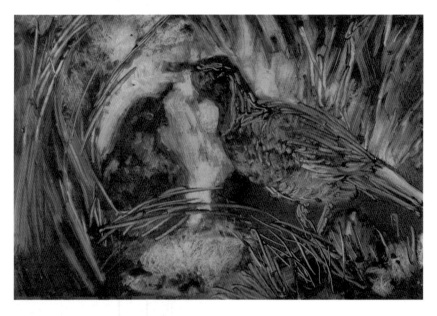

The transfer has been completed. Notice how the ink appears darker and less red in the print than it did on the plate.

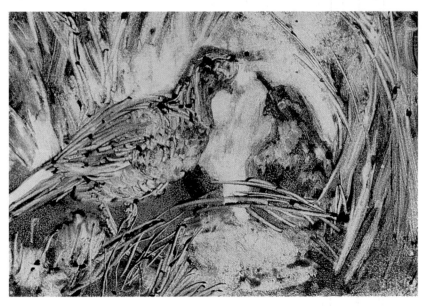

Using Color in the Subtractive Approach

In this demonstration, I built up the dark field using water-based inks—yellow, green, and blue. Before applying any color, I placed masking tape down on the Mylar plate to act as a resist and to create the sharp edges I needed to suggest tree trunks. Using a brayer, I rolled on the yellow and green inks. Then I removed the masking tape and painted those blank areas with blue. After this point, I began working in the subtractive method, manipulating and removing the ink with a piece of cloth, a brush, and a pointed tip.

The transfer was accomplished by hand rubbing the back of the Mylar plate with a baren.

First I adhered masking tape to a few areas on the Mylar plate in a vertical pattern, which I wanted to represent tree trunks. Here I apply a water-based yellow ink with a brayer.

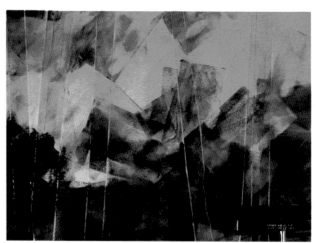

In the same random manner, I apply dark inks.

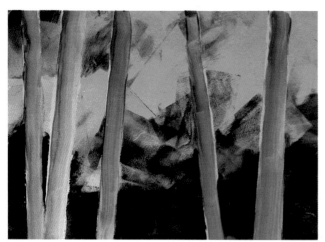

Next I remove the masking tape, and paint blue ink in those blank areas.

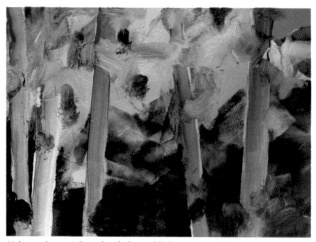

Using a tissue, I drag the darks and lights across the blue verticals.

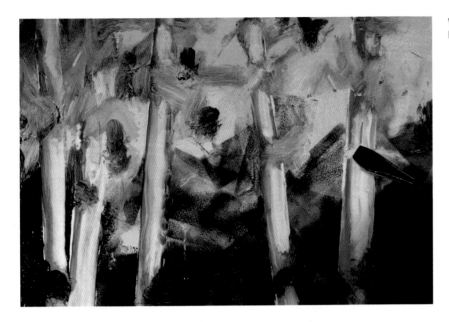

With a brush, I create lights by lifting ink.

Then, using a wooden pointed tip, I scraped out additional shapes.

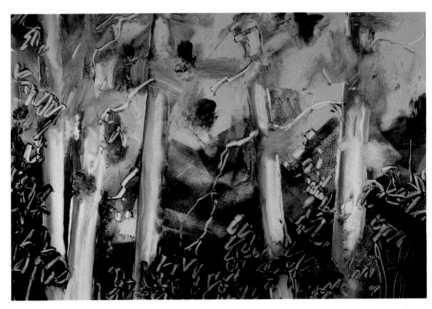

At this stage, I turned the thin Mylar plate over onto moistened Arches 88 paper and began rubbing the back of the plate with a Japanese teacher baren.

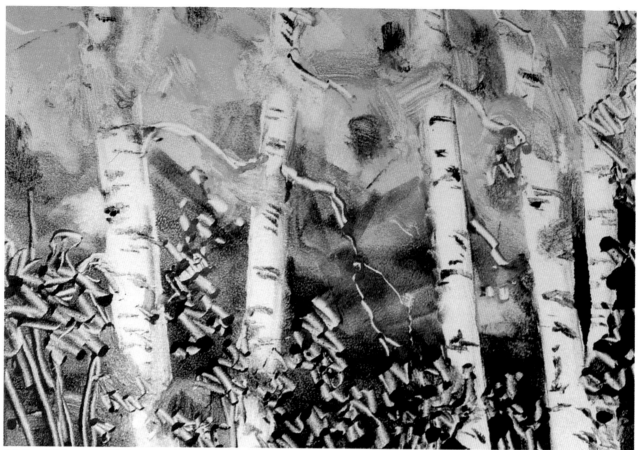

Julia Ayres, *Fall Aspen,* 15 × 22″ (38.1 × 55.9 cm).

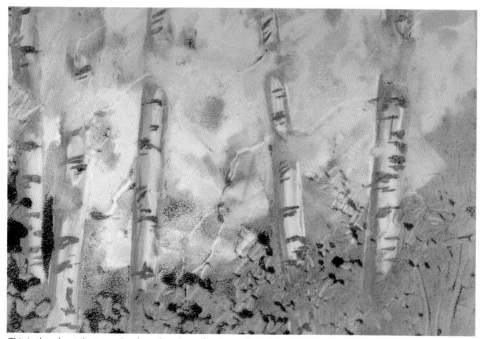

This is the ghost that remained on the plate after I transferred the image.

Additional Techniques

The basic monotype techniques involve either the additive or subtractive methods, but you should not feel restricted to working in one manner. Most artists use a combination of techniques. In fact, there are a number of approaches that do not clearly fall under either method. One such technique is frottage, where a textured surface is created during the transfer process.

Subtractive Then Additive

When using this method, I first apply a thin coat of ink to the plate. Then I develop the image by clearing the plate in designated areas with subtractive wiping and removal techniques. Next I begin adding color by painting directly on the plate in specific areas. This is an ideal way to create expressive and textural elements against an even background.

Some artists roll a light-colored printing ink on the plate to serve as an underpainting or background for the entire image. This creates a uniform tone and prevents uninked paper space from appearing in the final work.

Additive Then Subtractive

Frequently, when I work directly on a clean plate in the additive painting method, I will also include some subtractive ink techniques. I might wipe out, scrape, or lift color to develop the work on the plate. These removal steps are used to enhance forms, such as creating shadows to add perspective, and to produce varying textures.

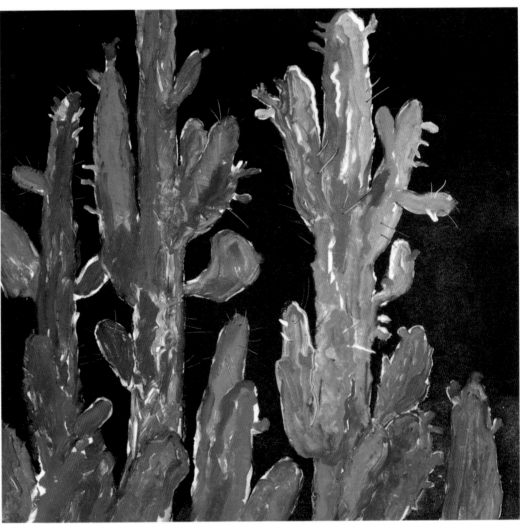

Gloria Jacobson, *Night Bloomers,* 12 × 13″ (30.5 × 33.0 cm), 1988.

This monotype was developed by first rolling thin, dark inks onto the plate. Next the saguaro cactus shapes were wiped from the plate. Then colored inks were painted in to complete the image.

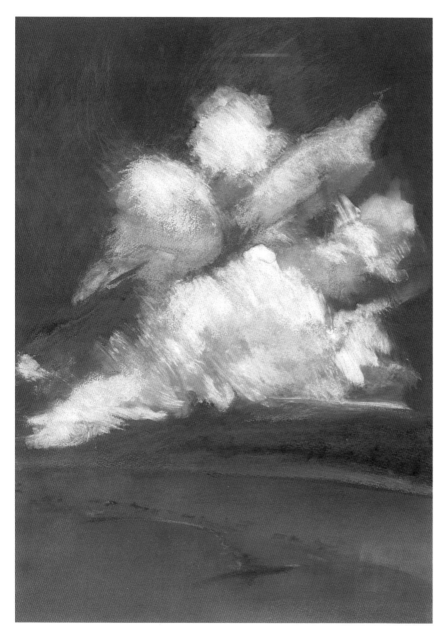

Frottage

Frottage is a hand-transfer technique by which you create unique images by placing paper over a textured surface and rubbing the paper with wax crayon or pencil. You can also roll a lightly inked brayer gently over the paper.

To utilize this process in a monotype, place a thin, inked Mylar plate (with the ink side facing up) over a textured surface. Then place a sheet of paper on the plate and begin hand rubbing—you may want to place a sheet of newsprint on top of the transfer paper to protect it. The textured object under the plate will appear in your final image on paper. For multiple transfers, you can use different textured surfaces for each transfer step to develop your image.

You can also place the textured surface on top of the inked Mylar sheet and monotype paper. Then you can make the transfer by rolling the stack with a brayer. Whether you place the textured material on the top or on the bottom is a working preference since the results will be similar.

Joyce Macrorie, *Blue Skies Smiling,* 25 × 18"
(63.5 × 45.7 cm).

Macrorie used printing inks with a roller and brushes to develop this image. The cloud shapes were created by removing and blending inks with paper towels and a little solvent. After the print was dry, cloud details and the road were emphasized with oil pastel.

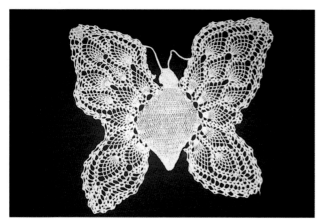

For this frottage monotype, I chose this crocheted butterfly, which I will later place on top of my plate and mulberry paper for transfer.

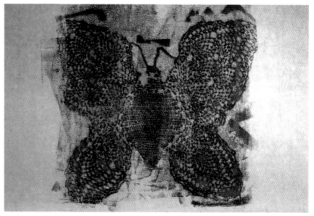

Using a plate that was randomly inked, I placed a sheet of mulberry paper and then the crocheted butterfly on top. I used a brayer to roll over the crocheted butterfly. This picture is the transferred frottage image.

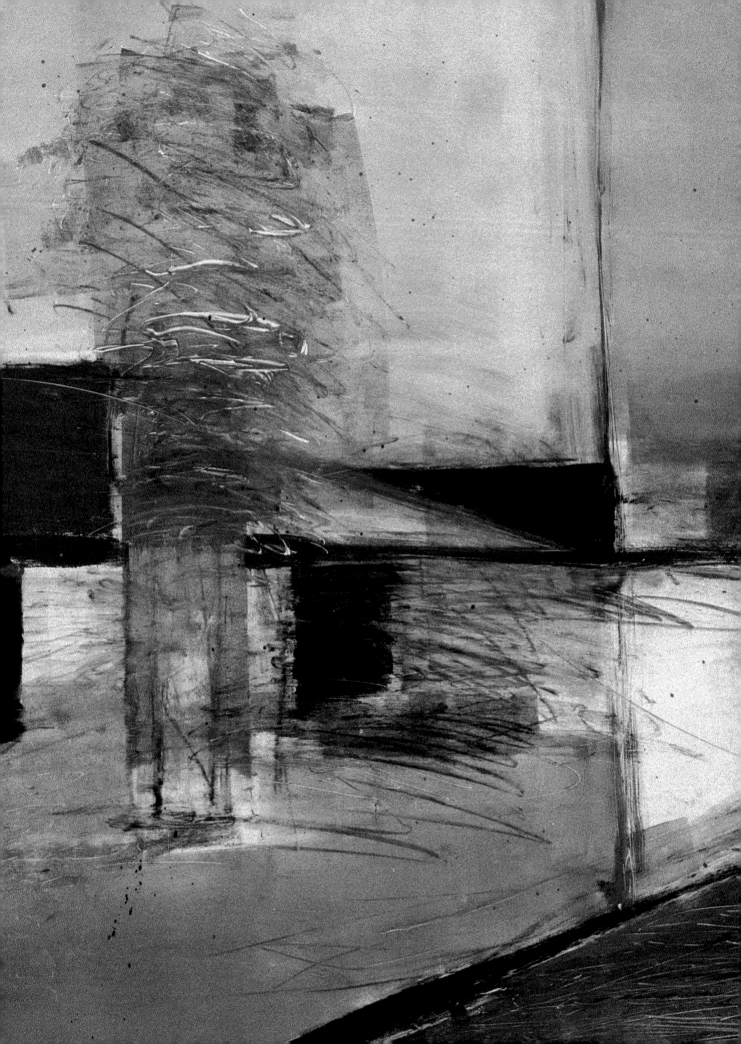

Chapter 3

Printing the Plate Work

Transferring the image you've created on the plate to paper—printing—can be accomplished either by hand or on a press. Hand transfer is especially well suited for working in a painterly manner, while printing on a press ensures the most uniform transfer of ink or paint to paper.

You can render a finished image on the plate with water- or oil-based mediums and transfer it in just one step, or develop the work, layering colors and shapes, through multiple transfers from plate to paper. Plates developed in the subtractive method—worked from a dark field—are usually printed in a single transfer. A multiple-transfer approach allows for somewhat more complex imagery, and is especially appropriate for fast-drying mediums such as acrylic because you don't have to wait long for it to dry to continue with the next transfer.

Both single and multiple transfers involve registration—aligning the image on the plate with the paper so that it prints clearly. Registration for a single transfer is a relatively simple matter of making guide marks for the plate and paper on your working surface—a table if you are transferring by hand, or the press bed if you are transferring by press. Multiple transfers require that you keep your paper in registration with successive stages of work on the plate so that each new layer will print exactly on top of the last. (Registration systems will be discussed later in greater detail.)

Ron Pokrasso, detail,
Panoramic Grove #4
(page 69).

Hand Transfers

Hand-rubbed transfers lend a special painterly quality to monotypes. When you manipulate transfer tools by hand, you can also influence the way your work will develop. For instance, you can create a variety of textures by using different tools such as a spoon, a pot scrubber, or a baren. Though a hand transfer may be your only option because you don't have access to a press, it may also become your creative preference.

According to the material you select for your plate, you will either place the paper under or on top of the plate during transfer. When you use thin materials such as frosted Mylar for a plate, you can place it on top and observe the progression of the transfer. With the proper alignment, or registration, of your paper and plate, you can easily

control the transfer. If your plate is metal, glass, or Plexiglas, it is necessary to place the plate under the paper for the most effective transfer of pressure. In such a case, the back of your paper should be covered with a protective sheet of either Mylar or newsprint paper to keep the back of the monotype free of abrasions from the rubbing.

The rubbing tool you choose and the way you manipulate it will be reflected in your print. If you use a pot scrubber, for example, you can obtain rough, uneven textures, whereas a wooden spoon will produce smooth, even areas. Small, hard implements such as tracing tools, blunt-ended points, or even dull-pointed pencils can be used to make linear textures—crosshatching, circles, and so on. In fact, you may want to use a combination of tools to complete

your transfer. You can use your fingers when you want shading in certain areas, or a variety of sharper tools to trace more defined details for transfer. The end of a palette knife handle or pencil and pointed wooden sticks also work well. My son Clark removed three tines from a fork to make my tracing tool. I especially like the shape of the long edge of the remaining tine for shading impressions or hard hand rubbings.

Registration in Hand Transfer

If you use paper that is larger than your plate, or if you plan to develop your print with multiple transfers, it will be necessary to make a registration system so that the image on the plate will print neatly and in correct alignment on the paper. One way to achieve this is to

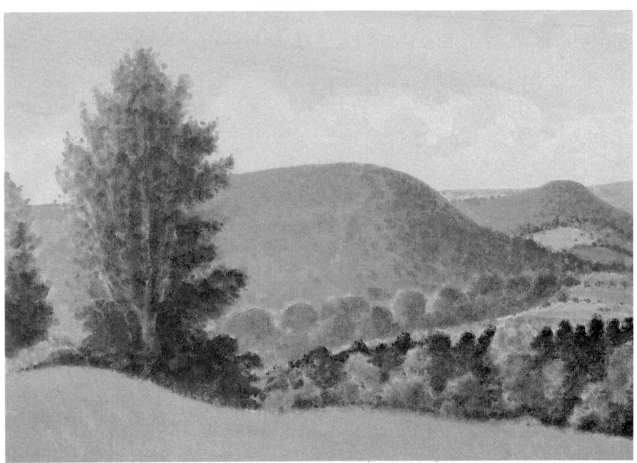

Ray Ciarrochi, *Cherry Valley*, 24 × 34" (61 × 86.4 cm).
This monotype was developed with multiple hand-pressed transfers. Ciarrochi transferred many layers of thin oil paint washes by hand rubbing the paper with a wooden spoon repeatedly. (Photo courtesy of Associated American Artists, New York City.)

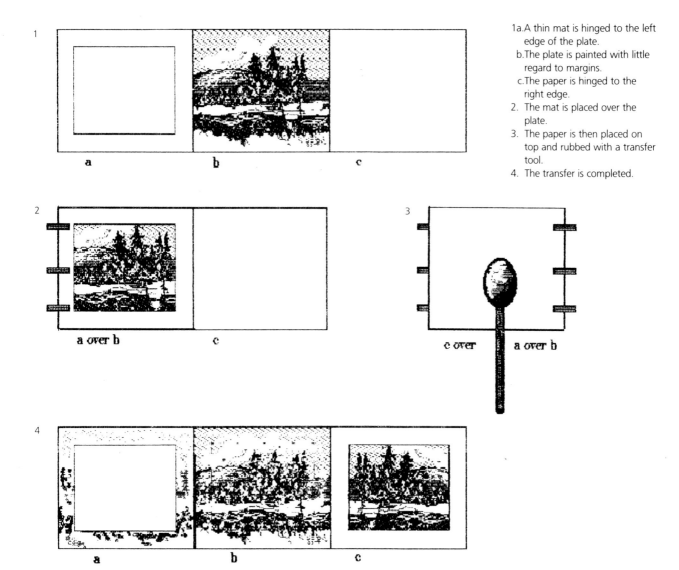

1a. A thin mat is hinged to the left edge of the plate.
 b. The plate is painted with little regard to margins.
 c. The paper is hinged to the right edge.
2. The mat is placed over the plate.
3. The paper is then placed on top and rubbed with a transfer tool.
4. The transfer is completed.

1 a b c

2 a over b c

3 c over a over b

4 a b c

tape a sheet of paper to your work table that is larger than the paper you plan to print on. This sheet will become your guideline. Next, draw in the outer dimensions, or outline, of your support paper onto the paper guideline. Then, if your support paper is larger than your plate, draw in the outer dimensions of the plate within the support paper outline. Make sure that you center the plate properly. The guideline is now complete. You can place your plate and support paper on top of the paper guideline—in the outlined areas—to begin your transfer.

If your paper and plate are the same size and you want clean borders, here is a simple way to keep a clean margin around the print. Cut a paper mat the same size as your plate and paper with the margin widths you want. If you are doing a single transfer, place the mat in alignment between the inked plate and the paper. You are ready to proceed with the transfer, which will block the transfer of ink on the monotype margins. If you are doing more than one transfer step, before you begin, you can ensure proper registration by hinging your monotype paper to the right of the plate edge and hinging your mat on the left edge of the plate. After your plate is developed, place the mat over the plate first to block out unwanted ink. Then bring your paper over the top of the mat for the transfer.

Hand-Pressed Plate Marks

Plate marks add a three-dimensional feature to a monotype. Whether you decide to use plate marks is an aesthetic choice rather than a requirement. If you want plate marks in a hand-rubbed transfer, you must first place the plate on the work table, and then the paper, which must be larger than the plate, is placed on top.

For hand transfers, metal plates with carefully beveled edges work best. The most suitable tool for beveling is a metal file. You should bevel the edges of your plate before you begin work on it. When you are ready to transfer, your paper must be moist. You can use the back of a spoon bowl or a similar-shaped metal tool to rub over the back of the paper. Pay special attention to the plate edges when you are burnishing the paper, since this is where the plate marks are produced.

Single Transfer by Hand: A Demo

Oklahoma artist Betty Sellars randomly rolls oil colors on her Plexiglas plate to make a traced monotype. She has placed a drawing under the plate to guide her. Next she lays a sheet of mulberry paper on top of the inked plate. Removing the drawing from under the plate, she now places it on top of the mulberry paper. With the pointed end of her palette knife handle, Sellars traces over the drawing. She rubs parts of the drawing with her fingers, pressing the paper against the inked plate to pick up shading.

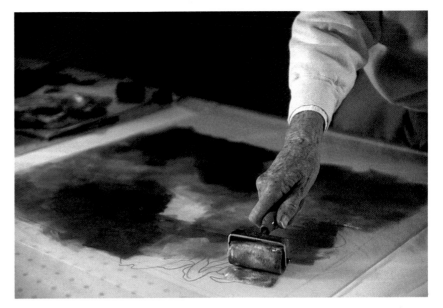

With a drawing under the Plexiglas plate to guide her, Betty Sellars rolls oil paints randomly over the plate.

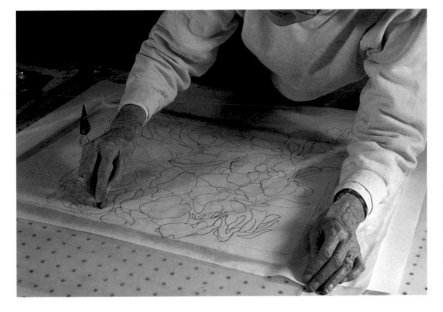

After gently laying a piece of parchment paper on top of the inked plate, Sellars removes the drawing from under the plate and places it on top of the plate and support paper. She then begins to trace the lines of the drawing with the pointed wooden end of her palette knife.

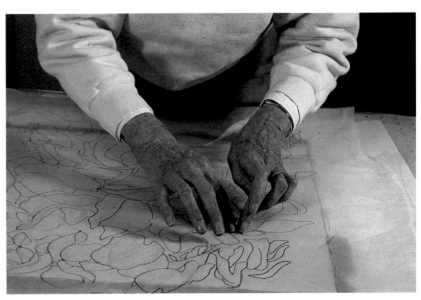

In the areas where she wants shading, Sellars presses the paper with her fingers.

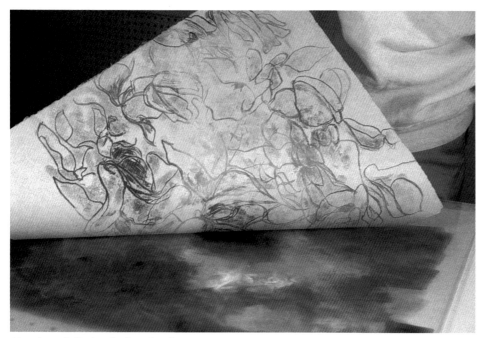

Here she pulls the transfer from the plate.

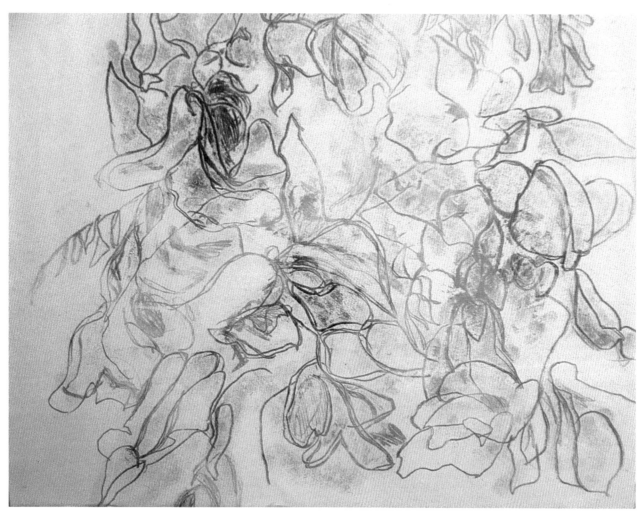

GMB Sellars, *Wisteria,* 20 × 24" (50.8 × 61.0 cm).

Multiple Transfers by Hand: A Demo

A more complex image is possible when a monotype is made with one transfer step on top of another. Ray Ciarrochi takes full advantage of multiple transfers. His overlays of transparent pigment create greater color variation, producing strong spatial depths and atmospheric effects for his landscapes.

For his largest monotypes, Ciarrochi uses two kinds of Fabriano paper, Rosaspina (220 lb.) and Tiepolo (223 lb.) white. For his smaller works, he uses Arches Johannot. The larger papers are 27½ × 39″ (70 × 99 cm), which he uses for a 24 × 34″ (61 × 86.4 cm) image with a 1½″ (3.8 cm) border. The smaller sheets, 22 × 30″ (55.9 × 76.2 cm), are chosen for a 19 × 27″

(48.3 × 68.6 cm) image size with a 1½″ (3.8 cm) border. Ciarrochi uses these papers because they are strong enough to withstand the multiple printings his work requires. He also likes them for their distinctive textures, which vary from open to dense grain and lend interesting effects to his prints.

Ciarrochi works on a glass plate. To ensure accurate registration during multiple transfers, he places two wooden right angles at the top corners of his plate, onto which he will tack his paper. Since he usually makes up to fifty impressions to complete a work, Ciarrochi reinforces the back of the paper edge with strips of masking tape where the push pins are used.

Next the artist places a drawing guideline under the glass plate, which

will be in registration with the paper on top. He uses oil paints in both a thick and fluid consistency. Ciarrochi usually begins his monotype by applying a ground color that is highly diluted with turpentine. After the ground color is transferred, he tends to work in individual areas, sometimes completing them, before proceeding to another area. At all times, he strives to maintain the grain of the paper and allows successive layers of color to show through as he builds pigment layers.

Ciarrochi transfers his work by hand with a well-worn wooden spoon he brought from Italy. Using varied pressures on his spoon, he manipulates the color densities and the details of the image. If the paint is very liquid, he simply rubs the back of the paper with his hand.

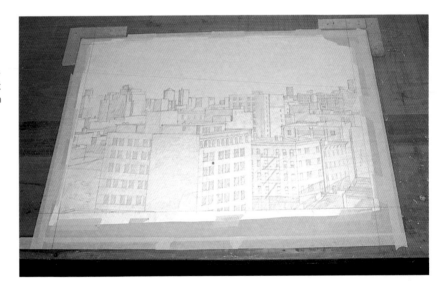

Ray Ciarrochi tapes a guideline drawing to his work table and covers it with a glass plate. Wooden right angles are used on the top corners of the plate to secure the paper and ensure correct registration. (Photographs by Ruth Klein.)

Ciarrochi reinforces the back of the bottom of the support paper with masking tape. (It is reinforcement for tacking the sheet to the wall away from the plate, which you see in the next step.) Then he attaches the paper to the wooden angles at the top of the plate with push pins. Ciarrochi's transfer tool is a well-worn wooden spoon.

Ciarrochi's palette of oil paints can be seen on an enameled tabletop to the right. Here, he begins to paint the first of many layers of pigment on his plate; his paper is tacked to the wall behind the worktable.

Here Ciarrochi has flipped the paper over the painted plate to transfer the first layer of pigment. He rubs the back of the paper with the bowl of the spoon to effect the transfer.

Once again, Ciarrochi pulls the paper away from the plate and applies additional color.

After a second transfer, he repeats the paint and transfer steps.

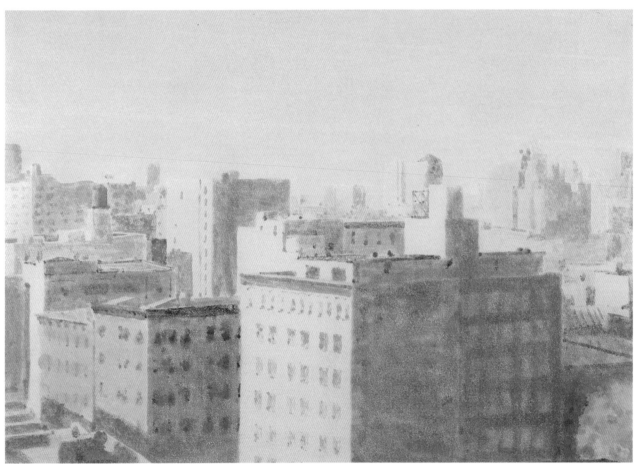

Ray Ciarrochi, *Manhattan June,* 19 × 27″ (48.3 × 68.6 cm).

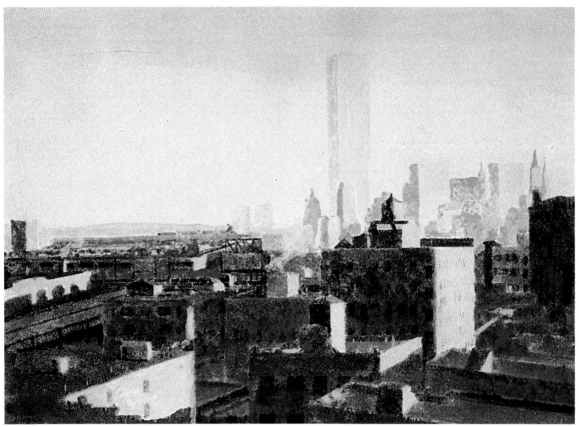

Ray Ciarrochi, *Manhattan Spring Morning*, 19 × 27″ (48.3 × 68.6 cm).

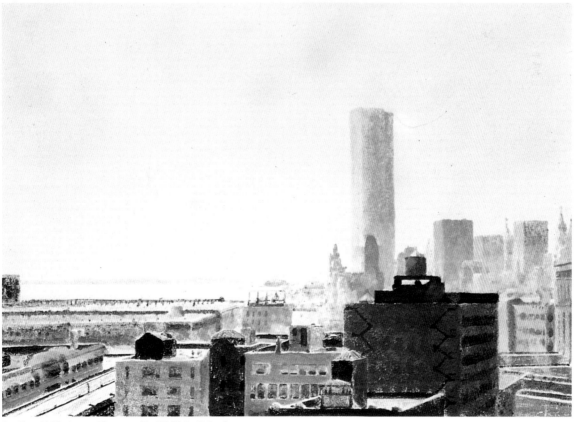

Ray Ciarrochi, *Manhattan Afternoon*, 19 × 27″ (48.3 × 68.6 cm).

Here are examples of completed monotypes that were produced in the same manner as described in the demonstration. (Courtesy of Associated American Artists, New York City.)

Press Transfers

A printing press will provide uniform, consistent pressure to transfer plate work to paper. You can change the amount of pressure applied with the controls or by adding more blankets. With a press, you can also combine embossing, lithographic, and intaglio techniques with your monotype work. When using a press, you place the plate and paper in registration on the press bed and then mechanically move the bed so that it travels under rollers (in an etching press) or a scraper (in a lithography press). Because presses are so expensive, you may want to rent time at a professional print shop or take a class to familiarize yourself with the equipment. Etching and lithography presses are used in most workshop facilities.

Registration in Press Transfer

To achieve a successful transfer, it is necessary that you keep the plate and paper in proper registration. Many presses have Plexiglas plates with registration guidelines that cover the entire press bed. If you have a drawing, you can place it under the Plexiglas and begin painting directly on top of it. If there are no guidelines, you can make simple marks with masking tape on the press bed to indicate where the corners of your plate and paper should be positioned. Another possibility is to make a template from mat board, cutting out the size of your plate so that it fits exactly.

If your print is to have a white border, the paper can be kept engaged under the roller to hold the paper in the same position for subsequent transfers while you change plates, which you should already have marked for registration on the press bed. Sometimes the paper may need to be misted, but you should have all plates ready before you begin the transfer work.

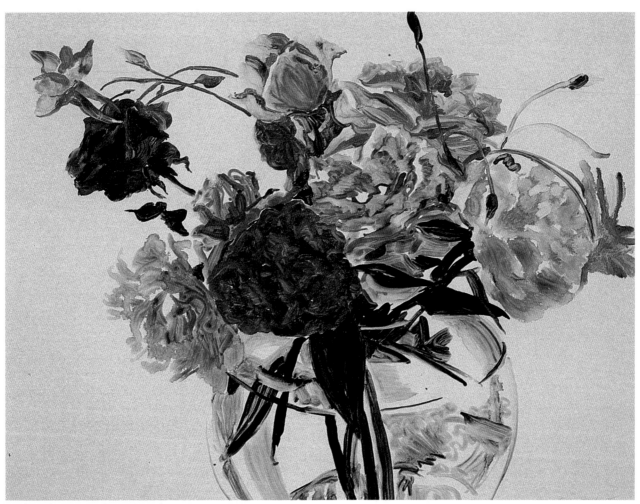

Carolyn Brady, *VI*, 30 × 40" (76.2 × 101.6 cm).

Brady worked with printmaker Maurice Payne in New York City to make this monotype. She used oils to paint onto a copper plate. The transfer was made to paper with one run through the press. (Printed by Maurice Payne; courtesy of Nancy Hoffman Gallery, New York City.)

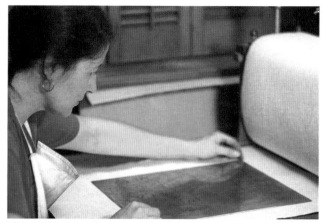

With a large sheet of paper covering the press bed, Maxine Richard places her plate on top of it and makes simple registration marks with a pencil.

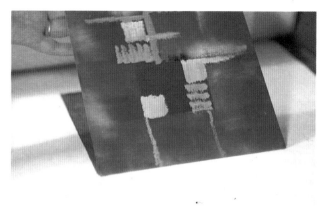

When more than one transfer is needed, Dianne Haralson tapes a template to the press bed to ensure registration. Here you see her placing her plate into the template.

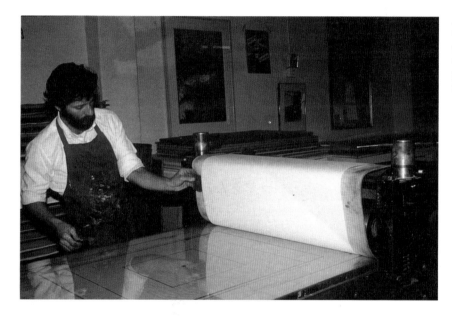

At the Graphics Workshop, registration is a simple matter with graph paper under the Plexiglas-covered bed. The most common plate and paper sizes are designated with colored-ink lines.

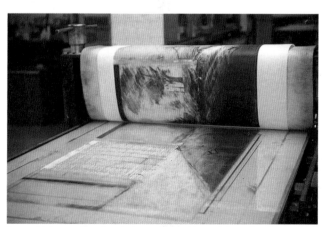

For multiple transfers, Ron Pokrasso keeps his work in registration by engaging the edge of the paper from the previous transfer under the rollers. Then he simply removes the plate and replaces it with another plate, which he has already prepared.

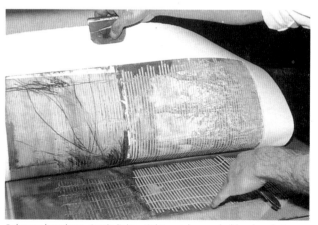

Pokrasso has these simple lightweight metal paper holders handy to keep the paper pristine while handling. Folded paper squares work well for this, too.

Multiple Press Transfers

When Françoise Gilot works at Solo Press in New York, she usually makes multiple-press transfers to develop her monotypes. Here she used thinned lithography inks to layer opaque and transparent colors to achieve three-dimensional effects. In certain areas she placed opaque colors next to transparent ones to create crisp edges. Such effects would be harder to achieve with a hand transfer since it would be difficult to apply enough pressure in the areas where the ink must go deep into the tooth of the paper.

The entire press bed is covered with a Plexiglas sheet that acts as the plate. A drawing of the image was placed under the Plexiglas plate to guide Gilot in developing her monotype; it also helped to ensure proper registration.

Francoise Gilot develops her monotype on the Plexiglas-covered bed of a Takach-Garfield lithography press at Solo Press in New York City.

Master printmaker Arnold Brooks, assigned to assist Gilot, places a sheet of paper with work in progress over the inked plate.

Brooks runs the plate and paper through the lithography press, sometimes enlisting the aid of another pressperson.

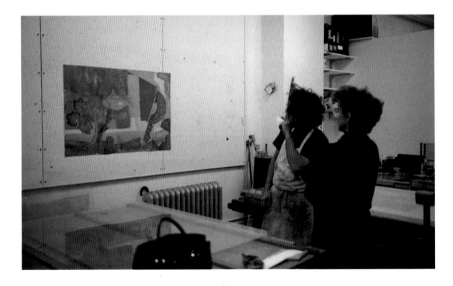

After completing a number of transfers, Gilot studies the work to decide its future development.

Other Types of Transfers

There are a number of ways you can transfer your image to produce varying effects. For instance, the "ghost," which is the ink or paint left on the plate after transfer, can be transferred as another work. It will appear fainter and softer than the original. You can also use a freshly printed monotype as a plate; this is known as a "cognate" or "counterproof." In such a case, the image will appear as it did in the first plate and not be in reverse. The counterproof could also be called an "offset" print because the image was first transferred to another surface (the print) that was then printed on a second surface (the counterproof).

Ghost Transfers

The transfers made from ghost plates are softer and perhaps more lyrical than the first transfer. Some artists discard the initial transfer and consider the second impression the completed work. Many artists prefer the lighter tones and blurred textures of the ghost print.

You can leave a ghost print as is or develop it with work on top. Degas, for example, used ghost prints as the base for a number of his pastel paintings.

Ron Pokrasso prefers developing his work with ghost ink that remains on the plate, as he is able to achieve greater contrasts in his work by leaving some parts of his plate with the ghost ink and adding fresh inks in other areas. Because he usually continues reworking his ghost plates after impressions are made, his plates are developed as a series or "states" of similar monotypes.

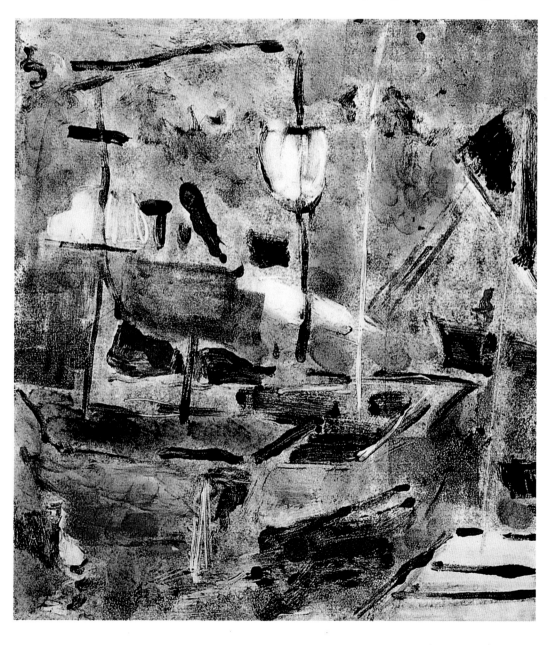

Suzanne Hodes, *Blue Harbor,* 12 × 10½" (30.5 × 26.6 cm).

Hodes developed this monotype by adding ink to a ghost plate after a traced monotype was pulled. You can still see the ghostlike lines in the final image.

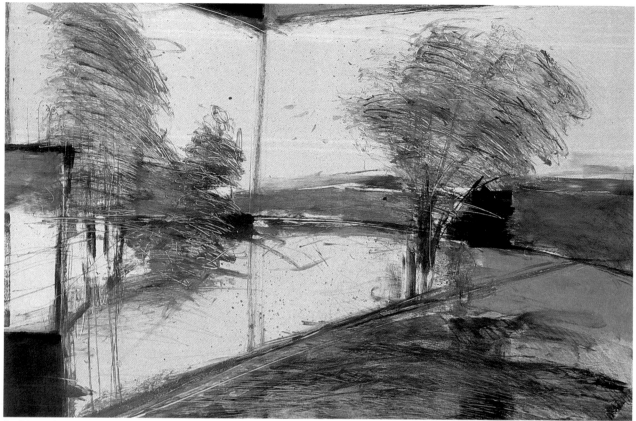

Ron Pokrasso, *Panoramic Grove #1,* 23 × 36" (58.4 × 91.4 cm), 1987.

This monotype was the first print pulled from the plate in this series. It was done with a single transfer.

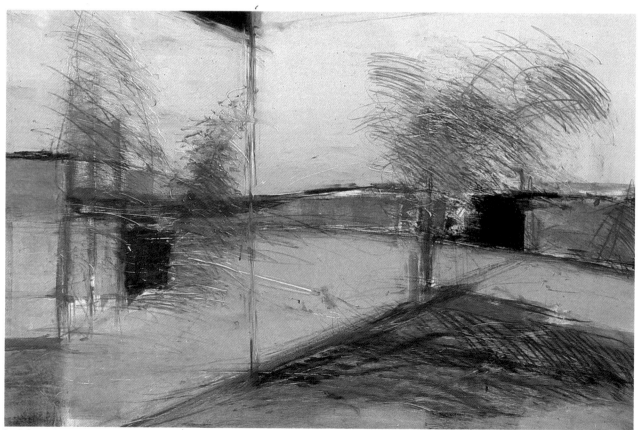

Ron Pokrasso, *Panoramic Grove #2,* 23 × 36" (58.4 × 91.4 cm), 1987.

For the second image in the series, Pokrasso worked with the ghost ink left on the plate from the first transfer.

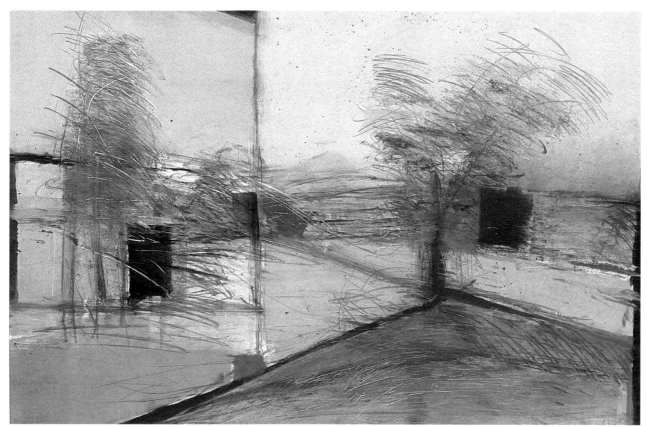

Ron Pokrasso, *Panoramic Grove #3,* 23 × 36" (58.4 × 91.4 cm), 1987.

Note how the plate continues to change and develop.

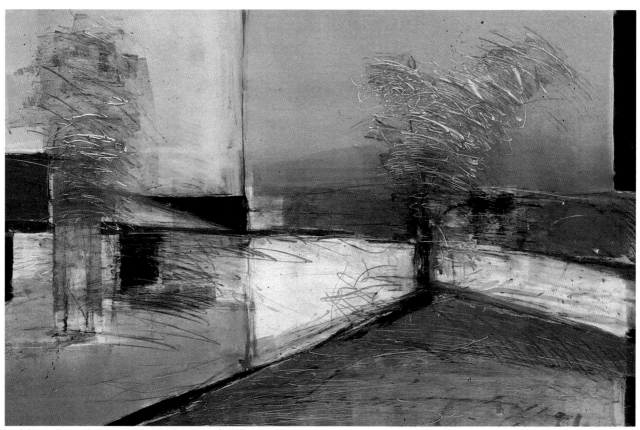

Ron Pokrasso, *Panoramic Grove #4,* 23 × 36" (58.4 × 91.4 cm), 1987.

Here is the last monotype in the series. Notice the underlying whispers of work left on the plate from the previous transfers.

Counterproofs and Cognates— Offset Printing

In commercial "offset" printing, the image on the plate is transferred onto a blanket, which becomes a plate that is used to print the image back on paper. Similarly, you can transfer a wet monotype onto another sheet of paper. This offset print is called the "cognate" or "counterproof."

You can intentionally make a heavily pigmented plate from which a cognate impression can be made. And if you transfer the ghost impression from the plate, you will have three similar but different works. They can be considered finished, or they can be developed individually in a variety of ways with additional transfers or direct work on top of each print.

You can also apply offset images directly to your plate work. With this technique, you can make an image in one section of your plate and repeat it in another area. To do so, roll a clean brayer over a design while it is still wet, then "unroll" the design onto another section of the plate. You can repeat the image by continuing the roll, but each impression becomes fainter as the amount of ink on the roller diminishes. The size of the image to be offset will determine the circumference and width of the roller or brayer you will need. With a large roller, you can cover the paper or plate completely in one turn. In offset printing, you can use two-dimensional painted imagery or three-dimensional textured materials such as lace or leaves. Slow-drying inks and paints are best for this technique. Just make sure your medium isn't too thin.

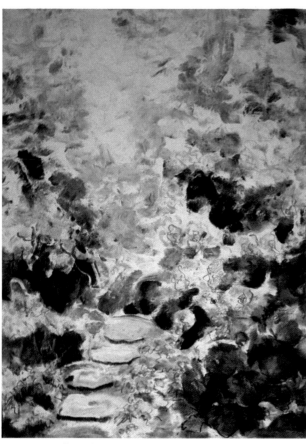

Nancy Bowen, *Tiffany Terrace 1,* 40 × 30" (101.6 × 76.2 cm).

This monotype was the first transfer from a plate richly painted with serigraphy inks.

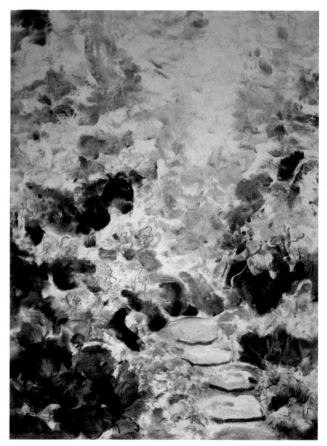

Nancy Bowen, *Tiffany Terrace 3,* 40 × 30" (101.6 × 76.2 cm).

Bowen pulled this cognate (counterproof) print from *Tiffany Terrace 1.*

Using a brayer with dark ink, I rolled it over a piece of lace (on left side). As a result, the lace created a pattern on the brayer, leaving the negative pattern of the lace (as seen on right side).

The circumference and length of my brayer are of a size that will let me pick up this wet image in its entirety.

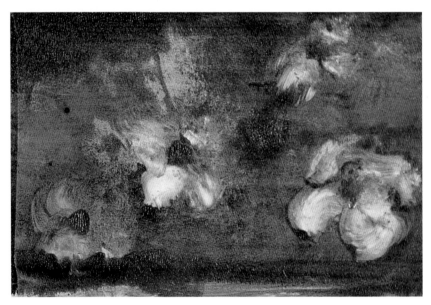

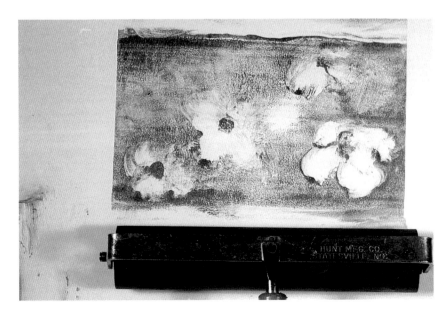

When I roll my brayer carefully over the picture, the roller picks up the image. Now I can roll the brayer on a clean surface to produce an offset print.

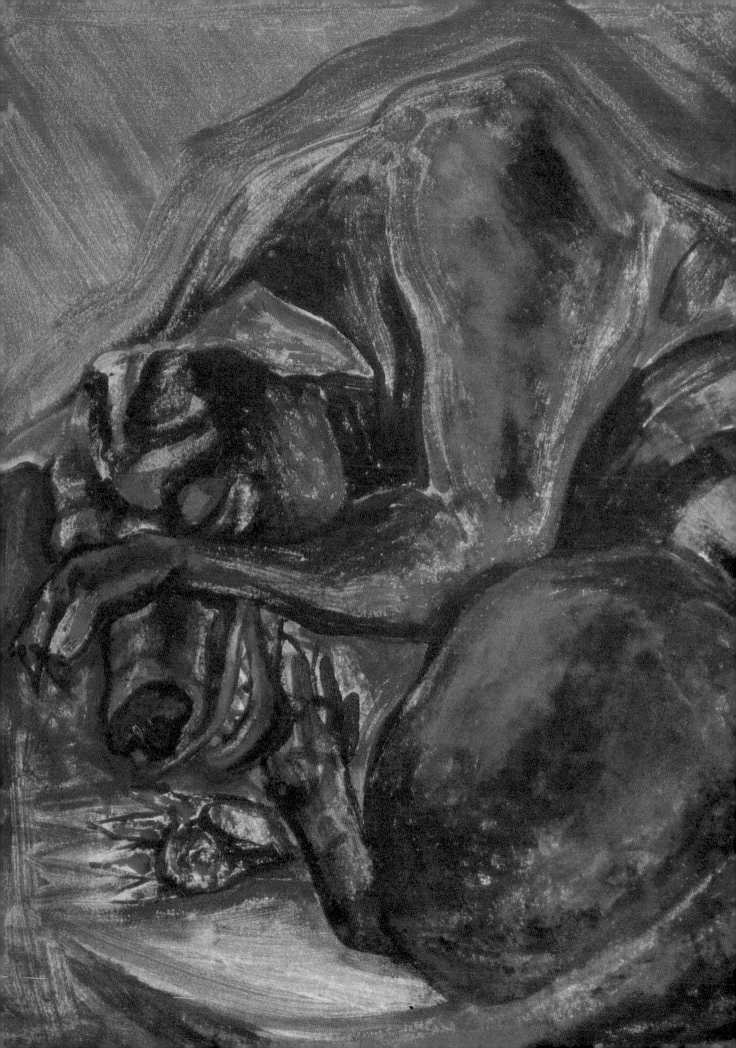

Chapter 4
Working in Specific Mediums

Most water- and oil-based mediums are suitable for making monotypes, and can be applied to the plate with a roller, brayer, brush, or by hand. In fact, many of the same techniques—such as splattering, developing washes, and detailed brushwork—can be used in all mediums. You may only need to adjust the consistency of the medium by thinning with either water or solvents—water for water-based colors and solvents for oil-based ones. However, some mediums have special characteristics that make for unique textures and effects. Watercolors, for example, can be diluted to such a thin consistency that you can pour them onto your plate. Printing inks are ideal for monotypes because they are specially designed to be used on a plate and printed on paper. For instance, lithography inks can be rolled thinly onto a plate and still maintain their color saturation; and serigraphy inks can be used to create marbleized and iridescent textures.

If you want the pigments to transfer completely, you can coat your plate with gum arabic or dishwashing detergent before you begin working on it. After transferring the image, you will find little medium left on the plate.

Watercolors

Because of the transparent quality of watercolors, you can easily blend colors, develop washes, and create soft, blurred edges and textures. It is a medium that encourages you to work spontaneously.

There are a number of texturing techniques that lend themselves to this medium. For instance, you can apply droplets of clean water into wet paint to create blotches, and use a brush to produce splattering textures on your plate. You can also manipulate fluid watercolors on your plate by blowing on them or turning the plate in various directions. It is possible to develop strong contrasts in an image by combining multiple layers of transparent washes with thick, opaque brushstrokes.

You can transfer watercolor work while the paints are still wet on your plate, or wait until they dry and transfer the image to damp paper. Coating your plate with such materials as gum arabic, starch formulas, or common dishwashing detergent, helps make a more complete transfer. Keep in mind that watercolors dry in a lighter hue than when they are first applied. Therefore, you should apply thicker, more vivid colors than what you plan for your final work.

Transferring with Wet Paint

With watercolor, you usually paint on the plate and transfer to dry paper while the paint is still wet. Because watercolors are fast drying, they work well when you are developing a monotype with multiple hand transfers. Waterleaf papers, such as Arches 88 or an unsized Oriental paper, usually work best for transferring wet watercolors, as they will readily blot up the pigment.

To ensure proper registration for multiple transfers, you can hinge the back of the paper to the back of the plate with low-tack drafting tape.

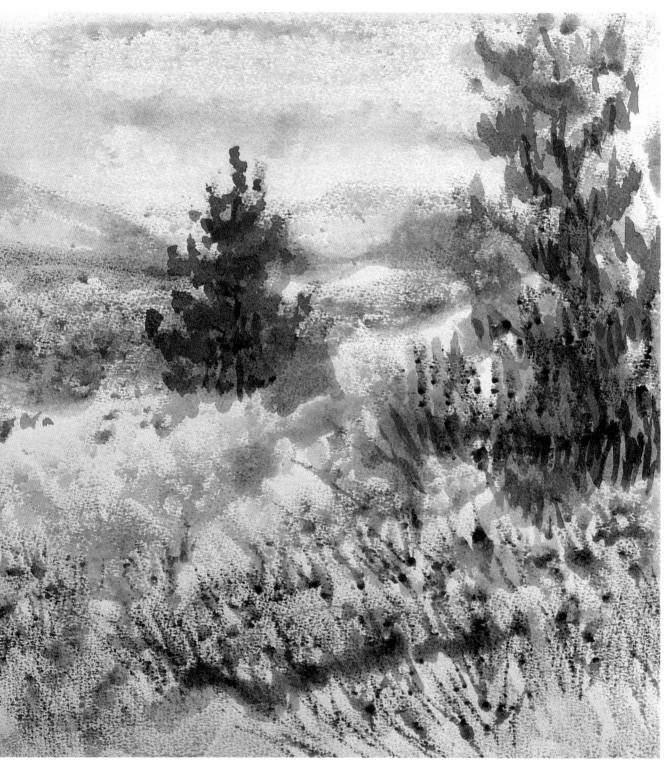

Julia Ayres, *Angeles Crest,* watercolor monotype, 22 × 30″ (55.9 × 76.2 cm), collection of Mr. and Mrs. R. K. Rawlins, Sedona, Arizona.

I developed this monotype with multiple hand rubbings, transferring the wet image on the plate to a dry sheet of Arches Cover paper. By thinning the watercolors to a fluid consistency, I was able to produce soft, transparent colors and textures.

Transferring Dry Paint to Moist Paper

You can also allow watercolors to dry on the plate and transfer the image later to moistened paper. The advantage of this method is that it allows you more time to work on the image before it is transferred.

When you apply watercolor washes to a nonabsorbent plate surface, they tend to run and puddle. As a result, the areas where the colors mingle often dry into interesting patterns that are ideal for monotypes. While the paints are drying, you can manipulate these areas with a brush.

Richard Berenson, art director for *Reader's Digest* magazine, has created a number of watercolor monotypes by transferring dry paint to moist paper. Working on tracing vellum, Berenson paints his watercolor landscapes on location. Later, with the aid of a press, he transfers the work from the vellum to moistened paper. When he wants a plate mark in the paper, he aligns the vellum on a beveled metal plate of the same size before it is run through the press.

You can also work in a relatively dry manner, brushing paint thickly on the plate. With this method, the direction of your strokes and the brush textures become an integral part of the image. Other tools such as sponges can be used to stamp color on the plate.

Once the paint has dried, you can use subtractive techniques to lift out areas of color. Using a brush moistened with water, you will be able to rewet an area and easily blot away paint. Splatters or drops of paint or water can be applied at various times during the drying period.

As the plate dries, you should prepare your paper for transfer. It is important to have the moisture evenly distributed for a successful transfer. You can accomplish this by soaking your paper in a tub of water for about twenty minutes and blotting it afterward. You can also use a large, wet natural sponge to moisten both sides of the paper until it lies flat. Your paper is ready for transfer just after the wet sheen disappears. For an additional wet test, press your wrist on the wet paper surface; if it feels damp but does not transfer moisture to the skin, it is ready. If the paper is too wet, you can blot the surface with paper towels or place the paper between blotters and roll out the excess moisture. Waterleaf papers need to be misted and left for a few minutes under a plastic sheet before transfer.

Richard Berenson, *Tree by Gate,* watercolor monotype, 14 × 11" (35.6 × 27.9 cm). (© Richard Berenson 1987.)

Using vellum—a lightweight material—for his plate, Berenson developed this landscape on site and let it dry. Later he transferred the image to moist paper using an etching press.

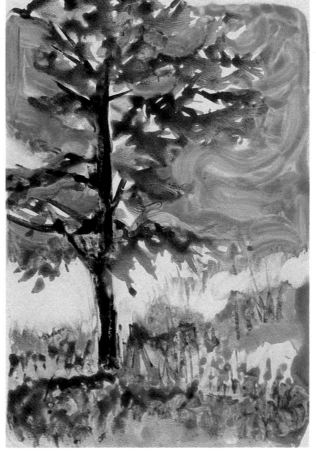

Richard Berenson, *Tree in Field,* watercolor monotype, 14 × 11" (35.6 × 27.9 cm). (© Richard Berenson 1987.)

For this monotype, Berenson painted on a zinc plate that had been cleaned with a common abrasive household cleaner, which made a tooth in the metal surface for the watercolors to adhere to.

Yolanda Frederikse paints her watercolor directly on an aluminum lithography plate. At times, she allows the paint to run at a slight angle as it dries. She also lifts color with a moist brush. When she is ready to print the image, she places the thin plate over a second plate of the same material to achieve the proper pressure for the etching press. She then places a sheet of moist paper on top of her plate. Frederikse checks the transfer carefully before pulling the paper from the plate.

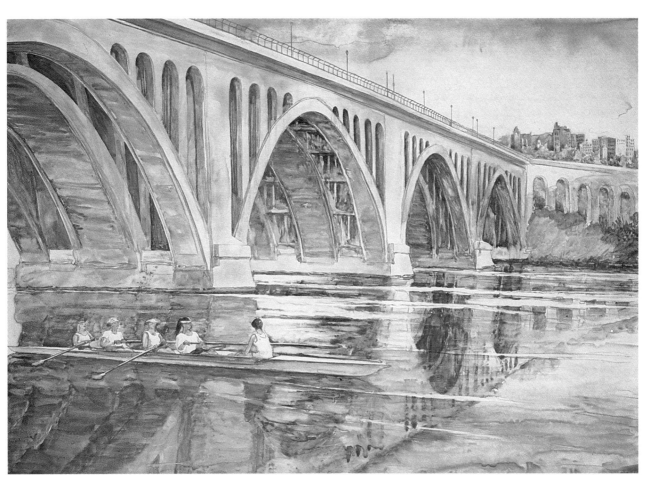

Yolanda Frederikse, *Sculling Under Key Bridge,* watercolor monotype, 17½ × 25" (44.5 × 63.5 cm).

Coating the Plate

When you coat your plate before applying paints, your transfer will be more complete because the coating allows very little medium to remain on the plate after the transfer. Sometimes there may not even be a ghost on the plate. For the coating, you can use liquid gum arabic, Winsor & Newton Aquapasto thinned with water, starch formulas, or common dishwashing detergent.

When teaching workshops and for personal use, I've had the best results with gum arabic. The liquid form is available in large bottles for the print trade. I dispense the gum arabic into smaller squirt-top bottles that are convenient to work with. I squeeze small lines of gum arabic on the plate, and then, with the help of a moist brush or a damp paper towel, I evenly spread it to coat the entire surface. While work may be done on a wet-coated surface, I prefer to let the solution dry before painting on top with watercolors.

Janet Siamis discovered that liquid dishwashing detergent will also act as a coating agent. She brushes the detergent on a thin, frosted Mylar plate and allows it to dry. Her images are developed with her regular watercolor palette, but she uses the colors in a thicker, more vibrant manner. While working, she keeps her colors fresh and liquid from the tube.

Siamis allows her paints to dry completely before they are transferred. She soaks Arches hot- or cold-pressed watercolor paper for at least an hour to remove the sizing. The paper is then blotted by placing it between two large blotters until the wet sheen has disappeared. The dry plate, paint side down, is then placed on top of the damp paper. She effects the transfer by hand rubbing the back of the plate with a number of tools, such as a rolling pin, a brayer, and a wad of cloth.

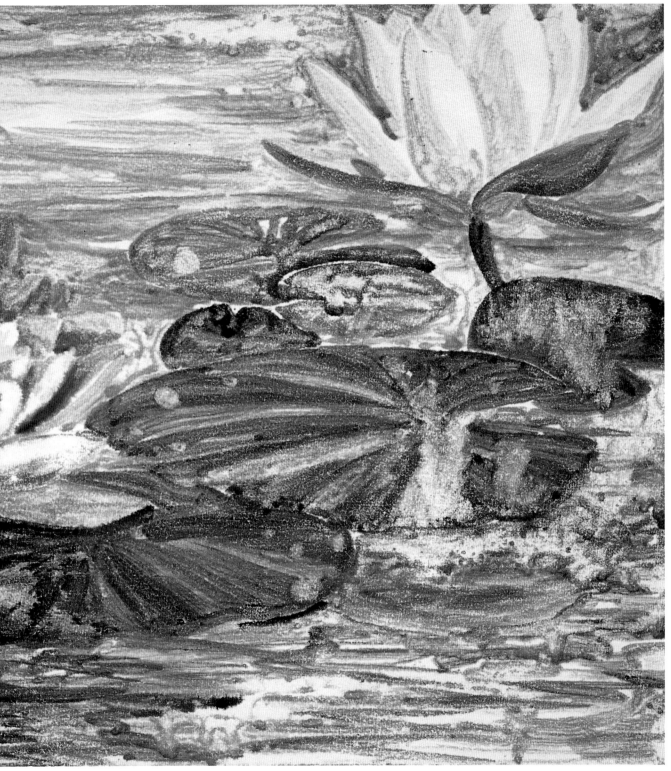

Janet Neal Siamis, *Waterlily,* watercolor monotype, 18 × 26″ (45.7 × 66.0 cm).

This monotype was made on a Mylar plate coated with a common dishwashing detergent that was allowed to dry. The image was developed with watercolors and allowed to dry before being hand transferred to Arches hot-pressed watercolor paper.

Pouring Technique

California artist Dorothy Hoyal has successfully developed watercolor monotypes using a pouring technique. She first coats a Mylar plate with a thin layer of diluted dishwashing detergent. This is allowed to dry. Then, in disposable cups, she thins watercolor paints with water. She pours her pigments on the plate in a random fashion. As images begin to suggest themselves, she manipulates the "pours" by lifting the plate and moving the wet paint with brushes.

The detergent coating also adds a spotty texture as the paints begin to dry. Hoyal continues to develop the plate work by both removing and adding paints even after the initial work has dried. When the image is completed, she transfers it by press to dampened Arches 88 paper.

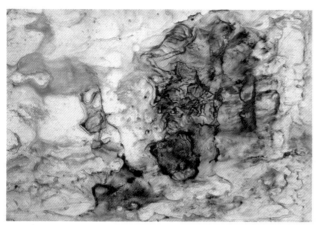

Dorothy Hoyal poured watercolors on a frosted Mylar plate and allowed them to dry.

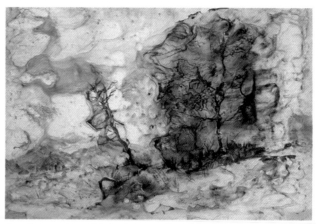

Details were then added using a small round brush.

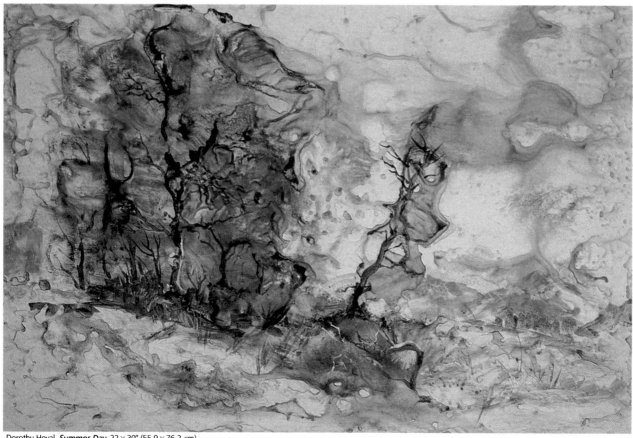

Dorothy Hoyal, *Summer Day,* 22 × 30" (55.9 × 76.2 cm).

More Texturing Techniques

There are a variety of materials that you can use to create diverse textures. Crumpled facial tissues and sponges, for example, make ideal stamps for impressing their textures onto your plate. Using a toothbrush, you can splatter water or paint onto the plate. With a palette knife, you can scrape paint and produce expressive linear textures. And for an abstract effect, you can use a dry brayer to press crumpled plastic wrap onto specific areas of your wet plate.

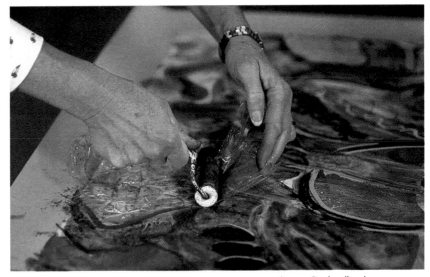

Joanna Duck rolls a brayer over plastic wrap, which has been placed over a specific area of the wet watercolor.

Detail of the transfer showing the plastic-wrap texture.

Joanna Duck, *Fish Frolic*, watercolor monotype, 22 × 30" (55.9 × 76.2 cm).

For this experimental watercolor, Duck used numerous texturing techniques as well as water-soluble crayons to develop the image before printing it.

Other Water-Based Mediums

A number of mediums other than watercolor are either soluble or compatible with water. One desirable feature of working with these paints is that they don't require the use of hazardous chemical solvents.

Perhaps the most popular medium in this category is acrylic paints, available in tubes or jars.

When using acrylics, you can obtain opaque and transparent colors. In fact, you will be able to manipulate non-diluted acrylics much like oils. You can use diverse brushstrokes and draw in linear textures with a palette knife. On the other hand, you can also dilute acrylics to a watercolor consistency and use the same techniques used for watercolors—splattering, developing washes, and so on. You can transfer acrylics while they are still wet or after they have dried.

Transferring with Wet Paint

Acrylics generally dry quickly, depending on how much moisture is in the air. You have to be able to judge the length of time the paint will remain moist on the plate so that it will transfer properly when you're ready to print. In especially dry air situations, you can use a vaporizer to increase the ambient humidity.

You can also lengthen the working time with drying retarders. Most manufacturers produce their own retarder. You can easily spread a thin layer of retarder on your plate by first pouring a small stream of it across the plate. (A squeeze-top dispensing bottle is especially convenient for this purpose.) Then use a water-moistened brush or paper towel to evenly spread the retarder and coat the plate. While the retarder is still moist, you can apply the

paint. It is important to keep checking the painted areas for signs of drying.

You can also add a retarder to your paint in a sparing manner. However, you should never use more retarder than one-third the paint volume. You can premix the retarder and paint on your palette or add in retarder to each brush load of paint you use.

Moist paper will help you make a successful transfer. (Waterleaf papers should be misted, while sized papers should be soaked and blotted.) If more than one transfer step is to be made, your paper should be kept moist under a piece of plastic while the plate is being worked. A light misting of the plate and paper as you are working will also retard the drying time. This is a technique that gets perfected with experience as too much moisture will make the color run.

Dewayne Pass tapes a sheet of frosted Mylar on top of his drawing. A sheet of Arches 88 paper the same size as the drawing is hinged with masking tape to the edge of the Mylar plate so that the paper can be brought over the plate for multiple hand transfers. Each transfer will be made with wet acrylics.

His image is composed of rich colors and bold brushwork. This is the ghost remaining on the plate when the monotype is completed. It is evidence of the many rich layers of paint Pass used to develop his image. The dried ghost image could be transferred to paper moistened with isopropyl alcohol.

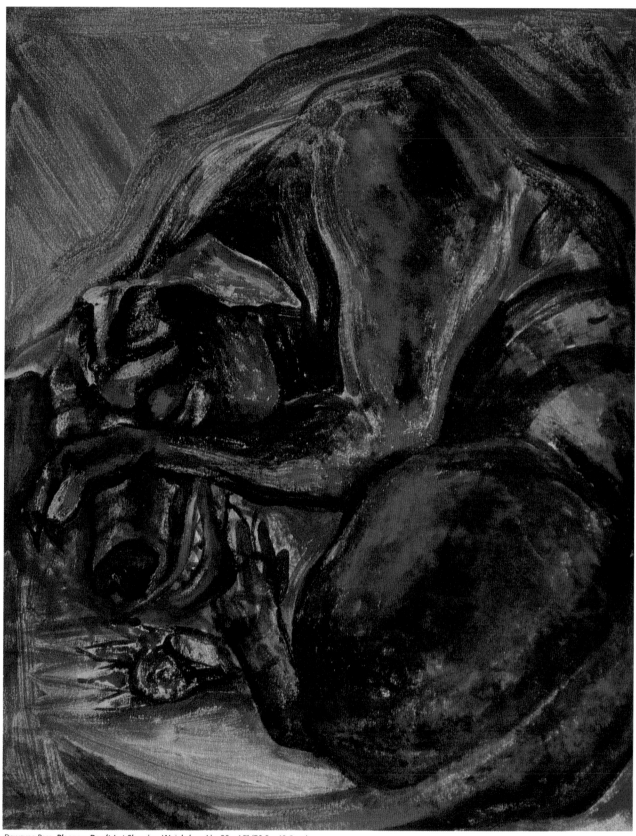

Dewayne Pass, *Pleeze—Don't Let Sleeping Watchdogs Lie,* 20 × 16" (50.8 × 40.6 cm).

Transferring Dry Paint to Moist Paper

You can let acrylic paint dry on the plate and still transfer it to paper if you first mist the paper with 99 percent pure isopropyl alcohol. This strength is available from chemical supply houses; the isopropyl alcohol commonly sold in drugstores is a weaker solution that will also work, but not as effectively. (Keep in mind that too much alcohol may result in a blurred image, while too little alcohol will not dissolve the dried acrylic for transfer.) When using water-leaf papers, misting with the alcohol will be sufficient. For papers that require soaking in water first, the misting is done after the water has been blotted from the blank paper's surface. It is important to work quickly once the misting has been done.

Warning: When using isopropyl alcohol, be sure your working area has proper ventilation. The vapors should be evacuated immediately to avoid excess inhalation. Alcohol is highly flammable. Most alcohol fires can be put out by dousing with water.

Julia Ayres, *Four Pelicans,* acrylic monotype, 12 × 9″ (30.5 × 22.9 cm).

This transfer was made from a plate with dry acrylic paint and hand transferred to Magnani Incisioni paper, which was misted with isopropyl alcohol.

Nancy Swindler, *Triplets,* 9 × 12″ (22.9 × 30.5 cm).

Swindler waits for the acrylic paint to dry on her plate before transferring it to Arches 88 paper, which is misted with isopropyl alcohol. The advantage of this type of transfer is that she is able to take her time developing the image.

Water-Soluble Crayons, Pastels, and Pencils

Caran D'Ache water-soluble crayons, made in Switzerland, are popular as a monotype medium. Caran D'Ache uses nontoxic pigments recommended by the American Society for Testing and Materials. They rate very well for light-fastness. You can use them wet or dry to draw directly on the plate, and in combination with another medium such as watercolor. With crayons, you can develop grainy textures and a variety of line strokes. You must always transfer water-soluble crayons to moist paper. After the transfer, you can use them on top of your paper to develop or enhance your monotype.

There are other similar products that you can use for monotypes. For instance, if you want finer, more detailed lines, you can also use water-soluble color pencils. Once again, you can combine different mediums to achieve a variety of textures for your monotype.

The Holbein Company has recently put water-soluble pastels on the market. The water-soluble pastels transfer readily to damp paper. You may want to experiment with different textures with this unique medium. You will find that linear drawing techniques as well as certain forms of blending work well. Crosshatching can be used to develop color areas on your plate. You can also use tube watercolors with the pastels.

I drew this fawn, temporarily left by its mother by my door, with Caran D'Ache crayons on a frosted Mylar sheet.

I transferred the image to a sheet of water-misted Magnani Incisioni paper.

Southern California artist Gloria Jacobson dissolves water-soluble Caran D'Ache crayon shavings in water in disposable plastic cups to develop a pastel-like medium that she can use as is or thinned with water as needed. Then she uses the pigments in both direct and subtractive techniques.

When using water-soluble crayons, Jacobson lightly sands her plate to eliminate its slick surface. She prefers using a transparent plate so that she can place a sketch under it to guide her while she paints. Sometimes she incorporates tube watercolors in her image. Jacobson also uses the crayons in their unaltered form for linear work.

Usually, she allows her work to dry on the plate before transferring it to Rives BFK or Arches print paper, which she soaks for at least an hour. Jacobson uses large blotters and newsprint paper to blot the paper. The newsprint is also placed on top of the plate and paper before it is covered with the blankets on her press. Before she pulls the paper from the plate, Jacobson slowly lifts a corner to make sure the transfer is complete and does not need more pressure or runs through the press.

Because Caran D'Ache pigments are very intense, Jacobson is often able to make a print from the ghost plate with little additional work. After the transfers, the damp monotype is placed between sheets of newsprint and blotters and weighted down under a heavy board. The newsprint is changed two or three times during the drying process.

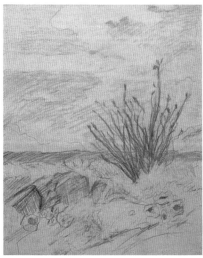

Gloria Jacobson placed a slightly sanded Plexiglas plate over her sketch.

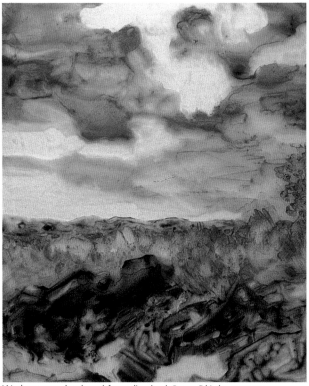

Washes were developed from dissolved Caran D'Ache crayons.

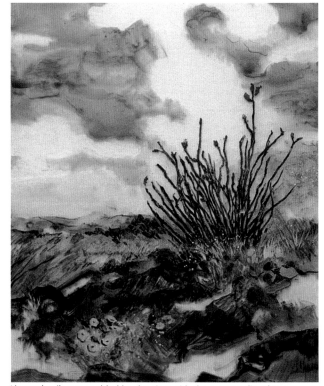

Linear details were added by drawing with the crayons directly on the plate.

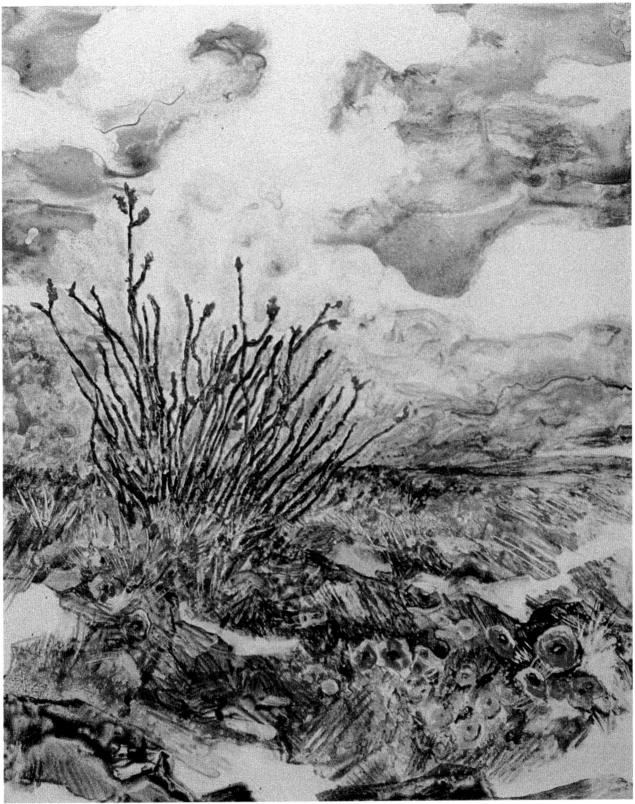

Gloria Jacobson, *Ocotillo 1,* 14¾ × 18″ (37.5 × 45.7 cm).

Monoprint Paints

The Colorcraft Company distributes a line of water-based paints called Createx Colors, more commonly known as monoprint paints. Advertised to be lightfast, they can be purchased in premixed colors or with liquid pigments to be mixed in their monoprint base, which is a white liquid that dries clear. Both the premixed colors and the ones to be mixed can be thinned with the monoprint base. They do not transfer well when thinned with water.

You will find that these monoprint paints offer more vibrant colors than you see in watercolors. The liquid pigments are purchased in small bottles and then added by the drop into the monoprint base. You can make transfers while the paints are still wet, or let them dry on your plate and transfer them later to damp paper.

You can easily mix the premixed colors by squeezing the colors on a butcher tray and adding them to separate mixtures as they are needed. This way the pigments stay clean. I was able to make multiple hand transfers of wet paint to dry paper as well as completing the entire work and letting it dry before transferring it to moist paper.

You can get a more complete transfer by first coating the plate with the Colorcraft monoprint base. After the coat is dry, the premixed colors can be directly painted or rolled on the dry base.

Toby Willner, *May Wonders Never Cease,* 18 × 24" (45.7 × 61 cm), 1990.

Willner produced this monotype by rolling Colorcraft monoprint paints on the plate and then developing the image with watercolors using a moist brush. The circular window in the center is actually the ghost from a previous transfer.

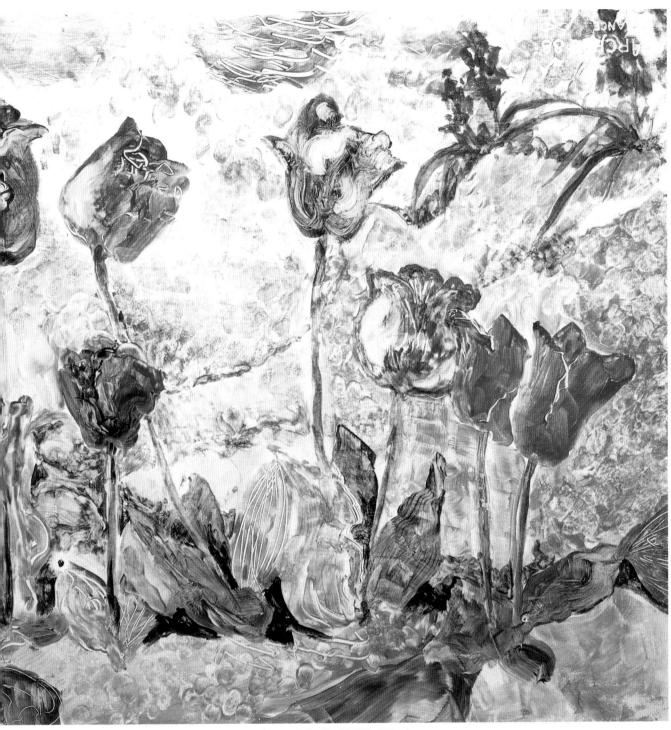

Julia Ayres, *Tulips*, 22 × 30″ (55.9 × 76.2 cm).

This monotype was developed with Colorcraft monoprint paints on a frosted Mylar sheet. For the background texture, I used my finger to produce fingerprints. I allowed the painting to dry before hand transferring it to moist Arches 88 paper.

Oil Paints

If you have painted with oils on canvas, you will feel comfortable with using them for developing a monotype. You will find that most techniques can be used on the plate. For instance, you will be able to use brushes and palette knives to lay down colors in varying textures—from expressive brushstrokes to detailed linear work. Scraping away and drawing lines into the paint can be done with your palette knife. When you add solvents, such as turpentine or mineral spirits, you can splatter paint and blend colors to create blooming effects as you would in watercolors. Unlike watercolors, oils are a thicker medium so your brushstrokes will transfer well. This factor should be a major consideration when you select oils for developing a monotype.

Since oils take longer to dry than most mediums, you will have more time to work on your monotype. But if you wish to speed up the drying time, you can thin oils with turpentine or mineral spirits. Oils can be transferred either by hand or by press.

How about oil paints on paper? There has been a great deal of anxiety regarding the archival stability of transferring oil paints to paper. After questioning, reading, and using common sense, I believe it is a matter of the quality of paper used as well as the consistency of the paints and how they are applied. (You should use archival papers in the pH neutral category.)

It is also important that the oil vehicle in the paints dry before the colors spread and "bloom" outside the intended brushstroke, leaving oil stains. If blooms of oil appear outside a brushstroke on the paper, it is usually because too much oil was added during mixing on the palette or the paint did not dry fast enough. It is for this reason that many artists use turpentine and mineral spirits to thin their oils for monotype work.

Stand and burnt plate oils are printmaking mediums used to extend oil-based inks and paints. They are raw linseed oils that have been heated to change their molecular structure, eliminating the acidity. These polymerized oils act as a coat that will protect the paper fibers once they have dried. On the other hand, nonheated raw linseed oils have a slight acid condition, creating a detrimental effect on untreated fibers. Therefore, the oil mediums you would use to paint on a protected canvas are not as suitable for making monotypes as the oil mediums made specifically for printmaking.

Hand Transfers

M. Stephen Doherty, the editor-in-chief of *American Artist* magazine, translated an afternoon of sketching to monotypes painted in oil colors on a Plexiglas plate, which he later hand transferred. His initial drawings were made at the Century Club, "an association of men and women of arts and letters" that occupies a Stanford White–designed building in New York City.

Doherty has used some of the club's wonderful painting collection as subject matter for his drawings and monotype work. He has also been inspired by some of the building's outstanding architectural features. He particularly admires the staircase, which he considers "a dramatic piece of architecture," and made a pen-and-ink sketch of it. Because he wanted his final monotypes to read the same as his original sketches, Doherty made reverse line drawings of the original sketches.

A reverse drawing was used as a guideline and placed under the Plexiglas plate. Doherty used oil paints from tubes diluted with turpentine to develop the image on his plate, then transferred it by hand to absorbent Oriental paper. Since oils take a while to dry, most hand transfers are done while the paint is still wet. With a hand transfer, Doherty was able to apply different pressures to various areas of his plate to achieve contrasting effects.

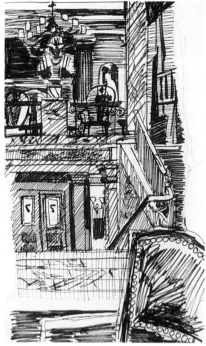

This pen-and-ink drawing was rendered by Doherty at the Century Club in New York City.

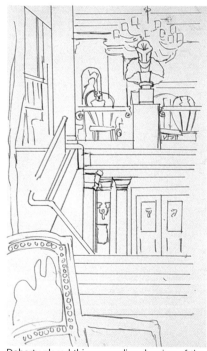

Doherty placed this reverse line drawing of the sketch under his transparent plate to act as a guideline for the oil paint work to be done on top.

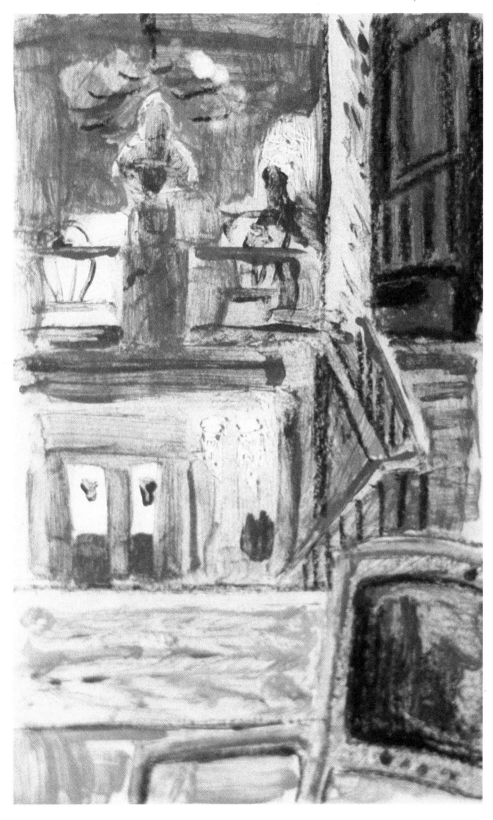

M. Stephen Doherty, *The Century,* oil monotype, 8½ × 5" (21.5 × 12.7 cm), 1986.

With a hand transfer, Doherty was able to apply varying pressures in different areas, thereby producing diverse textures. He also added oil pastel to the monotype after the transfer was made.

Press Transfers

The monotypes by Joseph Raffael shown here were done at the Experimental Workshop in San Francisco. They show Raffael's ability to manipulate oils to suit various techniques. By thinning oils with turpentine, Raffael is able to create a number of different effects and textures. For instance, with numerous brushstrokes, he makes textural contrasts—short, curvilinear strokes surrounded by expressive long lines. Sometimes, he uses a staining technique to blend fluid oil colors.

Both monotypes were developed on aluminum plates and printed on Rives BFK paper on a Takach-Garfield etching press. Using a press, Raffael was able to translate the complexity of his brushwork, which might have been lost with a hand transfer. Because the press can really push the paints into the tooth of the paper, the color contrasts are even and precise.

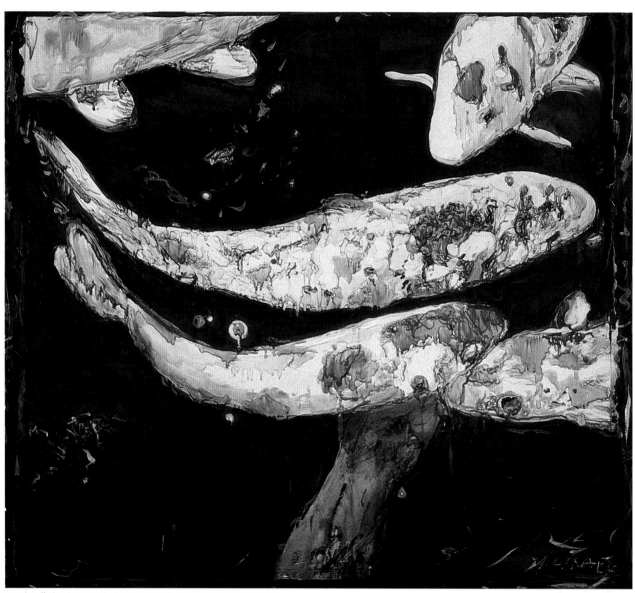

Joseph Raffael, *Winter Pond,* oil monotype, 42½ × 48″ (108 × 121.9 cm), 1985.

In this monotype, you can see a sharp contrast between the liquid, watercolorlike manner in which the fish were painted and the solid, dark handling of the background. Here is how the monotype was developed: First the background was inked with dark oil-based printing inks. Then ink was lifted to create the shapes of the fish. Finally the fish were painted with oil paints thinned with turpentine. (Courtesy of Experimental Workshop, San Francisco, and Nancy Hoffman Gallery, New York City.)

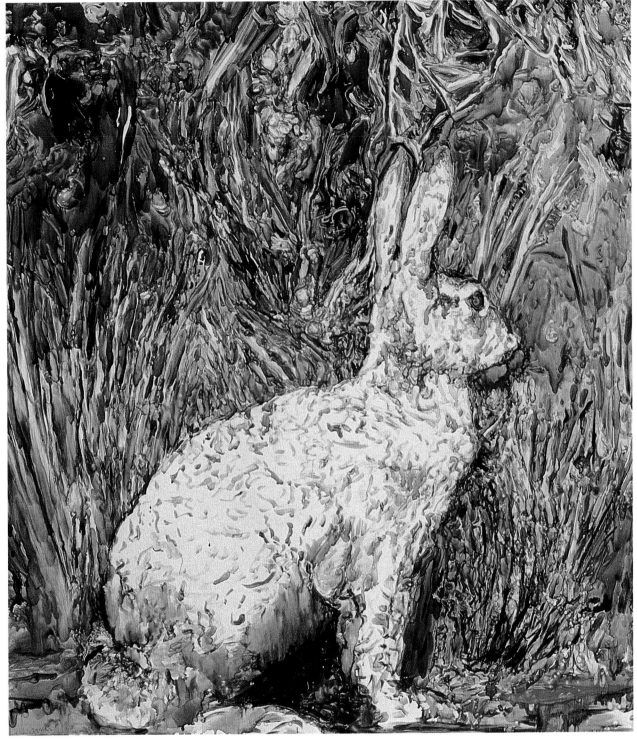

Joseph Raffael, *Rabbit,* oil monotype, 48 × 42½″ (121.9 × 108 cm), 1986.

This monotype was transferred with one pass through an etching press. By using a press, Raffael was able to pick up all the intricate brushwork as well as the rich, vivid oil colors of his composition. (Courtesy of Experimental Workshop, San Francisco, and Nancy Hoffman Gallery, New York City.)

Carolyn Brady also works in collaboration with a printmaker. She uses Winsor & Newton oils, usually thinned with turpentine, and sometimes she adds stand oil to extend the drying time. Recently, she has experimented with Oriental papers.

Brady's floral monotype is a fine example of the painterly qualities that can be achieved with oils. There is an interesting play between the strong, vivid brushstrokes and the soft, less textured areas.

Once again, with an even press transfer, Brady was able to pick up the intricacies of the detailed brushwork and the subtleties of the smoother textures.

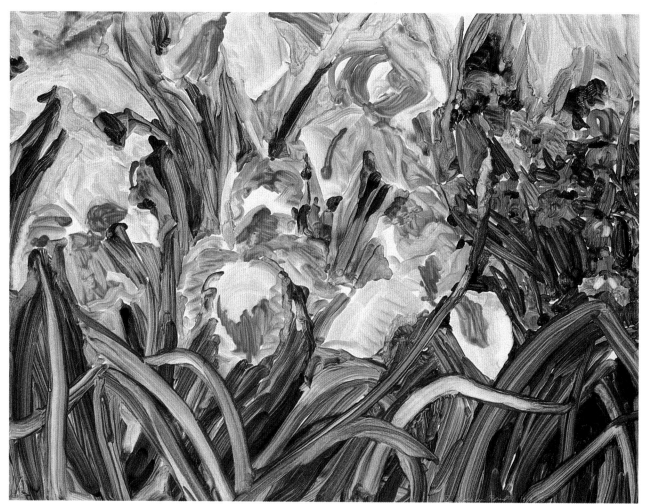

Carolyn Brady, *Pyramid IX,* oil monotype, 30 × 40″ (76.2 × 101.6 cm), 1986. Printed by Maurice Payne in Baltimore, Md., at Pyramid Press.

Brady prefers fresh, spontaneous images. Notice how her loose brushwork suggests form and details. The plate was transferred with one pass through the press. (Courtesy of Nancy Hoffman Gallery, New York City.)

Experimenting with Solvents

When Shirley Ward met with me to experiment with making hand-rubbed oil monotypes, she worked on a 9 × 12″ (22.9 × 30.5 cm) zinc plate. As the plate was beginning to dry, Ward lightly spritzed it with turpentine and immediately placed a sheet of highly absorbent Arches 88 paper on top of it. The paint transferred in droplets, giving a unique pointillism effect. Due to the nature of the paper, even the white un-inked areas received the same raised droplet texture.

Solvents, such as turpentine and mineral spirits, dropped into oil paints on your plate will also give you varied texture patterns, according to the thickness of the paint and how much solvent is used. You can mist, splatter, or brush a solvent into oils on a plate.

Detail of *Sunday Afternoon*, showing the textural effects of turpentine misted on waterleaf paper.

Shirley Ward, **Sunday Afternoon**, oil monotype, 9 × 12″ (22.9 × 30.5 cm).
Ward created pointillistic effects by spritzing turpentine on her plate.

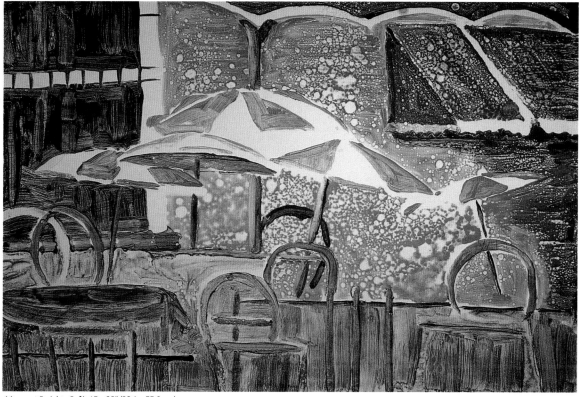

Margaret Enright, **Café**, 15 × 22″ (38.1 × 55.9 cm).

In this monotype, you can see what happens when turpentine or any other solvent is dropped into the image on the plate. The paint will disperse, in this case leaving white-circled patterns on the blue wall.

Alkyds

The same pigments used to make oil paints are added to an alkyd vehicle. Alkyds are considered to be archivally sound. The advantage alkyds have over oils is that they dry faster. All the alkyd colors dry at the same time, so you don't have to wait or worry about varying drying times for transfer.

For making monotypes, you can thin alkyd paints with a solvent, such as turpentine and mineral spirits, or extend them with Winsor & Newton Liquin medium. You work with alkyds the same way as you would with oils.

Water-Miscible Oil Paints

The Mastercolor oil paints produced by Pelikan in West Germany mix with water without a need for solvents or oils. You can use them to make monotypes in both the additive and subtractive techniques. They transfer readily from the plate to paper. While some feel the qualities of traditional oil paints are missing (for example, the consistency is different, the paints cannot be manipulated the same way as oils, and the colors are brighter), they are a good substitute for those of us who have problems working with solvents.

Water-miscible oil paints come in tubes with convenient dispensing tops that are especially helpful for squeezing a controlled line of paint across your plate. You can then roll out the paint with a brayer to cover the surface or use brushes to develop your image.

With water-miscible paints, you can get a ghost image as good as one from an oil transfer. In fact, you can make a traced monotype with the ghost. Just do a drawing the same size as the plate. Then, place a sheet of paper on the ghost plate with your drawing on top of the paper. Use a pencil to trace over the drawing. You will be picking up arbitrary colors and creating a multi-colored line drawing on paper.

Since you thin water-miscible paints with water, you can spritz water on top of the painted plate to created spotted textures. You can also use water-moistened brushes and rags to manipulate and subtract paint. When the work is finished, your plate and tools are easily cleaned with soap and water.

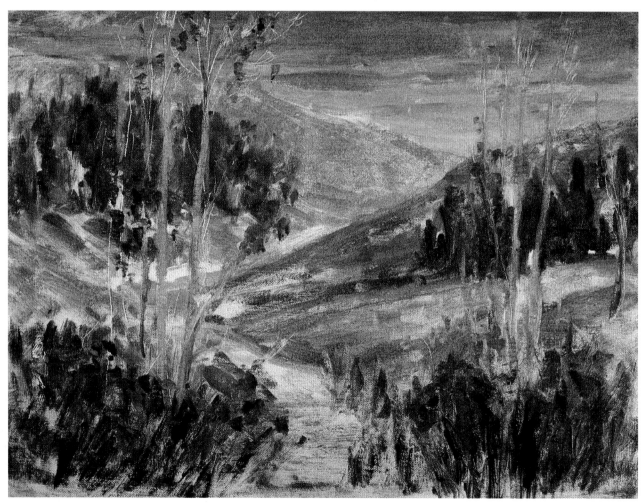

Marilyn Crocker, *Day's End,* alkyd monotype, 12 × 16" (30.5 × 40.6 cm).

This monotype was transferred by press from a painted canvas board. All the painterly qualities of oils can be achieved with alkyds.

Julia Ayres, *Roses,* 22 × 15" (55.9 × 38.1 cm).

Pelikan water-miscible oils were used in this monotype. I used some tracing technique to add calligraphy to the image. You can see that the colors are as rich as regular oils. I placed my Mylar plate on top of a sheet of moist Arches Cover and rubbed the back of the Mylar with a teacher baren.

Oil-Based Printing Inks

For every printing technique—lithography, intaglio, silk screen, block printing, and so on—there are inks manufactured to suit the specific procedures involved. When making a monotype, you can use any of these mediums to suit your purpose.

In this section, I will discuss the most commonly used printing inks for making monotypes—oil-based lithography, intaglio, and serigraphy inks. Since printing inks are designed specifically to be used on a plate and printed on paper, you will find them easy to manipulate. You can incorporate some

of their unique characteristics into your work. Lithography inks are made to roll thinly on a plate and maintain their color saturation; intaglio inks are stiffer but can be thinned easily and applied to a metal plate that has been heated to produce unique blends of color. Serigraphy inks have a heavy consistency that makes it possible for you to create marbleized effects.

Using Lithography Inks

Martin Green is not only a monotype master; he is also experienced in other printmaking techniques, such as inta-

glio, lithography, and cliché-verre—a photographic printing process made on glass. Green uses Sinclair and Valentine lithography inks to make his monotypes. Through the years, his monotype images have become quite large. Today, it is not unusual for him to create monotype panels that cover an entire wall.

Usually, Green extends his inks with stand oil, most often building his images in thin layers through multiple runs with the press. Sometimes he manipulates press pressures to accomplish the effects he desires, such as crisp

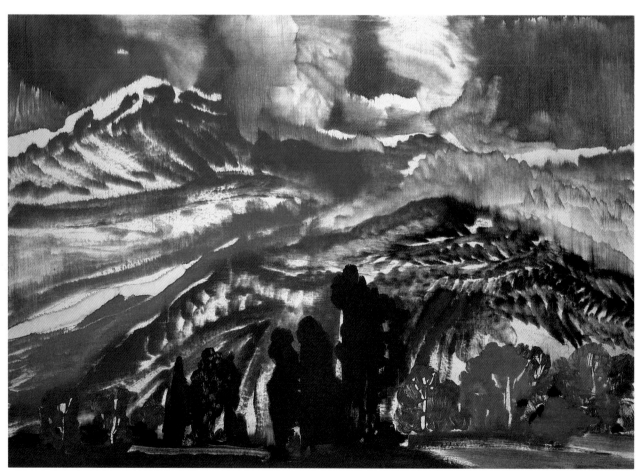

Martin Green, *Stormy Landscape,* 34 × 48″ (86.4 × 121.9 cm).

Using lithography inks thinned with solvents, Green developed this monotype with layers of soft colors and edges that blend harmoniously. It usually takes several runs through the press to produce this type of layered color effect. (Courtesy of Louis Newman Galleries, Beverly Hills, Calif.)

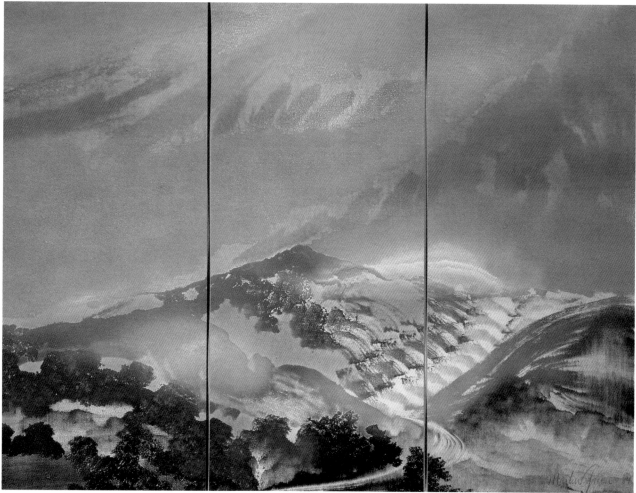

Martin Green, *Light on the Land,* 30 × 40″ (76.2 × 101.6 cm).

In this triptych monotype, you can see the thin layers of soft edges and colors that Green creates using lithography inks thinned with solvents.

hard edges against soft, blurred color fields. For instance, the first run through the press may be light pressured. Stencils are then placed on the plate to mask desired light areas before a second run with a heavier pressure is applied to produce a consequent darker printing.

To Green, the purest form of monotype is when the image is developed by removing it from an inked field. He does this by manipulating a 4-inch-wide piece of mat board on the plate to move and subtract color, creating irregular textures.

Green paints directly on the plate. Sometimes he uses stencils to block the ink on the plate from printing on the paper. The stencils are also used when he is applying ink with his airbrush. For airbrush work, Green thins his litho inks with mineral spirits. He keeps the mixture well mixed while working. The airbrush is used both on the plate and on top of the transferred monotype.

In his well-organized workshop, there is ample room to accommodate his large images. He premixes his paints on a large palette. When he is

through working, the mixed inks are scraped from the glass and stored in plastic-covered butter dishes. A ventilation system covers his work space to evacuate the toxic fumes from solvents.

The artist works on a Laguna etching press that has a 42 × 84″ (106.7 × 213.4 cm) bed. His plates are cut from 48 × 96″ (121.9 × 243.8 cm) panels of white plastic-coated Masonite, which he purchases from the lumberyard. Since he doesn't require plate marks, the plates are the same size or larger than his paper—Rives BFK, which he buys in wide rolls.

Using Etching Inks

Dianne Haralson is experienced in making multiplate color etchings as well as monotypes. She uses Graphic Chemical intaglio inks mixed with small amounts of Easy Wipe Compound, which makes the inks easier to control. If the etching inks were used unaltered, they would be too stiff for inking and painting on top of the plate.

For this demonstration, Haralson works with two copper plates of the same size to make her monotypes. One plate has an aquatinted surface, which has a grainy texture produced in an etching process. (Haralson often reuses plates from her etchings to make monotypes.) The second plate is the smooth enameled back side of a used etching plate. She prefers copper because it is an even heat conductor, beneficial to her way of working.

First she heats the aquatinted plate for a short time on top of an electric hot plate, which has a metal disk stove-burner cover. By heating the plate, she will be able to move the ink more smoothly on it. When the plate is warm, she places it on her work surface. Her glass palette with the mixed inks is ready—there are cloth daubers for each hue. The daubers were made by tying a wad of cotton in the center of a cloth circle or square; the ends of the material were then made into handles. Haralson uses the term *la poupée*—French for "little doll," which the daubers resemble—to describe her way of inking the plate.

She inks the plate with various colors in a random fashion. When finished, the warm plate is placed paint side down on newsprint. Slowly Haralson pushes the plate to smooth the ink and takes advantage of the various viscosities of the colors. Sometimes the paint will move on top or underneath another color. This movement across the paper produces newly blended colors on the plate. The edges of the plate are then wiped and the plate set aside.

Next she warms the second plate for a short time and an image is brushed on using the same palette. This time she uses darker colors and oil painting brushes. When the work is completed, the edges of the plate are cleaned. This, too, is set aside while Haralson prepares the press and paper.

She dips Rives BFK paper in a pan of water several times until it is well soaked. Then she places it between blotters to remove the excess water. The press is set with the blankets pulled back. A template the same size as the paper is taped on the press bed. The plates will fit exactly in the centered opening cut into the template.

Haralson places the first plate in the template, aligns the paper on top, pulls the blankets over the work, and begins the transfer by turning the large star wheel of her Sturgess etching press, which has a $18 \times 48''$ (45.7×121.9 cm) bed. The edges of the paper and template are kept engaged under the roller as Haralson replaces the first plate with the second plate containing the painted image. Haralson lowers the paper and blankets over the plate and makes a second transfer. Then she tapes the moist monotype to a board with white-gummed paper so that it will dry flat.

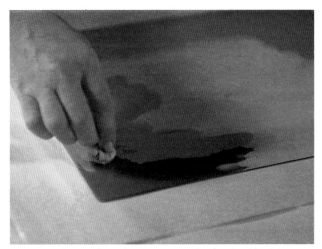

Dianne Haralson prefers using two copper plates and etching inks to make her monotypes. Here she is using a dauber to apply color to her first plate.

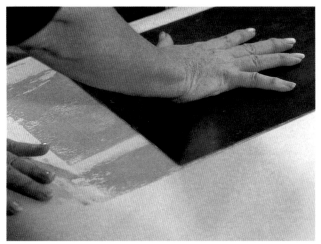

The first plate is then placed face down on newsprint paper. Haralson pushes the plate down, forcing the inks to move and merge together.

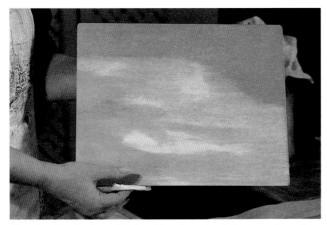

After the plate has been lifted and its edges wiped, the image is ready to be transferred to paper. The pattern of the inks suggests to Haralson an image that she will paint on the second plate.

The first plate is printed and the paper and blankets are held engaged in the press. The second plate is placed in the template on the press bed and readied for the next transfer, which will complete the monotype.

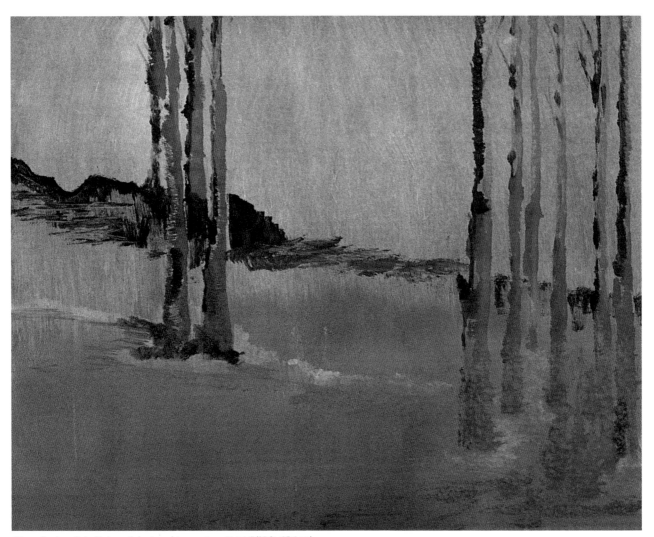

Dianne Haralson, *Rain-Birdsong Lake,* two-plate monotype, 11 × 14" (27.9 × 35.6 cm).

Mixing Oil-Based Printing Inks

Katherine Liu, well known for her wonderful watercolors, is also an established monotype artist. To develop her metal plates, she freely uses both oil-based lithography and etching inks as well as oil paints and crayons. She uses large brushes to apply the colors onto the plate, and adds more detailed notes with smaller brushes. Her abstractions are a combination of various techniques; for instance, solvents and inks are splattered onto the plate to achieve random textures. Using the subtractive technique, she lifts the medium from the plate with a brush. She uses oil crayons not for their color but to subtract or draw lines into the ink, which become white lines in the final print. Her transfers are made from a wet plate to dry paper, and she prefers not to use the ghost that remains.

By combining techniques and mediums, Liu creates abstractions that exemplify the monotype process. By mixing printing inks with oils, for example, she is able to produce a larger color selection.

Liu avoids adding slow-drying oils to the mixtures. She thins her inks with solvents such as turpentine or mineral spirits, burnt plate oils, or Graphic Chemical's Easy Wipe Compound.

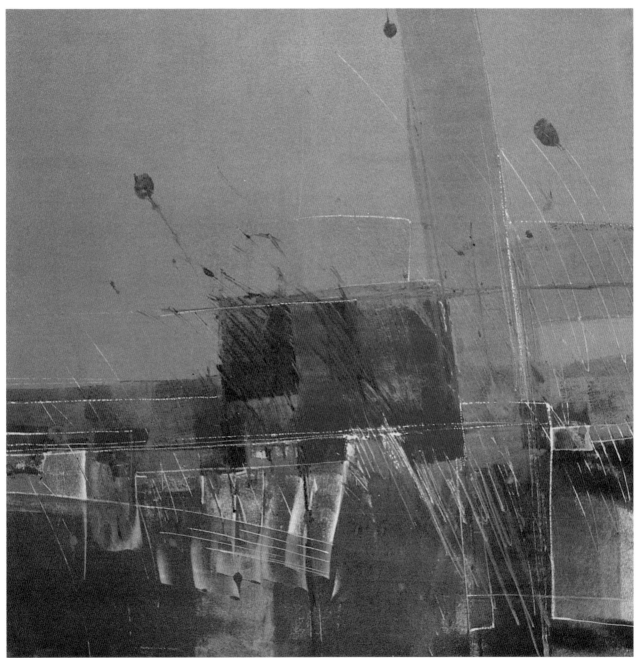

Katherine Liu, *Street Music #5,* 17 × 17" (43.2 × 43.2 cm), 1989.

The white lines in the monotype were created using oil crayons to push the inks and paints on the plate. (Courtesy of Louis Newman Galleries, Beverly Hills, Calif.)

Using Serigraphy Inks

Nancy Bowen began experimenting in monotype with Naz Dar 5500 series oil-based serigraphy inks, which she had been using for screen printing. She was drawn to the marbleized and iridescent effects she achieved with the inks when pulling more than one print from the same plate. Each print had a slightly different marbleized pattern. Bowen believes the heavy, molasseslike viscous quality of the serigraphy inks helps to produce the marbleized textures. The inks sit in a puddle on the plate until she manipulates them with a brush or applies pressure by hand to push them together.

Before she starts working, Bowen makes sure there is an ample supply of premixed colors. The mixture is composed of the oil-based serigraphy inks with an extender of paint thinner and pine oil. She makes her mixtures in glass mason jars and then decants them into squeeze-top dispensing bottles.

Bowen works on a Plexiglas plate usually slightly smaller than the paper she will use. The edges of the plate are beveled. She also has a spray bottle of paint thinner on hand. Bowen squeezes the colors onto her glass palette, where she mixes the needed hues. The work is developed in the direct painting method with brushes. Periodically, she sprays a light mist of thinner on the plate to level the ink as well as extend the drying time.

When the work is completed, Bowen wipes the plate edges clean. She transfers the completed plate work to smooth absorbent Arches 88 paper. She prefers transferring her monotypes by hand. The nature of the inks allows a second and sometimes even a third transfer.

Nancy Bowen spontaneously applies rich-colored serigraphy inks to her plate.

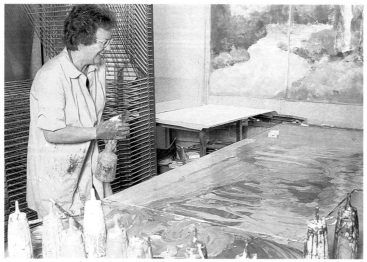

At various intervals, Nancy Bowen sprays solvent retarder to even the strokes.

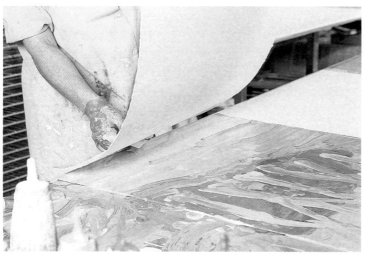

Since she is making a diptych, she places paper over the first plate and then another sheet over the second plate.

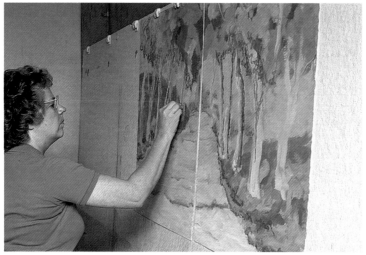

After the work is printed by hand, Bowen tacks the monotypes to the wall for further light development with pastel on top.

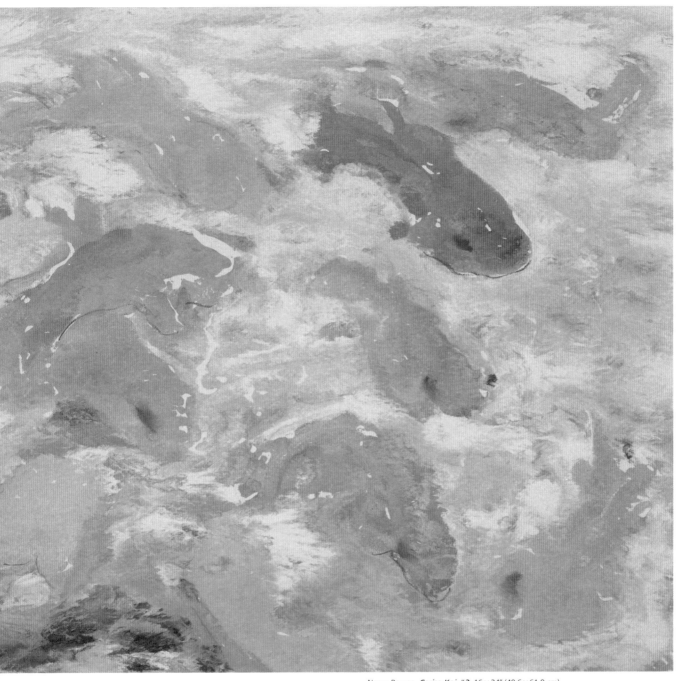

Nancy Bowen, *Cerise Koi #2*, 16 × 24″ (40.6 × 61.0 cm).

This is a fine example of the iridescent and marbling effects that Bowen achieves by using serigraphy inks. (Courtesy of South Coast Fine Art Editions Limited.)

Chapter 5

Special Techniques

There are a number of techniques that you can use to enhance your monotypes. Masks, used widely in watercolor painting, can be applied before or during transfer to block out ink from specific areas of your monotype. Stencils can be used to paint in special designs on your plate. A technique that is popular in other printmaking processes is embossment. It is a relief process that enables you to transfer three-dimensional effects onto damp paper. You can also collage thin papers onto your monotype paper before or after transfer to create a composition of overlapping materials, shapes, and colors.

These techniques impart unique elements that can enrich the development of your work, creating stronger contrasts in texture, color, and form.

Howard Hersh, detail, *Is, Was, Will* (page 109).

Masks and Stencils

Masks, or blockouts as they are sometimes called, are materials used to block the ink from reaching specific areas of the paper during transfer. There are various organic and man-made masking materials available—frisket film, masking tape, masking fluid, leaves—or you can cut out the shapes you want to block out from heavy paper or thin cardboard. (Most masking materials can only be used once.)

Stencils are patterns cut from durable, reusable materials—thin metals, plastics, or cardboard—that are placed over the image area and ink or paint applied through them; only the exposed sections of the design receive pigment. You can either cut out a positive shape, ink it separately, and then place it on an inked plate for transfer, or you can use the negative image and paint the shape in on the plate.

Using Masks Before Inking a Plate

To save areas where you want the color of the paper to show, you can cut out a mask from thin cardboard or Mylar in the shape you need, and tape it to the plate. (Make sure you adhere tape on the back of the mask.) Then you can proceed to develop the monotype. When you are finished painting or inking your plate, remove the mask. You now have a clean design on the plate surface that is ready for transfer.

There is a low-tack frisket film available for airbrush work that you can cut to any desired shape and attach to the plate. Then you can proceed with developing the plate work. After the masking material is removed from the plate, the clean surface of the plate can be left as is or developed.

When working with watercolors or water-soluble inks, you can use masking fluids to brush in areas of the clean plate that are to remain white (or the color of the paper). The material is removed from the plate after the paint has dried. You can protect your brushes from damage when using these materials by lathering the hairs with mild soap before and after using the masking fluid. After the plate is dry, you can peel away the hardened masking material with a plastic pickup square, available in stationery stores.

A shape cut from a thin Mylar sheet is attached to a copper plate with masking tape.

After the plate, Mylar shape, and masking tape were inked, the masking materials were removed, leaving a clean plate area. The plate is now ready for further development.

Using Organic Objects as Masks

Leaves, flowers, and other natural materials lend their special patterns and textures to monotype work. You should press leaves and flowers before using them on the plate so that they lie flat. When using a press, it is wise to place a plastic sheet on top of your paper to keep organic materials from staining the press blanket.

Howard Hersh arrived at the Graphic Workshop with a collection of plant materials, an assortment of fine Japanese papers to transfer his work to, and four 5 × 26″ (12.7 × 66.0 cm) Plex-iglas plates. He arranges foliage on the plates, rolls ink over them with a brayer, and prints the plates in sets of four. Then he rearranges the leaves and ferns, developing layers of rich-colored, organic shapes. He makes multiple press transfers that take advantage of the ghost ink from the previous transfer. Frequently, he checks the work in progress by examining the reverse side of the transparent plates to see how they will print.

Solvents are also dropped in the ink to create additional textures such as splatters and blurred edges. The used plant materials carry residual inks that will transfer on the plate, adding further variety. At times, the brayer is rolled past the plant material, so that the offset pattern that develops on the roller can also be printed later.

After several days of working, Hersh has a large selection of transfers to work with. Though the panels were developed in sets of four related images, he feels free to change the arrangements to produce new compositions. Some of the sets are collaged on support paper, while others are used for his encaustic paintings.

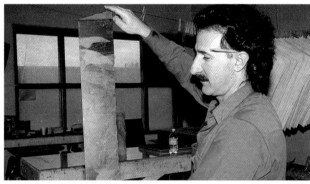

Howard Hersh checks the reverse side of his Plexiglas plate to see how his plant-form patterns are developing.

Hersh prints his panels in sets of four. You can see overlapped plant materials, which were repositioned during each transfer.

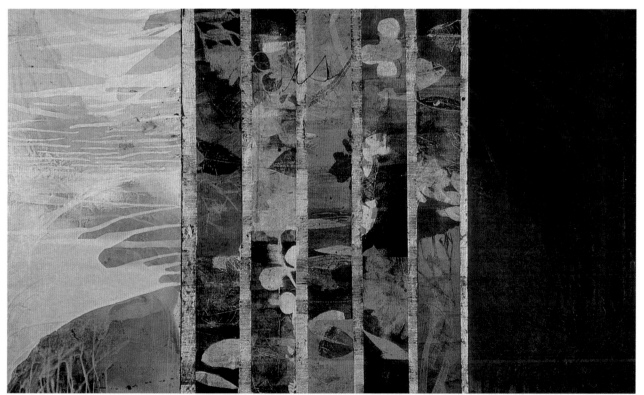

Howard Hersh, *Is, Was, Will,* encaustic painting with collage, 40 × 60″ (101.6 × 152.4 cm), 1990.

For this painting, Hersh collages a monotype on paper with paint on canvas.

Masks Between Plate and Paper

You can place thin materials, such as cut or torn fabrics, Mylar, or paper, on specific areas of an inked or painted plate to block out the transfer of paint to paper. After your mask is positioned on the plate (it should adhere to the plate via the medium), you can place the paper on top for transfer. The mask elements will block the ink from transferring to the paper.

For partial masks of an inked surface, you can use thin tissue paper shapes. The pressure of the press will force a small amount of ink to pass through the tissue fibers to the paper. The tissue will often adhere to the paper, but you can peel it away while the paper is still moist.

You can also place Japanese lace paper on an inked surface for transfer. The lace paper acts as a patterned mask that will transfer its image onto paper. After the transfer, the lace paper will be inked on one side. You can use this inked lace surface for another transfer by placing the inked side up on a plate for a subsequent transfer.

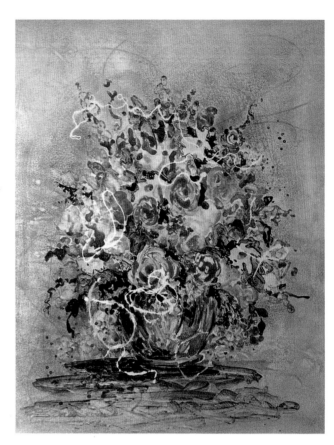

Susan Milliken, *Roses in a Vase,* watercolor monotype, 30 × 22″ (76.2 × 55.9 cm).

This monotype was developed on a frosted acetate plate. Milliken applied the background color with an airbrush. Then she arranged embroidery floss on her plate to create the lively white calligraphy—the floss blocked color from reaching the paper during the transfer.

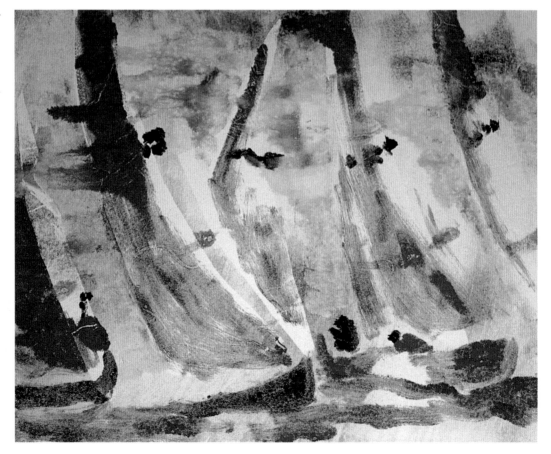

Joanna Duck, *White Sails,* 8 × 10″ (20.3 × 25.4 cm).

Duck used tissue paper to block out the sails for her boat shapes in this monotype. Because the tissue was thin, it allowed some faint color to bleed through to the support paper.

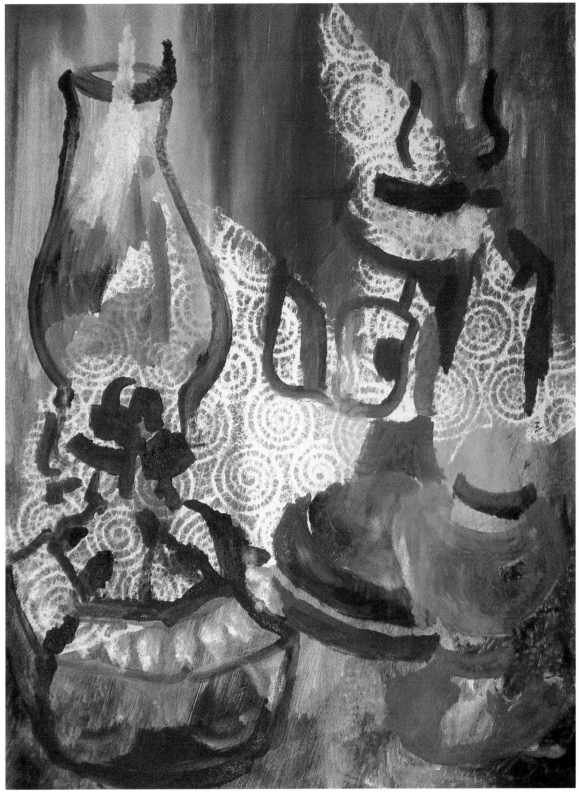

Shirley Ward, *Grandmother's Lanterns,* 18 × 14" (45.7 × 35.6 cm).

Ward made this monotype with two plates. She inked her first plate and placed lace paper shapes on it, subsequently making the transfer to paper using a press. On the second plate, she painted the image details, which she transferred to the same paper.

Stencils

Stencils are usually made of more durable materials than masks—such as Mylar, thin aluminum, and lightweight cardboard—and are reusable. Once you have cut out your shape, you can use both the positive and the negative images. The positive shape is used almost as a relief in the sense that you paint it and then assemble it onto your inked plate for transfer. Alternatively, you can place the negative shape on a clean plate and paint in the cutout area, then develop the surrounding areas.

There are stencils made commercially that you can purchase in art-supply stores. You can also make stencils from plastic tops of food containers. They are easy to clean and can be used numerous times.

AnaMaria Samaniego, a Santa Fe printmaker, developed a series of small landscape monotypes using stencils made from aluminum soft-drink cans. The size of the monotypes were partially determined by the size of the flattened cans she used. The plate was inked first with a gradation of color. The stenciled land shapes were then inked separately and assembled on the inked plate for transfer. The result is a landscape that has a three-dimensional effect.

Martin Green places a moon-shaped stencil on a blue-inked plate. The monotype in progress is held in registration by the rollers of his press.

Here you can see the successful transfer of the moon shape.

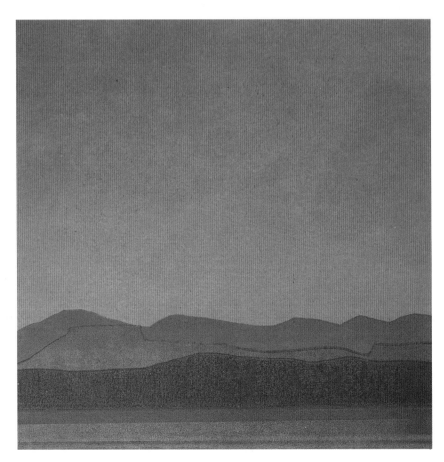

AnaMaria Samaniego, *Las Tierras de Nuevo Mexico #94,* 7¼ × 7¼″ (18.4 × 18.4 cm).

This monotype is part of an extended series depicting the transformation of the landscape according to the time changes during a New Mexico day. The land shapes are thin aluminum stencils, inked and then laid on a plate that has been covered with a color gradation.

Embossments

You can create wonderful raised designs and textures in monotypes by pressing any number of different materials into your paper, using a press transfer. Hand transfers can be done, but they aren't as effective as press transfers. Embossing is usually done with moist paper, although it is possible to impress patterns into dry paper. There are a number of ways to incorporate embossing in monotypes, and numerous materials that you can use.

To create bold embossed shapes, you can cut stencils from a sturdy material such as an AHC multimedia board, and then use a hot-glue gun to trace designs on top of the cutouts; these tracings will appear in relief on the paper. Fabrics and other pliable or absorbent materials can be used untreated, or you can stiffen and seal them with varnish or acrylic medium so they can be inked easily or even used as plates themselves. Handmade lace is an ideal fabric

to use if you want a lovely, delicate pattern.

A prominent wood grain will also emboss onto paper. Use a wire brush to remove the softer areas, leaving the stronger pattern of the hard grain in more definite relief. Dampening the brush facilitates this process. When the wood is dry, coat it with varnish or polyurethane to protect it from ink applications. For textural contrast, you can collage smooth materials on top of the wood's surface.

Gesso and modeling paste are excellent for building textures on a plate. You manipulate the wet medium with various tools such as palette knives; then when the modeling paste has dried, it's wise to sand away any sharp edges that might cut the paper. You can then paint or roll ink on top of the textured plate for transfer.

Thin aluminum plates can be cut into desired shapes for embossing with

an old pair of scissors—soft-drink cans opened up and rolled flat work well for this purpose. You can glue pieces together with dots of a strong adhesive such as a fast-acting (five minute) epoxy glue and add patterns by scratching, hammering, or puncturing the metal's surface with hard tools.

Whatever embossing element you choose, it must be thin; a material that is too thick won't allow ink to transfer to the paper, resulting in a white halo around the image. You can apply more pressure by placing extra cushioning over the embossment during transfer.

If you are using an etching press for transfer, first lay a blanket on the press bed, place your plate with the embossing elements on top of it, and then position the paper over the plate, followed by two blankets. Using all three blankets in this manner will cushion the embossment and is essential if you use dry rather than moist paper.

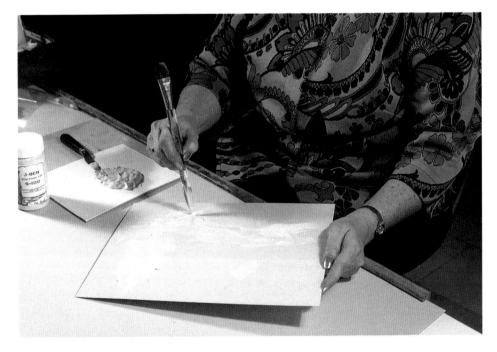

Juanita Niemeyer demonstrates how modeling paste can be used to texture a plate. A palette knife was used to spread the compound on her mat-board plate. Here lines are drawn into the compound with the point of a brush handle. Texturing tools such as sponges or coarse fabric can also be pressed into the surface. After the compound is dry, the entire plate is sealed with acrylic varnish.

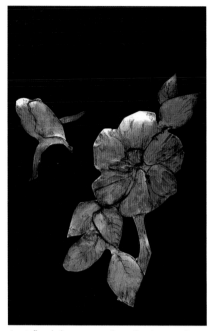

I cut floral shapes out of an aluminum soft-drink can, then assembled and attached them to my plate with an epoxy glue. Next I painted the aluminum forms with watercolor. (This picture shows the ghost paint on the surface left from the transfers.)

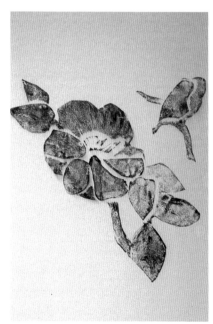

This first transfer had too much white halo around the elements, where the paper did not reach the paint.

Julia Ayres, *Rose,* 12 × 9″ (30.5 × 22.9 cm).

The halo effect was lessened when I placed toweling over the plate and paper to add more pressure during transfer.

Embossing with Tin

Santa Fe artist Ford Ruthling constructs thin tinwork plates by cutting and soldering them to specific designs. First he draws the design; then the metal is cut to fit the design shapes. Simple tools are used to stamp and further develop the shapes. He solders pieces together where needed.

When it is time to print, Ruthling places his original full-size design on paper on the press bed. He then places the inked tin shapes and organic elements in the design. The background of the print will be untouched paper. Then he places moist paper in alignment over the paper and tinwork, and he runs them through an etching press. The shapes are embossed and leave color according to the design. Later, Ruthling uses a brush to develop the embossed monotype on top with oil paints.

Detail of a piece of tinwork that Ford Ruthling has cut and soldered.

Ford Ruthling, *Hidden Faces—Masked Thoughts #21,* 29½ × 42" (75 × 106.7 cm).

Ruthling's embossed image was printed from many tinwork plates that were individually painted and then arranged on the press.

Embossing with Found Materials

Robert Lee Mejer, a professor of art and gallery curator at Quincy College in Illinois, began working in monotype in 1974. During this time his images have changed from abstract expressionism to representational figurative to abstract illusionism to the present use of "found" materials. He describes his current work as watercolor monotype assemblegraphs, which he pioneered in 1979.

Sometimes Mejer's embossing materials are shapes cut from a thin aluminum lithography plate or a thin Mylar sheet, string that has been formed and shaped, pieces of paper that may be parts of an old watercolor, burlap, sandpaper, torn tracing or newsprint paper, masking tape, corrugated cardboard, pipe cleaner, or metallic ribbon with circular cutouts. He considers these objects to be the "vocabulary" of his work. At times, the objects become the painted embossed image or carry the drawn image or act as a stencil.

Usually, Mejer uses several water-based mediums. His primary tube watercolor palette emphasizes the staining colors such as phthalo green, phthalo blue, and alizarin crimson because of their ability to transfer well. Cadmium and earth colors are also used to round out the palette. He also has experimented with the Colorcraft monoprint paints and Caran D'Ache Neocolor II crayons, and uses them interchangeably with tube watercolors. Mejer uses oil bristle brushes for applying paints and wooden sticks, damp rags, paper towels, sponges, a spritzer bottle, and his fingers for removing the medium.

Mejer uses grained Plexiglas plates, which often carry the ghost colors from previous sessions; this provides the color variations and spatial depth he wants. His relief components are painted separately. Both the plate and the relief shapes are left to dry before assembling.

For a textured field, he adds freshly printed newspaper to the plate by spraying it on with water. When he is satisfied with the image, he carries the work to the press bed.

He places a damp sheet of Rives BFK paper on top of the dry assemblage on the press bed. A piece of newsprint is then placed on top of the plate and paper to help protect the blankets and absorb the excess water and sizing.

Mejer works on either a Charles Brand or Takach-Garfield etching press. He uses more pressure for a ghost transfer and a deeper embossment. If there is too much pressure, any paper embossing elements will adhere to the print and must be removed slowly. (Plastic and aluminum embossing elements will not usually stick to paper.)

The majority of Mejer's works are created with one pull from the press. If he feels a work needs further development or wants to vary the first assemblage, he makes a second run through the press.

When Mejer uses a second plate to layer colors, he uses a registration system. After the first color has been printed and is dry, he mists the back of the paper before printing the second plate. This layering effect is not possible when painting one color on top of the other on the same plate. At times, Mejer prints multiple plates in sequence from light to dark, such as yellow light for the first press run, red medium for the second printing, and finally dark blue in chosen areas for the final print. (To check the overlay of color and the registration, you can use a light box.) He has also printed an oil-based plate over a watercolor monotype to produce a richer range of tones.

Robert Lee Mejer, *Impulse,* mixed-media assemblegraph, 17¾ × 14" (45 × 35.6 cm).

Robert Lee Mejer's unique assemblegraph process yielded this print. As he says, "It reflects my image in nature—clouds, land, moisture, atmosphere, shapes, and so on, and how my vision is framed by windows and doorways, creating illusionistic passages of space."

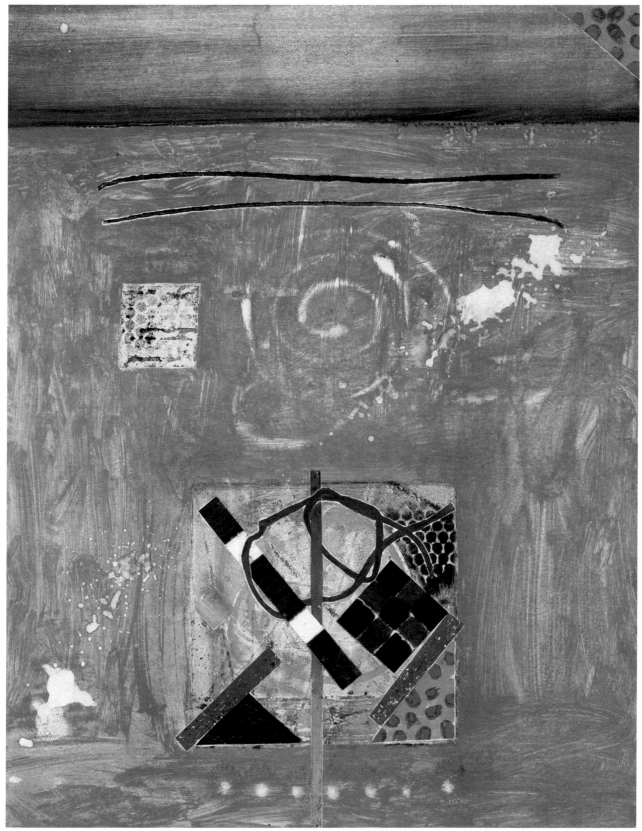

Robert Lee Mejer, *Twilight,* mixed-media assemblegraph, 18 × 14″ (45.7 × 35.6 cm).

In this experimental monotype, Mejer used an airbrush with water to create white spaces on the plate, such as in the spiral and dots. He also sprayed a red-pink color on top of dried blue paint that was on the plate. The found embossing elements consisted of string, aluminum plates, and triangular paper. Caran D'Ache crayons were stippled into the blue on the plate.

Collage

If you want to include some three-dimensional elements into your monotype, you can collage thin materials—such as paper and fabric—during various stages of development. The collaging can be done during transfer, or you can add it to the top of the printed monotype. *Chine collé* is a French term used to describe the popular collage method by which thin papers are adhered to the monotype during transfer.

Once you begin experimenting with collage, you will find endless possibilities in overlapping unique textures with color.

Chine Collé

In the chine collé process, you collage thin papers, such as Japanese papers,

to your plate for transfer on the press. (It is also possible to transfer by hand rubbing.) You need to moisten the collage papers, powder them with dry wheat or rice paste, and then lay them on the plate, adhesive side up. The moistened paper for the monotype is then lowered over the collage elements and run through the press to bind all the components together in the desired pattern.

Applying powdered adhesive is simple if you use a dusting box. You can make one from a corrugated box, cutting slots into the top edge on the long sides. Through the slots, weave pliable picture framing wire across the top. You now have a screen for the moist papers to lie on. Moisten your papers,

spread them on the screen, and sprinkle dry wheat paste over them. For the dry-paste sprinkling container, you can use a simple round jar or box with an opening covered with cloth mesh, similar to several layers of cheesecloth. The excess dry paste falls to the bottom of the box for recycling.

After moist papers have been glued together, they tend to dry at different rates and often begin buckling. The papers can be flattened if you place them between blotters while still damp, with a board and weights placed on top. If the papers continue to buckle, mist the back of the monotype paper and repeat the same flattening procedure until the papers relax and lie flat. Thinner papers have fewer buckling problems.

a. A round cardboard container with mesh cloth tied on the open end is used to sprinkle fine-powdered wheat paste.

b. Framing wire is strung in one-inch widths across the open top of the box and anchored in slots that are cut along the sides.

c. A large corrugated cardboard box.

d. Moist papers, back side up, lie on the wire screen.

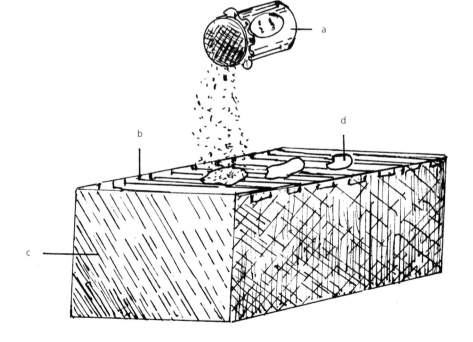

Here, Ron Pokrasso selects various paper elements that he will chine collé to his inked plate.

First, he moistens the collage papers and the support paper. Next he dusts the backs of the chine collé papers with wheat paste and lays them back side up on the plate. Here he is placing the paper onto the plate for transfer.

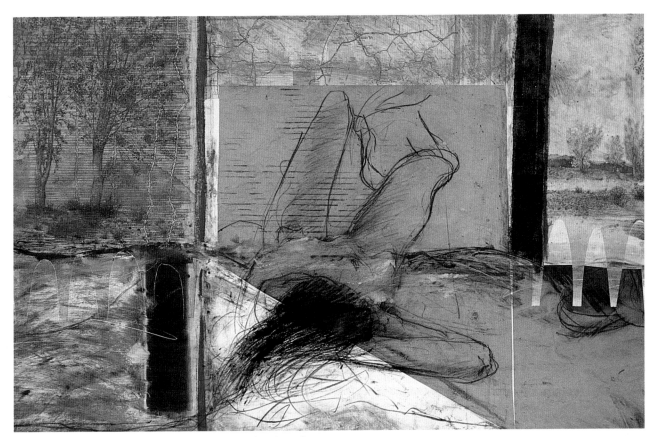

Ron Pokrasso, *Studies for Conditioning with Nature #2,* 24 × 36" (61 × 91.4 cm).

This monotype contains several chine collé elements: The etching you see on the right was cut into arched shapes, while the center drawing maintains a rectangular shape. Above the nude drawing, there is a piece of a road map.

Other Collaging Methods

There are a number of other collage techniques that monotype artists have adapted to suit their personal artistic needs. For instance, Howard Hersh often collages his monotype work on support paper with an acrylic gel medium, which also acts as a glue. The papers are dry when glued in contrast to chine collé work, which is done with moist papers. He finds it easier to keep papers from buckling when they are collaged in this manner.

One of the best-known contemporary artists incorporating collage work in her monotypes is Françoise Gilot. She usually begins by collaging various papers to the support paper that will eventually receive the monotype transfer.

Gilot works with both natural and tinted Japanese papers, stenciled Mingei papers, lacy and translucent papers, foil, and on occasion, exotic old paper money. She brushes rice paste or PVA adhesive on the collage papers, and then positions them on the support paper. She then runs them through the press. Next, the papers are weighted dry, as she develops the ink work on her plate.

The work is developed in a free, spontaneous fashion with multiple transfers through a lithography press. Gilot sometimes includes additional chine collé work during the subsequent transfer steps. After the final transfer, the print is slightly dampened and run through the press for flattening.

Françoise Gilot, *Daydreams,* 32 × 27"
(81.3 × 68.6 cm), 1987, collection of
David and Julia Ayres.

In this monotype, Gilot incorporates patterned papers, collaging them with the lithography inks she has painted her plate with.

Making Your Own Collage Papers

Since commercially manufactured colored papers tend not to be lightfast, it is often desirable to make your own collage papers. There are a number of methods you can use to make collage papers—through direct painting or with the monotype process. For instance, a monotype can be transferred to thin paper and torn for collage.

Rubber stamps are wonderful for creating patterned papers. Harder to find, but wonderful to use, are wood blocks used in hand textile printing. You can roll paints or inks on the surface of the blocks, and then stamp them on the papers as you choose.

You can also directly paint or roll paints and inks on the papers. Textures can be created by rolling ink over paper that is placed over a textured surface.

To create marbleized paper, you might want to try the floatagraph process. In a flat, shallow pan (I use a 9½ × 13″ [24 × 33.0 cm] baking pan) filled with water, add oil-based paints or inks. You will see the pigments float into marble patterns on the surface. Using thin papers, you can pick up the marbleized patterns by gently laying the papers on top. Recently, there has been experimentation with floating acrylic paints on a thick fluid such as undiluted liquid starch or water thickened with tragacanth or carrageenan. Commercial products for thickening water are becoming available in art-supply stores.

A ghost of a watercolor monotype by Shirley Ward transferred to mulberry paper for collage work.

Assorted papers stamped with commercial rubber stamps and painted with acrylic paints.

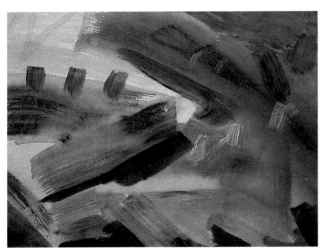

Acrylic washes painted by Shirley Ward on mulberry paper.

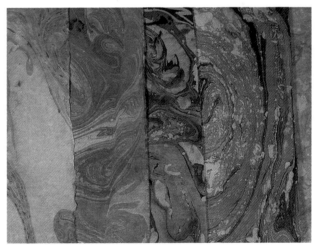

Thin papers with marbled patterns were produced using the floatagraph process.

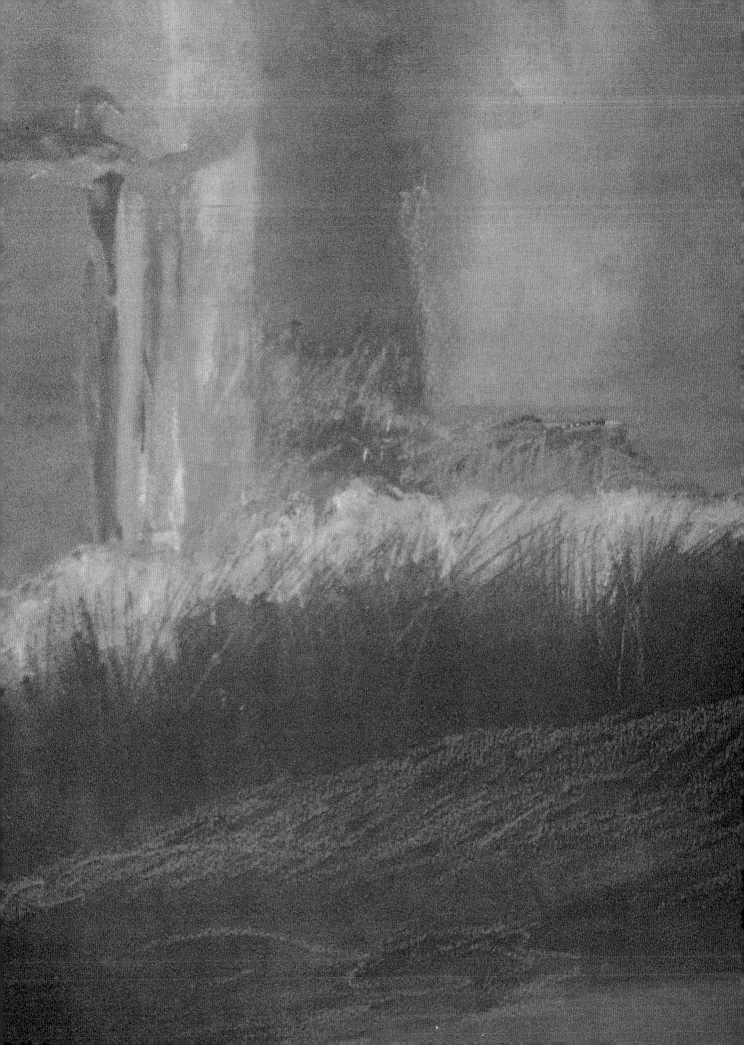

Chapter 6

Monoprints and Mixed-Media Monotypes

When a monotype includes the matrix of another printmaking process—intaglio, relief, or lithography—it is called a monoprint. In producing a monoprint, you can combine the monotype work and the other printmaking process on one plate, or you can use separate plates for each process. By combining processes, you can create a limitless number of unique effects, such as fine line drawings with intricate shaded areas and dramatic textural contrasts.

Once you begin merging various processes, you will also find yourself mixing mediums. Distinctions between medium and technique blur, leaving you a wide range of choices. For instance, you can combine watercolors or oils with pastels or crayons to develop your plate and work directly on top of the transferred print. If you are working in multiple transfers, you can add different mediums in between transfers.

There are few boundaries for where or when mediums can be used. Part of the monoprint process is to explore new materials and techniques to fit the image you want to print.

An Overview of Intaglio Techniques

This is only a glimpse of basic intaglio techniques, as it is impossible for me to give you all the information you need in the space provided here. More in-depth study is necessary if you want to use any of these processes.

Intaglio printmaking processes, which include etching, drypoint, and engraving, are those in which imagery is incised into a plate. The lines and textures are made with hard-pointed metal tools directly on the plate. To prepare the plate for printing, ink is applied to the plate and then wiped off the surface with tarlatan until only the incised lines and textures of the image hold ink. All intaglio plates need to be transferred with an etching press. The dampness of the paper, the degree of pressure applied, and the number of blankets used are all factors that determine the quality of the print.

Drypoint work is done directly on the surface of a metal or plastic plate with a scribe, needle, or Dremel electric tool. A slight burr—a flange of metal or plastic turned up at the edge—is created along the incised line that will help hold ink.

Engraving is also done directly on a metal or plastic plate with a hard steel burin or lozenge tool that will incise a groove into the surface and produce a crisper line than the drypoint scribe.

In both drypoint and engraving, you can create diverse textures by using the incising tools in a number of pencil-drawing techniques such as crosshatching or stippling. Unlike etching, both drypoint and engraving techniques do not require grounds or acid baths.

Etching involves more steps. Basically, a metal plate is first covered with an acid-resistant ground, then imagery is incised into the ground with a sharp tool. The plate is placed in an acid bath, where the incised, exposed metal areas are etched, or "bitten," by the acid, thus creating the intaglio design. The ground is then cleaned from the plate with kerosene and alcohol and the plate is ready to be inked and wiped for printing.

Soft-ground etchings are made with a regular etching ground, plus 50 percent tallow, which keeps it soft. With soft ground, you can impress imagery such as fabric textures into the plate surface. You can also place a drawing on top of a plate covered with soft ground, and make a tracing of it with pencil. When you finish the tracing, the plate is then soaked in an acid bath. The lines produced in this technique have more variation in strength and width than lines in a hard-ground etching.

Aquatint is an etching method in which you produce tones instead of lines using powdered rosin as a ground. The rosin is applied to the desired areas on the plate, and then the plate is heated to bind the rosin to it. Later, when the plate is placed in an acid bath, the acid will eat into the metal around the rosin, creating small pits to catch the ink. The small pits create a grainy texture.

In lift-ground techniques, you draw or paint an image on the plate with a water-lift medium such as a sugar and gum mixture. Next you need to cover the plate with a thin layer of hard ground, and allow it to harden. Once hardened, you place the plate under warm water. The water-soluble medium will then lift the hard ground only in the areas that were drawn or painted and expose the metal surface, which will later be etched in an acid bath. This technique allows you to incorporate brushstrokes as well as fine line details.

Dorothy Hoyal, *Ghost City,* monoprint, 25¾ × 17½" (65.4 × 44.5 cm), 1987.

Hoyal's procedure for this monoprint was to cut the shape of the etching plate (the inset) from a mat board of equal thickness. Then she sealed the mat board with acrylic varnish. The etching plate was then placed within the mat board plate as the monotype was being developed with watercolors. When Hoyal was finished with the monotype plate, she removed the metal plate and wiped it with etching ink. Then she dropped the etching plate back within the mat board plate, which was placed on the press bed. Hoyal's work was transferred to moist Arches Cover print paper with one run through the press.

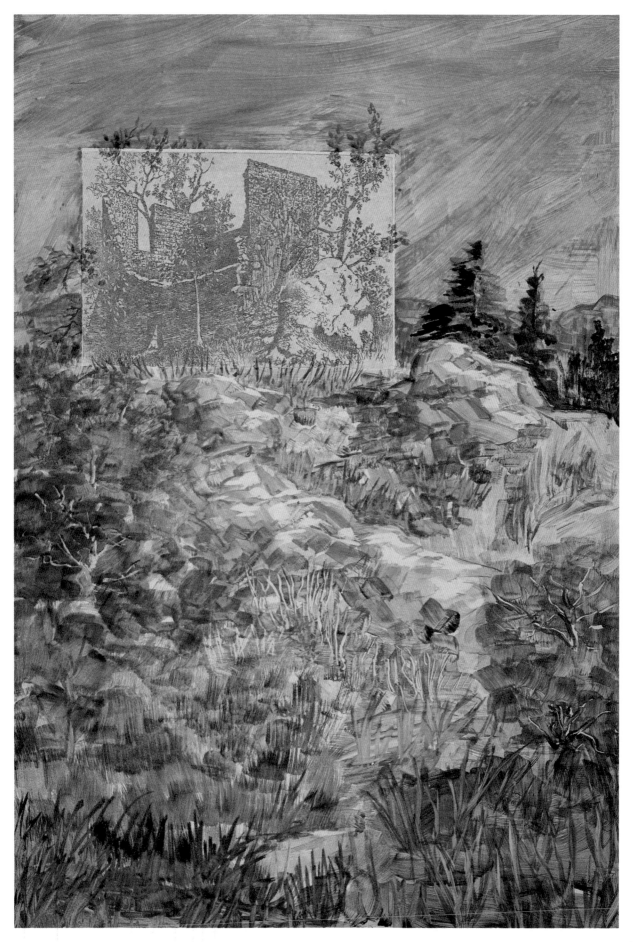

Intaglio Monoprints

Ron Pokrasso works in several techniques to make intaglio monoprints. His intaglio plates are often made with combinations of hard-ground etching, drypoint, and aquatint. The print plate for the Egyptian Eve series is drypoint on Plexiglas. The lines were incised with a Dremel tool and scribes. First Pokrasso inked the drypoint work with black ink. Then he wiped the flat surface of the plate clean and used it as a monotype plate, applying colored printing inks with a brayer and brushes. The transfer was then made with one run through the press.

Pokrasso also develops intaglio work on zinc plates to incorporate almost exclusively in his monoprints. The plates are printed and finished in basically

two techniques. One way of working is to print the intaglio plate first, and the second plate is worked as a monotype and transferred on top of the intaglio. In the second method, the intaglio print is torn and becomes chine collé elements that are transferred with monotype work on a smooth Plexiglas plate. Guidelines to keep the work in registration while painting are made with a lithography crayon directly on the back of the Plexiglas plate.

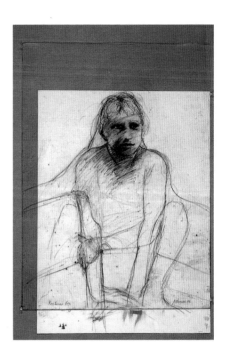

This life drawing by Ron Pokrasso inspired his Egyptian Eve series. Here a clear Plexiglas plate was positioned over the drawing. Pokrasso then used a Dremel tool to drypoint the image into the plate. One plate was used to develop this series. Some of the monoprints printed from this plate are shown on this page.

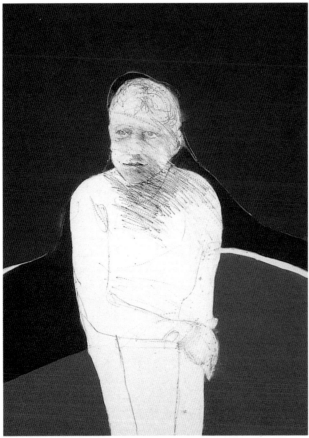

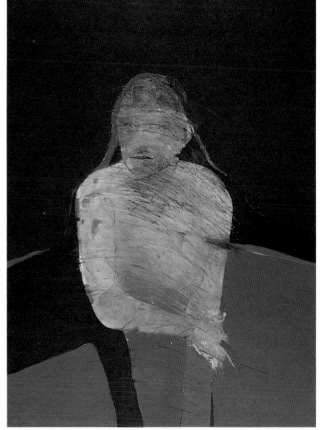

Ron Pokrasso, *Egyptian Eve #4,* intaglio monoprint, 33 × 24″ (83.8 × 61 cm), 1986.

Ron Pokrasso, *Egyptian Eve #10,* intaglio monoprint, 33 × 24″ (83.8 × 61 cm), 1986.

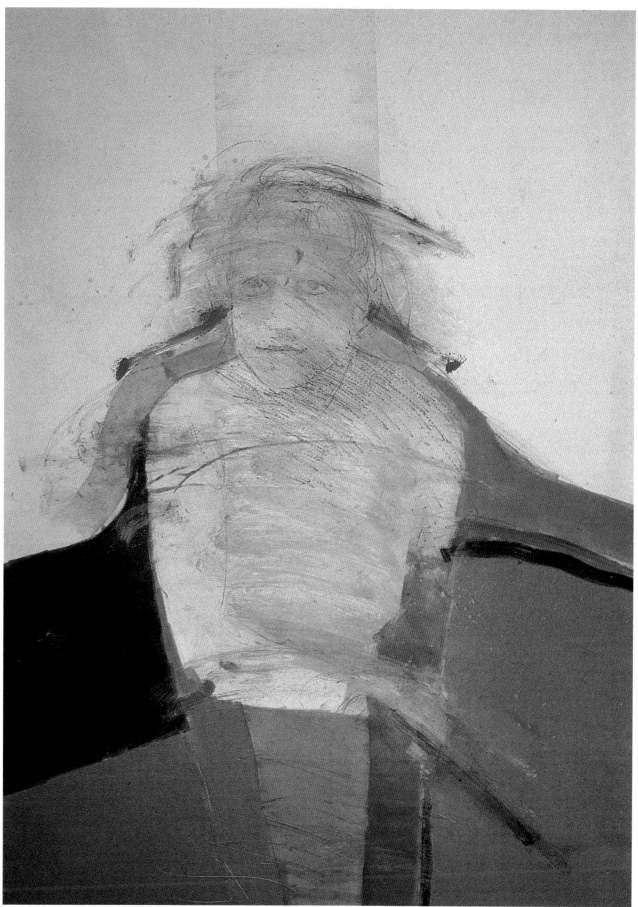

Ron Pokrasso, *Egyptian Eve #22,* intaglio monoprint, 33 × 24″ (83.8 × 61 cm), 1986.

Working with Two Plates

When Maxine Richard makes intaglio monoprints, she often uses two plates. The first plate is either zinc or copper for the etching, and the second is Plexiglas for the monotype work.

First, Richard makes a print on paper from the metal intaglio plate. While the ink is still wet, she lays the print face down on a Plexiglas plate that is the same size as the print. She then runs them through the press to print the image on the Plexiglas plate. After the ink has dried on the Plexiglas plate, Richard covers it with clear contact paper; this will be her monotype plate. Using the intaglio lines as a guideline, she can now develop the monotype elements and see what the completed monoprint will look like. After both plates are completed, Richard inks them and each one is run separately through the press.

In *Peyton's Corner,* by Dianne Haralson, a large copper plate that had been used previously for a series of etchings was reused as a monotype plate. A second, smaller plate was used for the portrait inset. To insert the etched image into her monotype plate, Haralson first inks the etching plate and transfers the image to paper. (She uses a template for registration.) Then while the ink is still wet, she takes a blank copper plate, places it in the template, lays the etching on top, and passes it through the press. The image is now on her monotype plate.

Haralson begins work on her monotype plate by applying yellow and blue inks to its surface. Then she pushes the plate face down on newsprint at a slight angle to exploit the inks' different viscosities, allowing them to blend to create the greens that you see in the reproduction. Next she paints small dots of red and yellow flowers on the plate.

When the monotype plate is completed, she drops it into a mat template on the press board. A small piece of rice paper is used as a mask and pressed into the wet ink area where the portrait plate will later be printed. The work is then printed on damp Rives BFK paper. The rice paper partially masks ink from reaching the support paper.

Next, the small portrait plate, a soft-ground etching with aquatint, is inked with black and wiped in the usual manner for preparing an etching plate. Haralson then places it in registration on the press bed so that it will print in the area on her support paper where the rice paper had masked out ink. She then runs the small plate and her paper through the press to complete the monoprint.

Dianne Haralson, *Peyton's Corner of the World,* 11 × 14" (27.9 × 35.6 cm).

This monoprint was produced with a large plate for the monotype and a small plate for the etching. A partial mask of rice paper blocked out ink in the area where the small plate was to be printed.

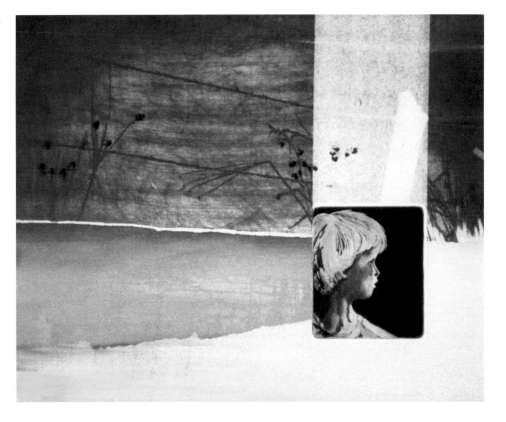

Shown here is Maxine Richard's Plexiglas monotype plate printed by offset with the image from an etching plate. She uses the offset image as a guide for applying color to her monoprint.

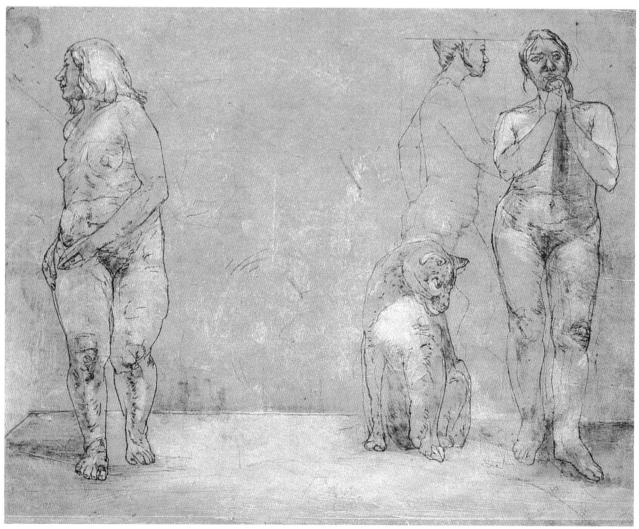

Maxine Richard, *Two Women with Cat,* 12 × 15″ (30.5 × 38.1 cm).

Colored inks were rolled and wiped on the monotype plate. Then Richard ran the etching plate through the press, followed by the monotype plate.

An Overview of Other Techniques

Once again, this overview only gives basic information. If you want to use any of the relief and lithography techniques mentioned below, you should do a more in-depth study.

When you prepare a plate so that the raised surface is to be printed, this is known as a relief printmaking technique. The most common of these are woodcuts and linocuts. The negative areas not to be inked are cut away from the surface with metal tools. The surface of the plate—wood or linoleum— is usually inked with a thin layer of ink by rolling it with a brayer. Then you can transfer either by hand or press. These techniques can be developed as monoprints by including monotype techniques.

Lithographic printmaking differs from intaglio and relief printmaking as it depends on the antipathy of grease and water. Instead of lines bitten or etched into the plate, in lithography the lines of the image lie on top of the plate. In general, you create lithographic images by drawing or painting with materials such as grease crayons and tusche on a lithographic stone or an aluminum plate. When your drawing on the stone is completed, the en-

tire surface must be treated with chemical solutions so that the greasy drawn areas are fixed and the undrawn, blank areas become grease-repellent. Water is sponged on the stone before the ink is applied. The moisture is repelled by the greasy lines but accepted in the blank, undrawn areas. Ink is then rolled onto the stone, adhering only to the greasy drawn areas. The rest of the surface is damp and repels the ink. (The procedure is slightly different when you use an aluminum plate.)

Dampened paper is placed on the inked plate with a clean sheet of paper and fiberboard on top, and then the transfer is made. (You cannot print a lithograph by hand.)

Linocut Monoprints

When Texas artist Ro Reinthal made her reductive linocut series at the Graphic Workshop in Santa Fe, she began with a monotype. Using oil-based inks, she developed an image on a piece of linoleum, then transferred it by press. She repeated this process on several sheets of paper. The ghost remaining on the linoleum after each transfer was used as a guideline for the next monotype painting.

After the monotype work was completed, Reinthal began the linocut work. She cut all the areas away from the linoleum that were to remain the color of the paper. The linoleum plate was inked with the first color, yellow— she will be working from light to dark. A thin aluminum mask was positioned on the monotype area to keep ink from transferring on top of the image. After the transfer, the linoleum plate was reinked and the stencil repositioned for each printing of all the papers.

Next all areas that were to remain the first color were cut away, or subtracted, from the linoleum. The surface was inked, the mask again positioned between the plate and monotype, and the transfer made. The steps were repeated for all the colors. When it was time for the last and darkest inking of black, Reinthal also wanted to add black lines to the monotype image. Therefore, she cut away all the areas from the monotype shape that were not to receive any black ink. Then she rolled black ink on the remaining lines of the linoleum surface and completed the transfer. She repeated the procedure for each of the monoprints in the series.

AnaMaria Samaniego helps Ro Reinthal cut away the next area to be subtracted from her linoleum plate. They are comparing the plate to the reverse image of it on the paper to the right.

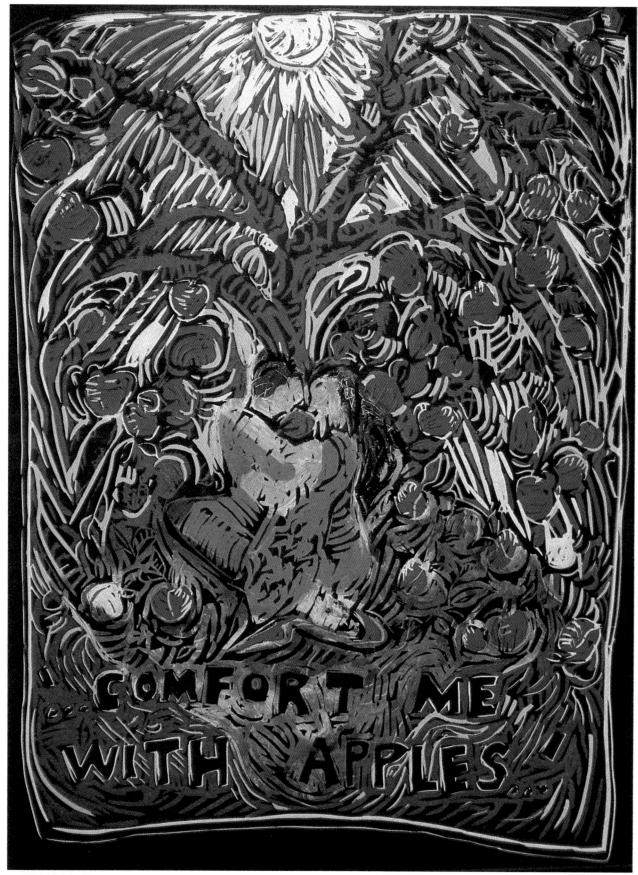

Ro Reinthal, *Comfort Me with Apples,* monoprint, 24 × 18″ (61 × 45.7 cm).

One plate was used for the monotype and linocut. After the monotype was developed and transferred, Reinthal began her subtractive linocut.

Nancy Friese prints linocut plates that have monotype work on them with one pass through the press. She paints colored inks in the recessed areas that have been cut from the flat linoleum surface. Then she rolls or paints in the remaining flat surfaces with inks. The flat surfaces print simultaneously with the recessed areas, producing a slight embossment that is typical of linocuts printed on the press.

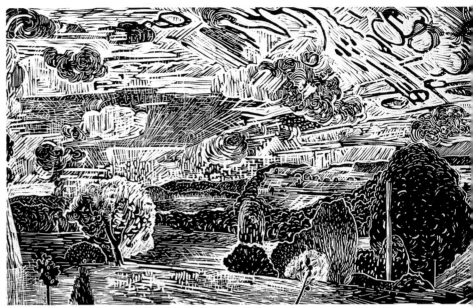

Nancy Friese, *Never Still,* linocut print, 18 × 29" (45.7 × 73.7 cm).

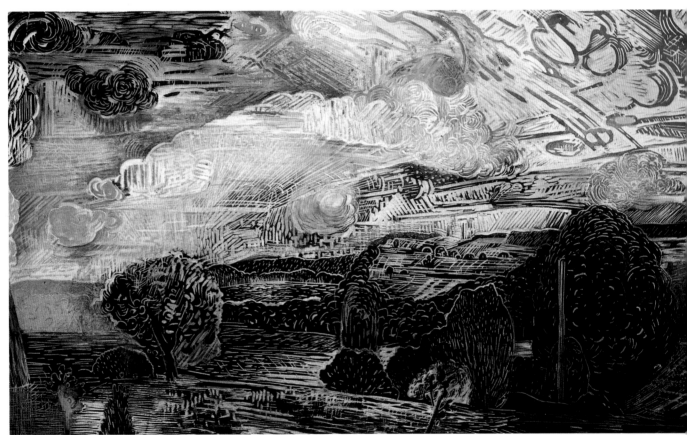

Never Still becomes a monoprint when monotype work is added by painting directly on the plate. (Both images this page courtesy of Giannetta Gallery, Philadelphia.)

Lithographic Monoprints

Robert Kushner arrived at Solo Press with unique handmade papers, that he had made with Bernie Toale at Rugg Road, a papermaking and printmaking workshop and gallery in Somerville, Massachusetts, close to Boston.

Kushner drew on $32 \times 52''$ (81.3×132.1 cm) aluminum lithography plates with litho crayon and tusche, using one plate for each color. The plates were first inked with black to examine the image. When Kushner was satisfied, the plates were cleaned with lithotine. The plates were then reinked with colored inks.

Each print was executed differently to create monoprints instead of running an edition. Kushner produced variations by eliminating some of the colored plates, changing the original color plan, alternating the sequence of the plates during printing, and, at times, applying additional colors directly on the plate using his hands and brushes. He also wiped ink from the plate using the monotype subtractive technique. Other times, he used masks to prevent color from transferring from the plate to the paper. By recombining and otherwise manipulating the imagery on his various plates this way, Kushner was able to create monoprints that work both individually and as a series.

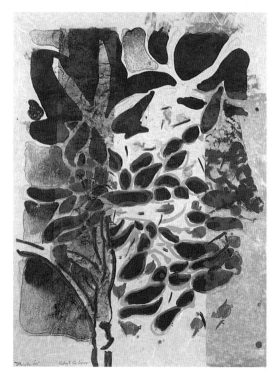

Robert Kushner, *Maple XIII,* lithographic monoprint, $23 \times 30''$ (58.4×76.2 cm), 1986.

For this series, Kushner produced litho plates in the usual manner, but altered the prints to make each one unique. For instance, he changed the colors of the inks and manipulated the sequence in which the plates were transferred. He also used various monotype techniques, such as additive and subtractive methods and applying masks and stencils. (Both images this page courtesy of Solo Press Inc., New York City.)

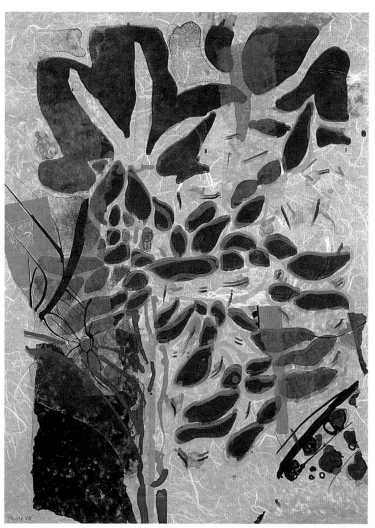

Robert Kushner, *Maple XIV,* lithographic monoprint, $23 \times 30''$ (58.4×76.2 cm), 1986.

Collagraphic Monoprints

Collagraphs are made by collaging a plate with textured materials such as cardboard shapes, modeling paste, incised surfaces, and both manmade and organic found objects. Once the materials are glued onto a board, the entire plate needs to be sealed with an acrylic medium or varnish. The plate is inked by filling in its recessed areas, and then by painting or rolling ink onto the flat surfaces. The transfer is usually done on a press. You can transfer by hand, but it is not as effective.

For a monoprint series, Dorothy Hoyal glues fresh camellia blossoms and leaves on a piece of mat board. After the glue is set, Hoyal coats the flowers and board with several layers of acrylic matte medium. She then applies a combination of watercolor and gouache, and prints the collagraph. Monotype work is then applied directly onto each collagraph print.

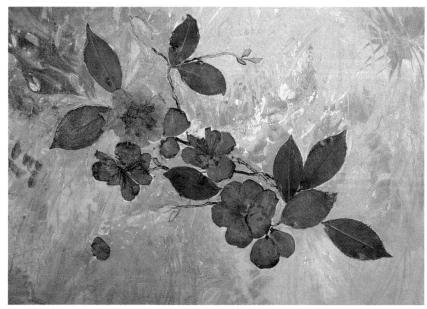

For this plate, Hoyal glued camellias with their leaves to mat board. The flower surface was then sealed with acrylic varnish. (Notice that there is ghost paint on the plate for this picture.)

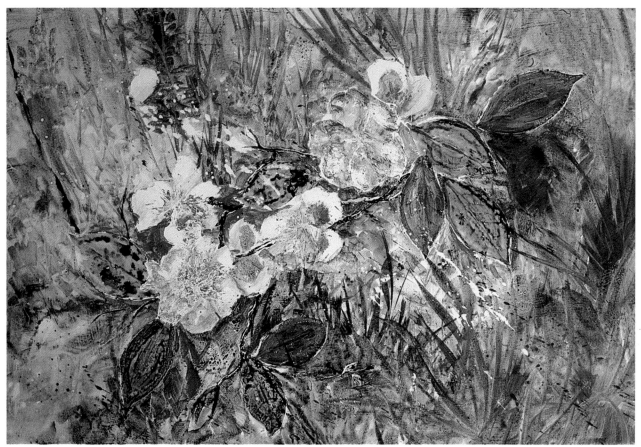

Dorothy Hoyal, *Camellias*, watercolor and gouache collagraph, 22 × 30″ (55.9 × 76.2 cm).

Hoyal developed a series of monoprints from the same plate by finishing each image differently. Varying colors and techniques were used before and after transfers were made.

Monotype "Remarks" with Prints

A "remark" is a small drawing or written comment that is usually placed near the artist's signature within the white border of a monotype.

When Nancy Bowen's galleries asked her to make remarks on the white borders of some of her serigraphy prints, she was reluctant to make small drawings as some artists have done. Instead, she solved the problem by making miniature monotypes. Bowen designed a small Plexiglas plate attached to a wooden handle. The monotypes are transferred much like one would use a stamp. Often the ghost image is also transferred. At times, the miniature works are developed with calligraphic notes in pastel.

Notice that in the remark there is also a little pastel calligraphy on top of the print.

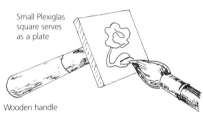

Small Plexiglas square serves as a plate

Wooden handle

Bowen's Remark Stamp

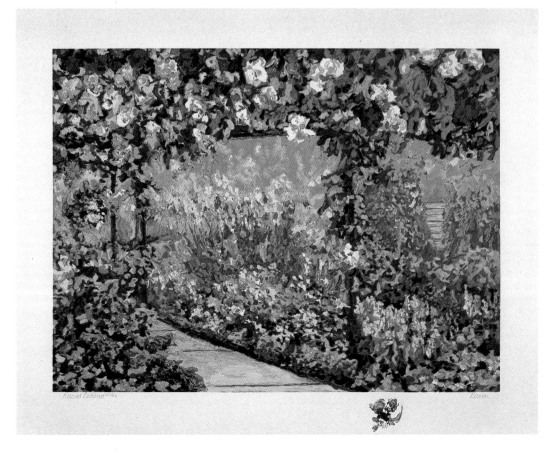

Nancy Bowen, *Roses at Butchart,* serigraph, 30 × 40" (76.2 × 101.6 cm).

Bowen has a special monotype "remark" that she uses. It is a small stamp made of Plexiglas.

Experimenting with Mixed Media

Since making monotypes is a spontaneous way of working, it readily lends itself to experimentation; many artists combine various methods and mediums to develop their work. For instance, your plate surface can vary from a slick, thin aluminum plate to a thicker textured surface such as wood. You can also experiment with the size and shape of plates—circles, triangles, or organic forms.

Tools will also help you to broaden the effects you want to achieve when developing your plate. For instance, you may begin by rolling ink on a plate, and then manipulate the medium with a brush. Cloth, sharp metal points, and crayons can help you lift or move ink.

There are various materials that you can transfer a monotype onto rather than the usual paper support. When Michael Mazur worked at the Experimental Workshop in San Francisco, he transferred his work onto silk. He needed to have wooden supports to stretch the fabric and hold it in registration during transfers. Before he arrived, the wooden support transfer system was built by master printers Will Foo and John Stemmer. You can experiment transferring onto other fabrics, aluminum, wood, glass, and plastic.

You can also use the same medium to develop the plate and to complete the work directly on top of the monotype. If you are using oil-based colors, type. If you are using oil-based colors, it is important to dilute them with a fast-drying thinner such as mineral spirits. With watercolors, you can use both dry brush and wash techniques. If the paper buckles after you have finished your work on top, it can be flattened by misting the back of the entire sheet with water, laying it between newsprint papers or blotters, and applying weights on top until it dries flat.

Water-soluble crayons, pastels, and pencils are very effective when you transfer them from the plate to damp paper and then use them again to work directly on top of the monotype. Litho crayons will also transfer well to moist paper. You can use them, too, to do additional work on the image after printing.

Michael Mazur, *Wisteria Door,* monotype on silk, 82 × 66″ (208.3 × 167.6 cm), 1988.

For this seven-part monotype, Mazur had silk firmly stretched over wooden frames. A rectangular plywood template was built to fill in and level the back of the screen during transfers. A wooden registration frame was attached to the press bed. Mazur worked on aluminum plates cut the same size as the image, using a mixture of etching and lithography inks. The fabric remained dry during transfers.

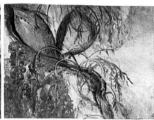

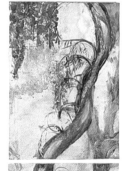

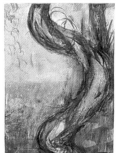

Joseph Raffael, *Blue Pond*, mixed-media monotype, 42½ × 78½" (108 × 199.4 cm), 1985.

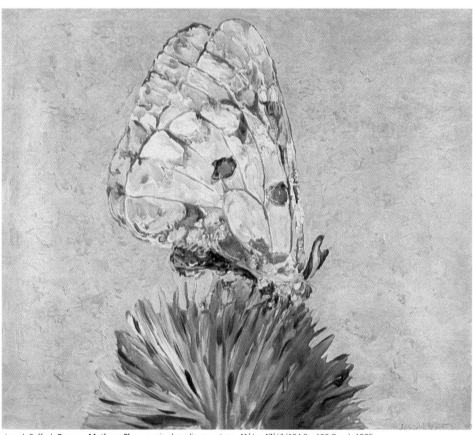

Joseph Raffael, *Passage Moth on Flower*, mixed-media monotype, 41¼ × 47½" (104.8 × 120.7 cm), 1985.

For these monotypes, Raffael used oil-based colors to develop the plate. Then he used acrylics to paint on top of the oils on paper. (Both images this page courtesy of Experimental Workshop, San Francisco, and Nancy Hoffman Gallery, New York City.)

There are times when you may want to work on the support paper before printing the monotype. Watercolor and acrylic washes can be added just after your paper is soaked and ready for printing. You can also make pencil and crayon images or lines before the transfer. When this is done, the reverse image of your plate must be taken into consideration in order to have this work appear in the correct placement with the plate transfer.

When it comes to mixing mediums, Nancy Friese moves freely between techniques. For example, Friese initially rolls her plate with a light coat of printing inks, usually light blue on one end of the roller and yellow at the other—the colors merge and blend in the middle. Then she wipes the ink from the areas that she will paint with oil colors

using brushes. Her images are developed with multiple runs through the press. At times, between layers of transferred ink, Friese will work directly on top of the paper with colored pencils and gouache.

Howard Hersh collages his monotype panels into his encaustic paintings. You can collage monotype papers onto various types of works on paper as well. It may be transferred, for example, to oil or watercolor work before, during, or after the preliminary medium work is developed.

Joyce Macrorie develops and transfers her monotype plates in a print shop, and then develops them further in her studio. At the print shop, Macrorie rolls printing inks onto a Plexiglas plate with rubber brayers. The inks are usually a mixture of both etch-

ing and lithography colors that she mixes to a desired medium viscosity. Detail work, kept at a minimum, is done with simple strokes applied freely, using the edge of the brayer. Then she transfers by press.

In the studio, Macrorie will complete the monotypes by working directly on top of them with pastels. At times, Macrorie will also use acrylic color, diluted with medium, which gives a glaze effect on top of the monotype. At this stage, she usually works with photo references to finish her images.

Monotype is perhaps the most creative, expressive means for an artist to work with few written restrictive rules. Since you can easily mix many mediums to produce a monotype, you will soon discover through experimentation that the possibilities are endless.

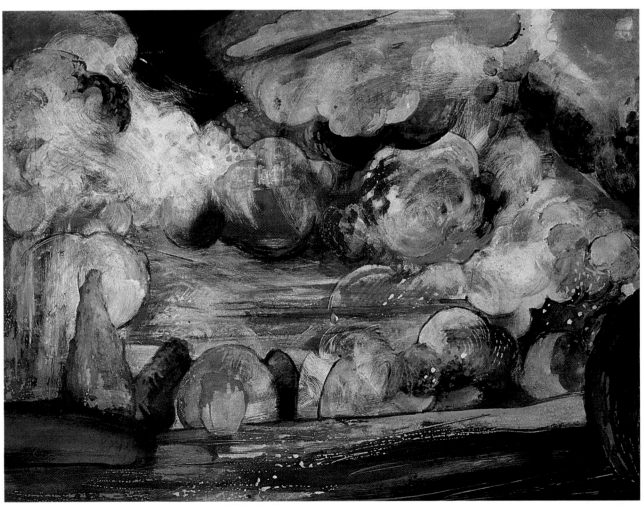

Nancy Friese, *Wind and Light,* mixed-media monotype, 18 × 24″ (45.7 × 61 cm).

First, Friese rolled her copper plate with yellow and blue inks, allowing the colors to merge in the middle. Then she wiped areas of the plate where she wanted to do direct painting with oil colors. Her image was developed with multiple runs through the press. She also worked directly on top of the paper between transfers with colored pencils and gouache. (Courtesy of Giannetta Gallery, Philadelphia.)

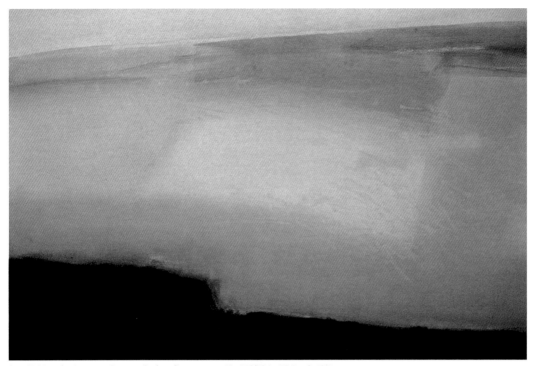

Joyce T. Macrorie, *Japanese Sunset,* mixed-media monotype, 15 × 22″ (38.1 × 55.9 cm), 1990.

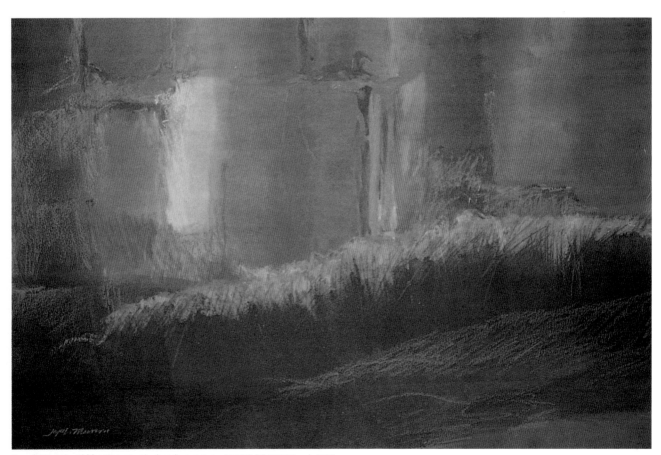

Joyce T. Macrorie, *Hidden Canyon,* mixed-media monotype, 15 × 22″ (38.1 × 55.9 cm), 1990.

After transferring an image from plate to paper, Macrorie uses pastels and, at times, acrylics to further develop her work.

Biographical Notes

Included in this list is a special group of artists and printmakers from Betty Sellars's Whitbread Press in Tulsa who met with me on a number of occasions to explore working in monotype techniques with various mediums.

Berenson, Richard J. Art director for *Reader's Digest* magazine.

Bowen, Nancy Bowen's work is included in numerous museum, corporate, and private collections including the Laguna Beach Museum of Art, Bank of America, and Rockwell International. She is represented by South Coast Fine Arts, Anaheim, Calif.

Brady, Carolyn Brady's work is in numerous museum and corporate collections including the Metropolitan Museum of Art, New York City; Springfield Art Museum, Missouri; AT&T, New Jersey; and Chase Manhattan Bank, New York City. She is represented by the Nancy Hoffman Gallery in New York City.

Ciarrochi, Ray The recipient of several prestigious awards, among them a Fulbright grant to Italy, Ciarrochi is a New York artist whose work has appeared in numerous museum and traveling exhibitions, including "American Watercolors 1800 to Present" at the Brooklyn Museum. He is represented by the Fischbach Gallery in New York City.

Crocker, Marilyn Crocker lives and works in the California desert. Her work has been shown at the Lancaster Museum Art Gallery and in the annual exhibition sponsored by Women Artists of the American West. She is represented by Kathleen Warner Fine Arts in Los Angeles.

Duck, Joanna S. A frequent exhibitor and award winner in juried regional shows, Duck is also a member of the Oklahoma Art Workshops. Her work is in a number of private collections.

Doherty, M. Stephen Editor-in-chief of *American Artist* magazine, Doherty is also an accomplished artist. His work was included in the Smithsonian exhibition "Young Printmakers." He has written numerous articles and books on artists and their techniques.

Enright, Margaret Murphy Enright, a Tulsa artist, has exhibited regionally, often receiving award recognition. Her work is in a number of private collections.

Frederikse, Yolanda Frederikse is a Maryland watercolorist whose work has been included in numerous exhibitions sponsored by such organizations as the National Watercolor Society, the American Watercolor Society, Allied Artists of America, and the Salmagundi Club in New York City. She is represented by Town Center Gallery in Bethesda, Md.

Friese, Nancy Friese is a recipient of the 1990 Giverny Reader's Digest Grant. Her work was shown in the 1985 "Contemporary American Monotypes" exhibition at the Chrysler Museum in Norfolk, Virginia, and may be found in the collections of Colby College Museum of Art, Yale University Art Gallery, Tulsa University, and the William Benton Museum of Art. She is the author of *The Poetic Etchings of Mary Nimmo Moran* and coauthor, with Anne Morand, of *The Prints of Thomas Moran.*

Gilot, Françoise Gilot is an internationally known artist whose life and work have been described in numerous publications, including the recent book *Picasso: Creator and Destroyer* by Arianna S. Huffington. In 1990, a book on her monotypes was published in French and English by Berggruen in Paris. She is represented by Riggs Galleries in La Jolla, Calif.

Green, Martin Green's work is represented extensively in corporate and public collections including the Fogg Museum, Cambridge, Mass., and the Los Angeles County Museum of Art. His monotypes were included in "New American Monotypes," a Smithsonian traveling exhibition. He is represented by Louis Newman Galleries in Beverly Hills.

Haralson, Dianne With bachelor's degrees in both science and fine arts, Haralson often lectures on the relation of the two. Her work is included in numerous private and corporate collections. She holds an Artist in Residence status with the State Arts Council of Oklahoma.

Hersh, Howard Hersh's work has been shown in numerous exhibitions including the Stamford (Connecticut) Museum and Nature Center; College of Santa Fe Monotype Monothon; Art Fairs, London, England; and LA Art, Los Angeles. Public collections include the Cincinnati Airport, the Walt Disney Corp., IBM, McDonnell Douglas, and Home Federal Savings.

Hodes, Suzanne Hodes's work has appeared in numerous solo and group exhibitions including "Interior Spaces," Newport Art Museum; and "Figure and Landscape" and "Boston Printmakers," De Cordova Museum. Her prints and monotypes are in the collections of the Boston Public Library Print Collection; the Fogg Museum, Cambridge, Mass.; and the City of Salzburg, Austria.

Hoyal, Dorothy Hoyal's work is included in the permanent collections of the State of California Interpretive Center, Lancaster, and NASA at Edwards Air Force Base. Corporate collectors include Bank of America, T.R.W., Sperry Univac, Toyota, and the Marriott Corp. Her monotypes were included in the exhibition "Printmaking from Currier and Ives to Andy Warhol" at the Lancaster Museum, California. She is represented by Kathleen Warner Fine Arts, Los Angeles.

Jacobson, Gloria Jacobson's works are in corporate collections such as Fairbanks Country Club, Fluor Corp., Bank of America, Hitachi, and North American Rockwell. She is represented by Art Angles Gallery in Orange, Calif.

Kushner, Robert Kushner is an internationally recognized artist whose work is included in the collections of the

Australian National Gallery; J. Paul Getty Trust, Malibu; Los Angeles County Museum of Art; Museum of Modern Art, New York City; San Francisco Museum of Modern Art; Tate Gallery, London; and the Whitney Museum of American Art, New York City.

Liu, Katherine Chang Past president of the National Watercolor Society, Liu has received numerous national and regional awards. Her work is in such public collections as the Palm Springs Desert Museum; Utah State Harrison Museum; royal collection of Saudi Arabia; IBM; ITT; and GTE. She is represented by Louis Newman Galleries in Beverly Hills.

Macrorie, Joyce T. Macrorie's work has been in exhibitions throughout the United States, notably in New York, Illinois, Michigan, and New Mexico. Permanent collections in which her monotypes may be seen include the Art Institute of Chicago, University of Michigan, Detroit Institute of Arts, IBM, and Kalamazoo College. She is represented by Munson Gallery in Santa Fe.

Mazur, Michael Mazur's impressive list of monotype exhibitions include such major shows as "New American Monotypes," a Smithsonian traveling exhibition; "The Painterly Print" at the Boston Museum of Fine Arts and New York's Metropolitan Museum of Art; and "Contemporary American Monotypes" at the Chrysler Museum in Norfolk, Virginia. He is represented by the Barbara Krakow Gallery in Boston.

Mejer, Robert Lee Mejer's work has been exhibited in over fifty one-person shows in numerous university galleries and in the Illinois State Museum. His monotypes were included in "New American Monotypes," a Smithsonian traveling exhibition in 1978–80. He is an honor member of Watercolor U.S.A. Corporate and public collectors include Kemper Insurance Co.; Bank of America; Skidmore College; Hallmark Cards; and HBO in Chicago.

Milliken, Susan Milliken's airbrush paintings have appeared in a number of trade publications. Most recently she has devoted her time to making watercolors and monotypes and is enjoying success in a number of one-person gallery shows. She is represented by the 5th Avenue Gallery, Upland, Calif.

Pass, Dewayne Pass's work is included in several private and public collections, including Arizona State University. Recent exhibits of his work include Oklahoma Artist Workshop 5th and 6th Annuals; Bartlesville Art Association, 1988; and Oklahoma Works on Paper, 1985. He is represented by M. A. Doran Gallery, Tulsa.

Pokrasso, Ron Director of the Graphic Workshop in Santa Fe, Pokrasso has had work included in a number of prestigious national exhibitions, and in 1989 was the subject of a solo show at the Riverside Art Museum in California. Collectors of his work include the Arizona artist Fritz Scholder; Exxon; Hughes Aircraft; and Walt Disney Corp.

Raffael, Joseph This well-known artist currently lives and works in France. The traveling exhibition "Joseph Raffael—The California Years 1969–78" originated from the San Francisco Museum of Modern Art. Public collectors include The Art Institute of Chicago; Cleveland Museum of Art; National Collection of Fine Arts; Smithsonian Institution; and the Whitney Museum of American Art, New York City.

Richard, Maxine Richard is the founder and operator of Mimosa Press in Tulsa. Her work has been shown in a number of solo exhibits, including the Canton Art Institute, Ohio; College of Wooster, Ohio; University of Tulsa; and Trinity College, Hartford, Conn.

Reinthal, Ro The work of this award-winning artist has been included in numerous regional juried and invitational exhibitions.

Ruthling, Ford Ruthling is a designer for the Museum of International Folk Art in Santa Fe. In 1977, four of his Indian pottery paintings were selected to illustrate United States Postage Stamps. Collections exhibiting his work include the Museum of New Mexico, Santa Fe; the Philbrook Art Center, Tulsa; Roswell Museum and Art Center, New Mexico; and the Wichita Falls Art Center, Texas. He is also represented in the Dallas Museum of Fine Arts; the School of American Research, Santa Fe; and the Smithsonian Institution, Washington, D.C.

Samaniego, AnaMaria Samaniego's work has gained rapid recognition in the New Mexico area, with several solo shows at the Dolona Roberts Gallery. She was also represented at the "Juried Print Exhibition" at La Luz, 1987; "Prints" at the Fuller Lodge Art Center, 1988; and "Platemaking in New Mexico—On the Road," 1990.

Sellars, Betty (GMB) Sellars has a small press in her studio, which is known locally in Tulsa as the Whitbread Press. She has been a frequent exhibitor and award winner in regional mid-American shows. Her work is included in a number of private collections in the United States and abroad.

Siamis, Janet Neal Siamis's work is included in the corporate collections of Home Savings of America, Fluor Corp., Security Pacific Bank, Embassy Suites, and the Marriott Hotels.

Swindler, Nancy Nancy Swindler is co-founder of Oklahoma Art Workshops in Tulsa. She has won over fifty awards in juried regional and national competitions. Exhibits include San Diego International; Telluride National Watercolor Exhibit; National Watercolor Society Invitational; and shows sponsored by the National Watercolor Oklahoma, Kansas Watercolor, and Southwestern Watercolor societies.

Ward, Shirley Ward exhibits both regionally and nationally. Exhibits include Oklahoma Art Workshops annuals; Louisiana Art Guild; Dallas '89 Artfest; Bartlesville Spring Art Show, Oklahoma; and the Harlin Museum, Missouri. She attends Whitbread Press sessions.

Willner, Toby Closely associated with the Los Angeles Printmaking Society and Women Painters West, Wilner has juried and curated a number of exhibitions. Corporate collectors include Disney Foundation; IBM; Dean Witter; and MGM.

Mail-Order Supply Sources

Charles Brand Machinery Inc.
45 York Street
Brooklyn, NY 11201–1420
(custom-built etching and lithography
presses)

Colorcraft Ltd.
14 Airport Park Road
East Granby, CT 06026
(Createx Colors monoprint paints)

Daniel Smith
4130 First Ave. So.
Seattle, WA 98134–2302
(catalog, printmaking and art supplies)

Dick Blick
P. O. Box 1267
Galesburg, IL 61401
(catalog, printmaking and art supplies)

Graphic Chemical & Ink Company
P. O. Box 27
728 North Yale Avenue
Villa Park, IL 60181
(catalog, printmaking papers and inks)

J-Ben Company
4573 West 13
Quartz Hill, CA 93536
(Sculpture-eze modeling compound)

Livos Plant Chemistry
Rudolph Reitz
1365 Ruffina Circle
Santa Fe, NM 87501
(nontoxic solvent)

Multimedia Artboard Company
P. O. Box 372
Redmond, WA 98073–0372
(AHC multimedia board)

Sinclair and Valentine, L.P.
P. O. Box 3525
Santa Fe Springs, CA 90670
(lithography inks)

Takach-Garfield Press Co. Inc.
3207 Morningside N.E.
Albuquerque, NM 87110
(etching and lithography presses)

Twinrocker Handmade Paper
100 East 3rd Street
Brookston, IN 47923
(specialty printmaking papers)

Index